Eco Amazons

BY Dorka Keehn

PHOTOGRAPHY BY Colin Finlay

Eco Amazons
20 Women Who Are Transforming the World

 powerHouse Books
Brooklyn, NY

This book is dedicated to the memory of my father, Grant Keehn, who passed away in June 1982. While born in 1900, he raised me to believe that as a woman there was no mountain I could not climb, no dream I could not manifest, no struggle I could not overcome.

Table of Contents

Foreword

We stand on a precipice. Behind us, tremendous triumph and tremendous tragedy. Before us, a chasm so huge many of us wonder how and if we will cross. We face a question that is possibly more all-encompassing, relevant, and prevalent than ever before in the history (and HERstory) of humankind. We are facing the question of whether or not we, as a human, animal species, get to keep living on this beautiful, tiny, potently powerful yet powerfully fragile planetary home, spinning in space, we call "Earth." We are facing not only the question, "Will we survive?" but asking even deeper, "Is it actually possible to thrive with all the challenges we face and seemingly disparate threads we have to figure out how to reweave?"

There are no easy answers. There are no easy paths. There are, however, many, many paths of courageous, loving commitment, carved into action through the lives of people who have answered the call of the S.O.S. (Save Our Species)—and much of that is through women. Women, whose stories mostly go untold, and who in the doing—or undoing, as is sadly so often the case—add to our knowledge and support the belief that a healthy, thriving, peaceful, loving, just, and sustainable world is not only possible, but is happening. Right now.

Right now, as you read these words, women are producing a majority of the world's nonindustrialized food sources; women are the main, and often only, caregivers and providers for their families. Women are leading the direct-action movement of restoring the damage caused to the earth and standing up against the push toward supposed "progress" that continuously rapes and destroys the Earth right out from underneath our feet and our future. Women are leaders in using tiny micro-loans to transform their entire communities. Women are coming up with brilliantly beautiful solutions to design questions and problems. It is women who are directly linked to the rhythms and health of the natural world.

What we do to the Earth, we do to ourselves. And the destructive side of that can be seen in the alarming rise in breast and ovarian cancers, birth defects, and other mental and physical challenges that children are being born with that are relatively new to the time line of our human family and more and more are being directly linked to the way we have polluted our planetary home. We desecrate the Earth; we desecrate woman and all she brings forth. We heal and restore our connection with the Earth and with woman; we heal and restore the human family through our relationship with women and the vital roles women play in this web of life.

We can now send people (and finally that includes women!) to the Moon...and to Mars. But the question we really need to be asking is, "Can we truly uncover the profound and great mystery that is the connection of humans to the cosmos?" Not just, "Can we conquer it?" but, "Can we live and thrive and support it as we dance the powerful and unscripted interdependence dance with it?"

Incredible friend and ally of women and the Earth, Drew Dellinger has a poem that reads, "It is a tiny planet spinning in space. It is time we started acting like it." I have been saying for quite some time, "We are ancestors of the future. It is time we started acting like it! What do we want our legacy to be?"

"Belief Creates Our Reality," read a sign I recently saw. Well, if only one half of the story is the main story being told—that of the male views and experiences—what kind of reality are we shaping through those beliefs?

This book is in no way antimale or antimasculine. If anything this book is a narrative that invites and embraces the fullness of who we are by shining a light on the stories of just a microcosm of the women who are transforming, healing, and protecting our world. Not by hating or destroying the masculine—because that would only perpetuate the disease of disconnect that is at the root of every problem facing our world—but rather by bringing and calling forth the stories whose times have come. Stories that are already *so* alive and potent in the world. It is only that we are just now catching up.

Each and every one of us are ancestors of the future and we are the family and community of *today*! What do we want our legacy to be? The answer to that lies in how each and every one of us, male and female, lives every moment, every choice, of every day.

May this powerful and poignant book remind you—regardless of your gender or gender identity—that if not now, when? And if not you, who? Telling the lesser-told stories—the stories of women leading the way, reminds us that the impossible is absolutely possible...it might just take a little longer...which is a feminine principle.

Not that we have inexhaustible resources of anything, including time. But we have been doing "bigger, better, faster" for a while.... And our beautiful sacred world and planet is in peril. Something is definitely out of balance. As we reclaim and shine the light on the stories of women, maybe, just maybe, we will create a belief so powerful, that our reality will begin to shift before our very eyes and become one that once again remembers that the Earth and all her beings are sacred.

And that women play a vital, inspiring, and moving role in transforming our world from one of deep, deep suffering, to one where each and every one of us, regardless of gender, can look back and say, "We did it!" Thanks be to all that we know and all the great mystery that we don't know for the miracle of every breath we take. We are ancestors of the future. It is time we started acting like it. And it is past time we told the stories that change our beliefs from ones of despair to ones of love in action! And women, yes, *women* are leading the way.

Yours for a healthy, loving, thriving, today, tomorrow, and always,

Julia Butterfly Hill

Introduction

I was moved to tears when Judy Bonds, an Appalachian activist from West Virginia, finished her talk. She referred to herself as a redneck but had spoken eloquently about the destruction of her home caused by mountaintop removal mining and the impact on her family, her community, and the environment. A waitress at the time with no political experience, she was determined to turn her feelings of helplessness into action and to stand up against the coal industry. In spite of numerous death threats, she's become a leading voice against the abuses of coal and on the urgent need to transition to clean, renewable energy.

Judy Bonds reminded me of many of the women I have encountered throughout my career championing women's rights. Women who, often with little education, no political training, and lacking support and mentors, stand up for what they believe is right. Most of them face discrimination, ridicule, and alienation from their families and friends and even threats of violence. In spite of these obstacles, they persevere and transform into leaders in their communities; but their leadership frequently remains unrecognized in media, literature, and the general public's consciousness.

My involvement in women's rights began in high school as an advocate for reproductive choice, and in the many years since then, has expanded to promoting employment, health, leadership, and educational opportunities for women and girls. The political arena has been my primary vehicle to affect change. I worked for the National Organization for Women in a variety of capacities and then served on the San Francisco Commission on the Status of Women

for over a decade. While a commissioner, I was also the West Coast director of Gloria Steinem's political action committee, Voters For Choice, which supported pro-choice elected officials and candidates. Observing the gender gap in politics in the United States—only 20 percent of elected officials at all levels of government are female—prompted me and three colleagues to found Emerge America, an organization that prepares women to run for public office.

Women in elected office and in leadership roles across all sectors of society bring new perspectives to issues, which increase the likelihood of conceiving and implementing effective and just solutions to social, economic, and environmental problems. After all, women represent half of the world's skills, knowledge, and talents. Their input is required if we are to successfully address the gravest question of our time: How to ensure a sustainable future? Judy Bonds is responding to this challenge, but who are the other women leading the charge to protect our planet and its inhabitants? And what can we learn from their insights, worldviews, value systems, and leadership styles?

I began my research on women environmental leaders online but found only a couple of short lists, a few publications by university presses, and *Women Pioneers for the Environment*, an anthology of women activists from around the world. But even in this small group, the majority of the women discussed were no longer living. As I continued my search, I chose to focus on women in the United States. Comprising only 5 percent of the planet's population yet consuming 30 percent of its resources, the United States had the

dubious distinction of being the number one polluter of the world—until it was recently overtaken by China.

Environmental Women Trailblazers

Rachel Carson topped every list. Popularly thought of as the mother of the modern day environmental movement, her book *Silent Spring* brought the issue of pesticide poisoning of wildlife to the public's attention. Trained as a zoologist, she wrote poetic prose in layman's terms, as she believed that citizens had a right to know—and a moral imperative to act. Initially she looked at local birds that had been killed by aerial spraying and then made the connection to all life forms and to the potentially detrimental consequences for future generations. Carson's findings spurred a shift in environmental priorities from conservation to health and urban matters, such as clean air and safe drinking water, and prompted new government regulations designed to limit exposure to toxic chemicals by wildlife and humans.

As I proceeded with my investigations, I discovered that Carson's perspective on nature is rooted in a long history of women's perception and engagement with the natural world. In 1850, a few years before Henry David Thoreau wrote *Walden*, Susan Fenimore Cooper published *Rural Hours*, one of the earliest pieces of nature writing by an American woman. She lived in the countryside and opened her readers' eyes to the beauty and wonders of the gardens, fields, and woods that surrounded her home. Her outlook contradicted the "taming of the land" mentality of the day. Describing the decline of animals from over-hunting and of trees from over-cutting, she was one of the first to see the natural world holistically and as a model for our behavior. For Cooper, nature was God's creation and its stewardship humans' responsibility.

During the Progressive Era (1890 to 1920), women were active in the male-dominated conservation movement, but like Cooper, perceived the environment within the confines of their immediate surroundings. Not long after President Theodore Roosevelt signed into law the creation of five remote national parks, Marjory Stoneman Douglas began her lifelong crusade to form the Everglades and Biscayne National Parks, where she spent afternoons picnicking. "There are no other Everglades in the world," she states in the first line in her book *The Everglades: River of Grass*, acknowledging their intrinsic attributes, and emphasizing their significance as providers of flood controls and safe drinking water for South Floridians.

In the late ninetieth century, Ellen Swallow Richards, the first female, American industrial chemist, and Jane Addams, the first American woman to be awarded the Nobel Peace Prize, identified environmental concerns in their communities and also labeled them as social and justice issues. In 1892, Richards developed the science of ecology to mean the "household of nature" and tested home furnishings and foods for toxic contaminants and investigated water pollution in her state. Her work led to the earliest state water-quality standards and municipal sewage treatment plant in the country. In 1889, Addams founded Hull House, the first United States settlement house in the slums of Chicago, Illinois, which served the working poor and immigrants. Her personal observations of the filth and

disease led to a mapping project of the physical conditions of the area. With this evidence, Addams linked—some eighty years before the term was coined—"environmental justice" priorities, such as housing, public health, working conditions, and sanitation, with civic reform.

What became apparent to me through my investigations was that unless you had enrolled in an eco-feminist course, the chances of encountering these women were slim. Environmental history books have focused primarily on men's roles and on conservation, leaving these groundbreaking women to disappear into obscurity. Yet even in the late 1800s, these pioneers were addressing environmental matters that continue to be of paramount importance. As I moved into the present with my explorations, I found that more and more women are at the forefront of efforts to create a sustainable future but are still not widely recognized, which sparked my desire to write *Eco Amazons.*

Modern-Day Eco Amazons

How did I pick the women featured in *Eco Amazons*? With much hairpulling! My intent was to illuminate the diversity of both the women leaders and their wide-ranging responses to environmental questions, as well as to highlight their efforts in new areas of ecological attention, such as art, design, economics, and food production. I found many women in the nonprofit sector and the environmental justice arena, which required refining the selection process by geography, race, and age, but a dearth in other fields, notably green businesses.

As I was meeting many of the women for the first time, my plan was to interview them in person, starting with a set list of questions. I knew from my experience as a radio talk show host and documentary filmmaker that a face-to-face conversation would enable a deeper connection that would better help me understand the influences that shaped their lives: their upbringing, their connection to nature, and their mentors. When we discussed their work, I wanted to know if there was a particular incident that mobilized them and if the women's or environmental movement played a role. I also

sought to learn what sustains them as they confront, often daily, seemingly insurmountable circumstances. We frequently deviated from the original questions, but we always explored my primary area of interest: their perceptions of themselves as women and as leaders and how these traits influenced their approach to resolving ecological problems.

Traveling to meet these women allowed me to observe firsthand the challenges they faced. On my first trip to South Chicago to interview Hazel Johnson, the mother of the environmental justice movement, I drove past the landfills, chemical manufacturers, and hazardous waste facilities into the partially boarded up housing project where she lived. When I entered the office of her nonprofit, with its peeling paint and mildewed ceiling, I was moved by the determination of this matriarch, who had chosen to fight for her community's well-being and to not abandon the place she called home.

For the portraits, my intention was to present the women in their "natural habitats." Fortunately, Colin Finlay's 20 years as a documentary photographer enabled him to shoot images with little or no setup, as these were not women who were prone to prepping or had much patience for the camera. One of the most memorable shots was of antitoxics activist Diane Wilson on the remains of her sunken shrimp boat. Diane gamely kayaked out with us at sunset and climbed aboard its rusted hull. Colin then stepped onto the last slivers of the bow, knee-deep in water. He almost fell in and cut open his leg, but still managed to capture Diane appearing as relaxed as if she were gazing out of her kitchen window.

While I had pre-planned concepts for the stories I envisioned telling through the supporting photographs, they were often thwarted by unfriendly security guards or wildlife not being in the "appointed" location at the "designated" time. Since the Homeland Security Act was passed after 9/11, it is illegal to photograph facilities near ports where many chemical plants are located. Colin and I learned this on our first shoot, after I was hauled in front of the Port of South Chicago authorities, and Colin had to hightail it down a riverbank to escape an SUV filled with very large unpleasant men who had

followed him. But we found a few brave souls who were willing to assist us, notably a couple of helicopter pilots who flew below the radar, enabling Colin to capture the featured aerial shots.

My goal was to edit the interviews into essays told from each woman's point of view to create as intimate a connection as possible. As our conversational language tends to differ from the way we write, I strove to keep the colloquial nature of their speaking voice. I also chose to access limited secondary sources—to really allow the women to tell their stories—so I only incorporated their own writings to fill in details. My greatest struggle was streamlining each woman's narrative to fit into a chapter. The most nerve-wracking aspect of completing the book was sending my final drafts to the participants, particularly since many of them are accomplished authors. The response was surprisingly positive, only a couple of the women added clarifying points or made chronological changes.

What emerged from the time I spent with the participants and the many hours reviewing, editing, and refining their essays, was a strong sense of continuum with the environmentalist women of the past. For all of them, the environment is where they live, where they work, and where they play, be it the South Bronx, the Arctic Refuge, or a sewing factory. Natural science writer and biomimicry innovator Janine Benyus carries on the tradition of the nineteenth-century author Susan Fenimore Cooper and turns the study of our natural world into a model for solving human problems. And women like eco-entrepreneur Marci Zaroff and garbage expert Annie Leonard expand on the notion of community from the local to the global—showing that we are all interconnected.

Outside of Movements

Most of the women featured in this book operated outside both the women's and environmental movements. Particularly for the women of color, but also for the activists in rural areas, these movements had not touched their lives. They were women who looked outside their doors, and at their families' and neighbors' health, and noticed there was something wrong. They often lacked academic credentials and were self-taught, learning on their own to navigate government bureaucracies and legalese. Only after their concerns garnered national media attention would environmental organizations offer assistance.

Historically, the mainstream women's movement concentrated on reproductive rights, parity, and sexual and domestic violence. Only in the 1990s did groups like the Women's Environment & Development Organization begin to link gender with environmental justice and climate-change issues. But a decade before, Winona LaDuke, a founder of the Women's Indigenous Network, and Lois Gibbs, who formed the Center for Health, Environment and Justice, were already training and supporting the predominance of women who, either alone or in small groups, were fighting industrial pollution in their communities.

While the women's movement did open doors to career opportunities in male-dominated arenas, such as business and the sciences, these eco amazons are pioneers in their fields and many of them experienced discrimination. When oceanographer Sylvia Earle entered graduate school in the late 1950s, there were few opportunities for women scientists, and she was told that assistant teaching positions were reserved for men. The art world, which has largely ignored female artists, made no exception with ecological and conceptual art innovator Agnes Denes. While she created work at the same time as many of the early male environmental artists like Robert Smithson (*Spiral Jetty*, 1970), Agnes only received well-deserved recognition later in life from art historians and critics. And Marci Zaroff points out the prejudice women in business still face today, not only with financing but also for not being home with their children. However, these are not women who are concerned with society's constraints.

In spite of discrimination and lacking role models, the participants view their gender as a benefit. Women are perceived as more nurturing and less threatening then men, which allows them to tap into everyone's humanity. Chemical workers opened up to Diane Wilson about their illnesses and waste traders unwittingly disclosed incriminating evidence to Annie Leonard. Judy Bonds placed women

on the front lines of rallies against the coal industry as a strategy to keep the violence down. And the Reverend Sally Bingham feels her role as a female priest helps in delivering the message on climate change, often considered a controversial topic.

Leadership Lessons

How do these women lead? My favorite response is Lois Gibbs' "mommy style," where she provided the same kind of emotional support to her coworkers that she would for her kids so they felt valued and nurtured, and she compared assigning tasks at the Love Canal Homeowners Association to delegating chores at home. While not all the women draw their skills from raising children, these leaders share power and responsibility and see themselves as being more inclusive and consultative in terms of decision-making and problem solving than their male counterparts. For Beth Waitkus, this meant including inmates in the planning process of designing the San Quentin Prison garden program, and for farm worker activist Kathryn Gilje, it was reflected in the community-led leadership of Centro Campesino, the advocacy organization she cofounded.

This collaborative approach to leadership extends to the ways these women connect and develop strategies to resolve ecological, economic, and justice issues. When implementing her Bronx Environmental Stewardship Training, eco-entrepreneur Majora Carter sought not only to provide job skills for individuals, but through teaching the participants to plant trees and install green roofs, the program supports families, improves air quality, reduces energy costs, and offers the neighborhood social benefits. Marci Zaroff sold her wellness center and founded an eco-fashion company to transform the textile industry, as she recognized the interconnection between the chemicals used to produce fiber and their impact on the health of farmers, factory workers, consumers, and the environment.

Studies of female corporate leaders show that they are more likely to take risks than their male counterparts, and the women featured in the following pages would rank in the top percentile. When Theo

Colborn first came out with her research on endocrine disruptors, not only did the chemical and petroleum industries attempt to discredit her, but also many of her fellow scientists were afraid to side with her. Several of the women have been arrested, and some, like Annie Leonard and Judy Bonds, have received multiple death threats. Diane Wilson was driven to extreme measures. She initially undertook several lengthy hunger strikes and finally sunk her boat—her livelihood—endeavoring to stop the pollution from the chemicals plants surrounding her home. These courageous women understand that it takes more than just pointing out a problem, but that change requires action, and they are willing to put their lives on the line to achieve their vision of a better world.

Sustainable Relationships with the Planet

What sustains these women as they confront often seemingly insurmountable challenges? To recharge, most of them retreat into nature, and some find strength in their spiritual beliefs; often the two are intertwined—Mother Nature embodying the divine. For women like Sally Bingham, Winona LaDuke, and Hazel Johnson, their spiritual values are the foundation of their actions. Hazel Johnson describes her work as a gift from God, and Gwich'in elder Sarah James believes she was placed on this earth to take care of the Sacred Place Where Life Began (the coastal plain of the Arctic National Wildlife Refuge). Driving these women is a deep sense of responsibility for their communities, the human race, and future generations. In spite of occasional moments of despair and for some a heavy toll on their personal life, they are committed to making this world a better place and are unwilling to walk away from the struggle.

Our effect on the environment and the ramifications for future generations is never far from these leaders thoughts. As a cancer survivor, Natural Resources Defense Council president Frances Beinecke worries about her daughters and their peers increased chances of acquiring an environmentally related disease. Theo Colborn's work shows that even infinitesimally small amounts of endocrine disrupting chemicals interfere with a fetus' development and affect a child's ability to learn, to love, and to bond. Both Diane

Wilson and Judy Bonds have children with disorders—autism and asthma—attributable to toxins in the air. These women are well aware of not only the costs to individuals and their families but also to a society increasingly saddled with the burden of physically ill, and emotionally and mentally challenged people.

While maintaining a strong connection with the perspectives of their earlier environmental sisters, the modern leaders are forging new relationships with the planet—an environmentalism that is democratic and inclusive. Majora Carter and Winona LaDuke speak of creating a "new pie"—a different world—one that is just and conducive to all life. These new ways of relating help people become self-reliant by creating local green economies that link poverty alleviation with environmental remediation, support the healthy production of food and fiber, and focus on developing the best sustainable practices to meet basic human needs. If we pursue these relationships, we are offered the promise of living in harmony with the natural world that sustains us.

The belief in democracy is one that is held firmly by all the women in this book, but they share the concern that our government has become a tool of corporations driven solely by profit. Many of them argue for the need to reform the way government functions. Annie Leonard, for example, advocates for people to reengage their "citizen muscle." Lois Gibbs and the tragedy at Love Canal offer a powerful example of individuals coming together, with no political training and limited education, but with perseverance and courage, to affect change, not only for their neighborhood, but also nationally and legislatively. The unexpected reward is that joining with others in a shared goal and participating in the democratic process contributes to our personal happiness.

Education is paramount to the democratic change process and is a key component of all the women's work. Whether it's with countries, corporations, grassroots leaders, engineers, designers, or youth, the women in the following pages pass on their knowledge with joy and compassion. They presume the public wishes to engage in a deeper conversation about our current environmental crisis and to participate in the vital undertaking of moving to sustainable and just practices to insure the survival of our planet and its inhabitants.

Wisdom for the Future

I feel particularly fortunate to be a recipient of these women's wisdom and for the opportunity to share it. Beyond the hours of interviews, I often spent days experiencing where they lived and how they worked. I will never forget walking across the tundra near Arctic Village, Alaska, with Sarah James as she pointed out each plant and explained its use, or sitting in the field behind Janine Benyus' house as she described the many years of remediation undertaken to reintroduce the prairie grasses, or the many other lessons each woman proffered, which I continue to recount through my own storytelling, thus expanding the circle of knowledge.

Most striking to me is that all of the women, regardless of socio-economic status, were formed by their childhood forays into the natural world, some in their own backyards and others on family camping trips or school outings. As parks across the country close or fees increase due to budget crises, we must insure that everyone, but particularly young people, are able to enjoy and be inspired by the healing power and beauty of nature. As Sylvia Earle states, "If you've never experienced it, you don't care about it."

While deeply aware of the obstacles ahead, the women in the following pages are optimistic about our ability to turn this world around. But they are clear. The state of our planet is dire: species expiring, human health imperiled, glaciers melting, and island nations disappearing. It will take each one of our efforts to ensure that life will persist in a manner that is conducive to all of Earth's inhabitants. My hope is that these eco amazon's insights, worldviews, value systems, and leadership styles will serve as models and sources of inspiration as we tackle how to ensure a sustainable future: the critical question of our time.

Dorka Keehn

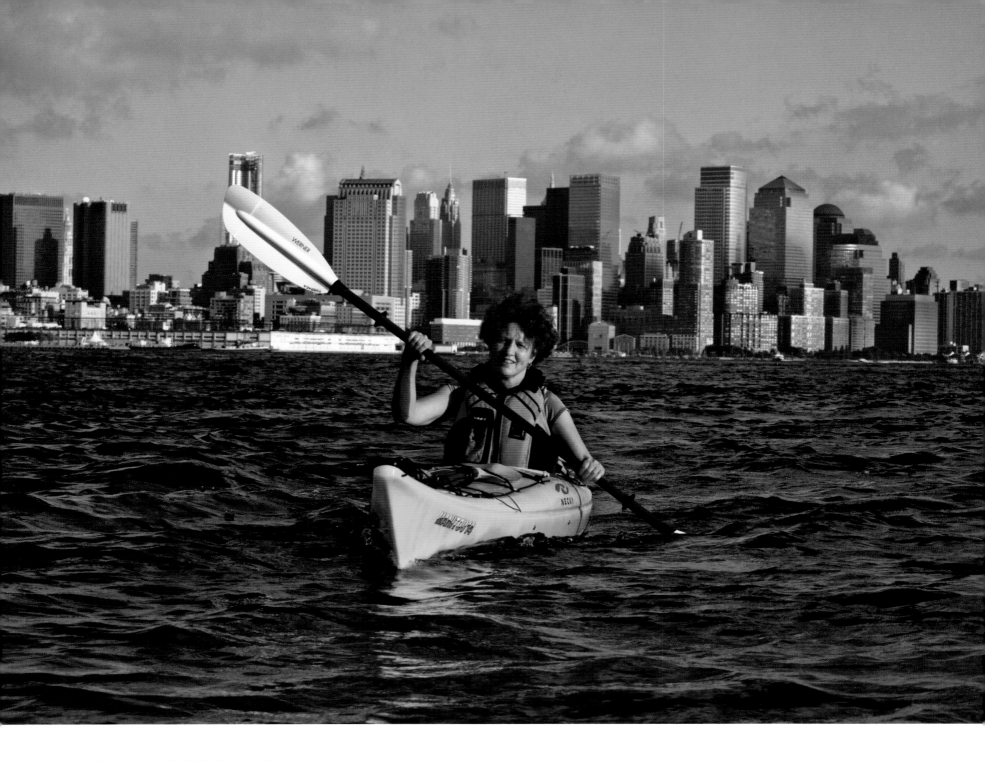

Born August 2, 1949, Summit, New Jersey

Starting over thirty years ago as an intern, Frances Beinecke is now the president of the Natural Resources Defense Council, the United States' most influential environmental advocacy group. She cofounded the New York League of Conservation Voters that works to make environmental protection a top priority with elected officials and voters. In 2010, President Barack Obama appointed Frances to the National Commission on the BP Deepwater Horizon Oil Spill and Offshore Drilling to develop strategies to prevent future spills.

Frances Beinecke

Defender of the Earth

When I was young, I lived in the moment. I didn't have a life strategy. Since I'm in a leadership position, the assumption is that I must have devised a plan; but for many people, it just comes at you at some point, and for me it was in college.

I loved being outdoors, which is a bit of an oxymoron, since I grew up in New Jersey. But I was fortunate, as my family summered on the coast of Cape Cod. We also took several trips to Grand Teton National Park in Wyoming, where I experienced the extraordinary landscape and marveled at the amazing open spaces and wild places. Still today, I am moved by the kind of splendor and resources that we are blessed with in this country. Of course, I've become increasingly conscious of how we use and abuse them and of our responsibility to manage these precious natural habitats in a sustainable manner for future generations.

I was a child of the '60s. There were riots and tremendous inequities of services and conditions in cities. Inculcated with my mother's commitment to a life of service, I started in the urban studies program at Yale College. But in 1970, Earth Day came along and created a more positive opportunity—the beginning of a movement. Since I had this passion for wild places, I thought this could be a

career where—and this is funny—I could be out in nature conducting some type of fieldwork. Now I spend my days in the offices of the Natural Resources Defense Council (NRDC) in New York City, thinking of those places. It isn't the direction I had imagined going in, but it's been an incredible opportunity and exciting every step of the way.

While in college, I fell in love with the Adirondacks in Upstate New York. There was much debate on how this six-million-acre park ought to be managed, and still today, it has some of the most innovative land-use planning in the country. I was amazed that this massive wilderness existed within three hundred miles of New York City, due to people's foresight in the nineteenth century. This was a legacy I hoped to continue, and I became very involved in land conservation in the Adirondacks.

After graduating, I traveled in Africa for several months. From a wildlife standpoint, it was unbelievable; something that you can't experience anymore in the United States, except perhaps in Yellowstone or Alaska. But the continent was suffering from the tremendous pressure of a growing population—environmental and human needs were in direct conflict. Upon returning to the U.S., I

was intent on finding solutions that would address those dual needs. I enrolled in graduate school at the Yale School of Forestry to study how to manage and improve ecosystems.

In my late twenties, I joined the board of the Wilderness Society, which heads the effort to protect our nation's public lands, and was mentored by one of the great environmental women of all time, Mardy Murie. She was the foremost voice in ensuring the passage of the 1980 Alaska National Interest Lands Conservation Act, which created the Arctic National Wildlife Refuge. Having lived in wilderness areas a good deal of her life she recognized how vital they were for the human spirit. She imbued me with the leadership skills that I depend on today: being a good listener, thinking of the

big picture, staying honest and compassionate, remaining curious, and most of all, maintaining a sense of humor.

John Adams, NRDC's founder, has been my greatest mentor and literally gave me every opportunity I've had there, from starting out as an intern while in graduate school to now serving as its president thirty-plus years later. Always an optimist, he conveyed his passion for safeguarding the earth to everyone he came in contact with. He impressed on me that a key role of a leader was to forge alliances and to support the team.

I even met my husband, Paul Elston, because of John. When Paul joined New York's Department of Environmental Conservation, John quickly invited him to our offices to discuss the State's plans

for land acquisitions. Paul was an ardent environmentalist and we immediately connected.

With philanthropist Laurance Rockefeller, Paul and I cofounded the New York League of Conservation Voters in 1989, as we recognized the need to connect politics and policy and to insure that electeds made commitments to environmental concerns in the state. As NRDC is a nonprofit, we are not allowed to engage in electoral work. Both the New York League and the National League, founded by David Brower, have been key parts of the environmental voice going forward, because it is at election time when accountability occurs.

Not long after I was married, I gave birth to my first daughter and pretty soon thereafter twin girls. Having three children under three years old was a handful. First I took maternity leave, but wanting to be with my children during the short period when they were young, I left NRDC. I stayed home until they entered school and thought I was very available to them. Instead, they remember me as always working.

I wasn't out of the movement; I was still very active on the boards of the Adirondack Council and the Wilderness Society and ended up chairing both. They were real opportunities to develop leadership skills and to look at how different organizations operated. I was able to participate in a different way, one that I could balance with raising small children.

When John Adams recruited me back as NRDC's executive director, I was ready to fully reengage, because the work I do is really for my children, both as individuals and for their generation. I think a lot about their future and what the world is going to be like in fifty years.

As John was the president, we worked very closely together. When he asked me to take over his role, it seemed like it was just one more step in the process. But it was tough getting my sea legs the first year, finding my own voice as president. It's challenging to follow in the footsteps of the founder, and John had particularly big shoes.

John was a lawyer and had established NRDC as an environmental law firm. In the early years, NRDC principally litigated, which was essential, since environmentalists had no voice in the political or policy process. Corporations owned that. Sitting at the table as a legal voice was a powerful part of NRDC's rise to leadership in the environmental movement.

Not having a legal background, I instead chose to focus on what other elements NRDC needed to be effective, not only in the present but also for the future. How do we ramp up our membership? How do we ensure that our science has the greatest integrity? What kind of economic analysis is required? When we're in the middle of a recession, is an initiative going to create jobs or is it going to cost jobs? To move our policy objectives forward, our success depends on providing well-grounded answers to critical problems and understanding what the most effective methods are for informing and activating the appropriate constituencies. My stamp on NRDC is that constant evaluation of our role and the broadening of our tool kit.

The issues that we address are global: the oceans, the atmosphere, and toxics. Part of my job is to strategically assess where we need to be and who to partner with. As the United States is no longer the only player, we've opened an office in China, and we're beginning to make inroads in India. And with the problems we tackle crossing all sectors, we've strived to bring more voices to the table including labor, business, the faith community, and local groups.

As we look for solutions to global problems, it's vital for human needs to be part of the answer. When I first got involved with environmental organizations in the Adirondacks, we only looked at land conservation. We didn't factor in the human side, even though there were villages and towns throughout the park with one hundred fifty thousand people struggling to make a living. At NRDC, we've partnered with community-based grassroots groups across the country to address environmental justice concerns. Even though it's not our primary focus, we have the ability to make an impact

because of our policy work and our scientific and legal expertise. Our staff engages with affected communities to understand the problem at a local, human level, whether it's mountaintop removal in West Virginia or a sewage plant in West Harlem.

One of the challenges that I struggle with, as does the head of every other mainstream environmental group, is how to make NRDC truly representative of the country's diversity. If we don't, NRDC and the environmental movement will be marginalized, because society is changing. We've largely been a white, middle-class movement, as we traditionally built our memberships through direct mail in English. The Internet offers real opportunities for us to reach a much broader audience: younger and more diverse economically and racially. La Onda Verde is our Spanish language website, and global warming is the number one reason people visit the site. My dream is that five years from now, NRDC will reflect America's multicultural population.

I've never been tempted to leave NRDC because the organization is constantly evolving and taking me along for the ride. I could say that I've had at least five careers. I worked on the lands program, on coastal issues, in management, and now on climate change. And I am continually inspired by the determination and the commitment of the people who work at NRDC.

Looking at the environmental indicators of the planet, it's pretty depressing but I am by nature an optimist—a cup half full person. I don't dwell on the negative. As John Adams would say, "If you're a leader of an organization and you don't believe you can succeed, nobody else will." Over the years, we have won numerous fights. The trick is to be focused and strategic and know the end goal, and then figure out how many steps it's going to take to get there, because it's never going to happen in one step.

I have developed my own style, which comes in part from being a woman. People often remark that my independent voice must derive from the fact that I attended an all-girls high school. I'm not sure I agree, but I do believe that staying true to yourself and your values is critical, whether you're male or female. My observation is that men and women approach issues with a different lens. I'd say women have a longer view over the horizon. Mothers are naturally protective of their children and think of their well-being in the long term.

One of the unexpected challenges that I faced was a diagnosis of breast cancer when I was in my forties. After doing the research, I'm certain that environmental factors played a major part in my illness. I grew up in northern New Jersey, where there was a tremendous amount of pollution from chemical plants. As a survivor, I worry about my three daughters. We grow fruit laced with pesticides, douse milk with hormones, and apply cosmetics on our face made with phthalates—all of which have been associated with cancer. When I was my children's age, I never thought about cancer, but now they think they could be next. That's not the legacy I want to leave.

In ten years I'll be seventy. While I hope to spend more time in places like the Adirondacks, I still plan to be on the front lines. Humans lay a heavy foot on the planet and we will continue to have great needs. As long as I'm here, I intend to be part of the solution.

Founded in 1970, NRDC today has 1.3 million members and a staff of more than three hundred fifty scientists, attorneys, and other specialists with offices in Washington, D.C.; San Francisco; Los Angeles; Chicago; Livingston, Montana; and Beijing. The organization's priorities are curbing global warming, developing a clean energy future, reviving the world's oceans, saving endangered wildlife and wild places, stemming the tide of toxic chemicals, fostering sustainable communities, and accelerating the greening of China. In its first year, NRDC won passage of the Clean Water Act, which allows citizens to sue polluters directly. In 2008, the organization stopped Shell from drilling exploratory oil wells off the coastline of the Arctic National Wildlife Refuge, America's most important polar bear habitat; but the company is applying for new permits, and NRDC is mounting a campaign urging President Obama to impose a seven-year moratorium on offshore drilling in the Arctic. NRDC is also working to phase out the toxic pesticide atrazine, which is found in 80% of drinking water samples taken from public water systems.

Born June 17, 1958, New York, New York

Coining the term *biomimicry*, Janine Benyus cofounded the innovation consultancy Biomimicry Guild, which helps designers, engineers, architects, and business leaders solve design and production challenges sustainably. She also cofounded the nonprofit Biomimicry Institute, which develops educational programs that look to nature for solutions. As a natural sciences writer, Janine has authored six books, including *Biomimicry: Innovation Inspired by Nature*. She has received numerous awards, among them the United Nations Environmental Programme's Champion of the Earth in the category of Science & Innovation, and was named a *TIME* magazine "Hero of the Environment."

Janine Benyus

Inspired by Nature

I was a late bloomer. Until I was three, I smiled a lot but didn't make a sound. Then one day in the kitchen, I spoke an entire paragraph. My mother almost fell over. As I was always the smallest kid in class, I dreamt of becoming a giraffe. They were the most unlikely and yet elegant creatures on earth. But once I discovered books, I aspired to be a writer. I had two modes: outside or reading. Or I'd combine the two and read in a tree.

We moved to Cherry Hill, New Jersey, when the town still had cherry trees. My parents both grew up on farms and valued having nature around the house. Every time suburbia would endeavor to roll over us, we would move farther out. The fact that my dad, who was the director of media research for an advertising firm, was okay commuting as far as he did probably saved me as a child. He would arrive home late on Friday night, take a flashlight, and mow the lawn in the dark so that on Saturday we could go canoeing or hiking in the Pine Barrens. Because my mom had tuberculosis when she was young and couldn't do anything strenuous, we'd return home and relive our adventures for her. She's no longer with us, but both of my parents were great storytellers, and we would talk for hours.

There was a field behind some woods and a stream next to where we lived, which is where I learned about observation. Early in the morning, I would leave with a lunch bag and a thermos of milk, and I wouldn't come back until the dinner bell rang. While making my rounds, I was recording my findings in my journal. I knew where every cottontail rabbit family lived, which caterpillar cocoons hatched the night before, and what birds were migrating. Those are some of my happiest memories.

One morning when I was twelve, I arrived at my field and noticed little orange flags on wire stakes poking out of the ground. Not understanding why they were there, I pulled them out. Then I saw footprints; because I was reading Sherlock Holmes at the time, I made a plaster of Paris cast from one of them. I also collected cigarette butts and stored them in a can—my mother found them and thought I was smoking. It turned out to be a layout for a subdivision. At the end of May, right when school let out, they bulldozed the entire area. I was sitting in the bushes the whole time while birds and animals rushed past me. To this day I can barely think about it. But I believed the guys in their machines didn't understand that those beings lived there. I thought if they only knew the creatures' stories, they would find a way for people and critters to cohabitate.

The tragedy in my field led me to obtain two degrees at Rutgers University: one in natural resource management and the other in

English literature and writing. I specialized in pastoral literature—literature about our relationships with the natural world—especially the transcendentalists and English romantic poets. I had a dual life as a beret-wearing poet hanging out with guys carrying jack knives while I sported pink suspenders. My seemingly divergent interests were a perfect combination for nascent science writing. For me, life made the most compelling story that you could possibly imagine—nonhuman life that is.

In college, I was strongly influenced by eco-feminist thinking. The philosophy articulated my feelings that the rape and exploitation of women and the land were connected. I read Carolyn Merchant's book *The Death of Nature,* in which she portrays the destructive consequences of the Scientific Revolution for women and the natural world, and other authors who write about the split between the mind and body and the religious connotations of flesh being bad—therefore, women are evil, and, subsequently, nature viewed as the feminine was scary and required taming.

My goal in majoring in natural resource management was to understand whole systems, from the roots to the shoots—the soil, the wildlife, and the botany. Then I'd be able to study and write about any ecosystem. Instead, we were taught about competition among individual trees for water and sunlight and about selectively cutting them to make the best consumer products. However, in my mind, each tree was a community member with amazing adaptations that not only kept it alive and lush but also nourished the entire ecosystem.

I wrote my first field guides based on this notion of community in ecosystems. At the time there were only individual guides to mushrooms or ferns or birds; you needed to carry a backpack full of books to sit down in a cattail marsh. My job was to write about how brilliantly organisms adapt to their places and to each other and all the cool tools they have in their bodies and behaviors. For me, those adaptations were technologies, or "tools for living," and were even more amazing because they were sustainably produced.

The concept of biomimicry came to me after five books and fifteen years of writing about plant and animal adaptations. Biomimicry built a bridge between humans and the natural world. We share the same needs—food, shelter, water—with all other living beings, yet we are destroying our habitat while they're living in harmony. The more I studied different organisms, the more I realized they were technologically advanced and that we could learn from them.

In indigenous cultures, the relationship was that of student to teacher between humans and the natural world. People would admire the gracefulness of an animal like an otter. The otter seemed to play all day long and would just nab a fish when it was hungry. Watching the otter, humans learned to swim and where to catch the best fish. Native Americans showed their respect for these beings by performing a dance while wrapped in eagle feathers, thanking the creature for allowing itself to be killed and eaten; and other indigenous people had their own rituals. And they instilled those values in their kids. For modern, Western cultures, those moments of awe don't happen very often.

Respect for the natural world is now being passed on to the scientists, designers, and inventors who are innovating with biomimicry. When they try to design a solar cell to mimic a leaf, they discover its complexity. Their need to continuously return to the leaf creates a conversation, and the organism becomes the mentor. That kind of admiration is where good behavior and sustainability begin. With true respect, laws or legislation are not necessary.

At a certain point, the universe picked me up by the nape of the neck like a momma cat and started to carry me around. After my book *Biomimicry: Innovation Inspired by Nature* came out, a biologist named Dr. Dayna Baumeister called from a pay phone and said, "I read your book, and I've been shaking for three days from excitement. I want to do this for my career." As I was already a couple of hundred pages into my new book and had no idea what she was talking about, I wished her well; but she persisted. Turns out she lived just down the road from me, which is a rare occurrence in Montana, and she ended up coming over. We talked for eleven hours, sitting on the floor in front of my fireplace at the foot of the Bitterroot Mountains. Her idea was to form a consulting firm to help people learn from nature. Very cozy in my little hermitage, writing and barely able to balance my checkbook, at first I said no. She persuaded me with, "Don't worry, I teach yoga and had a business sewing fanny packs." We high-fived, and off we went into the unknown.

I knew Dayna was on to something because she was not the only one who expressed interest in my book. I had expected a few environmentalists to get in touch, but in fact it was businesses and governments who called. They needed some biologists at the design table, as if I had a stable of them out back. And I had never even heard of a design table. We were biologists, babes in the woods; we didn't how the human world was made. We began to learn about design, and these days we're the first ones at the factory tour.

After consulting with our first corporate clients, we realized that most people didn't understand how to ask questions of nature. We developed workshops to bring architects, engineers, and designers

to ecologically rich regions like Costa Rica and to surround them with teachers—the plants, animals, and ecosystems. If the issue happened to be filtration, we would take people snorkeling to observe all the creatures in the ocean that were filtering salt water. Returning, they'd approach their discipline in completely new ways.

In my book *Biomimicry*, I offer a four-step path to a biomimic future. The first step is slowing down to allow for deep observation and the second is listening to nature. The groundwork for this practice originated in that field of my childhood, where I learned to pay attention and experienced gratitude. Spending time in nature is a spiritual experience for me—life is ecstatic. After the third step of emulating nature, the final step is to give thanks. The best way to do that is by protecting the organism's habitat.

Feeling gratitude and compassion are how I choose to run my life, in spite of being in the sciences. Bringing your heart to work in my field is verboten. People approach me after my talks and tell me they appreciate that I'm not just speaking from my head. Rachel Carson, one of my heroes, taught me this. She brought poetry into science writing and gave me permission to write lyrically about the natural world, using what the romantic poets called ecstatic language. I'm out on a limb doing it; fortunately I'm not looking for a tenured research position, but to get away with it, my science has to be meticulous.

At times, I can become disheartened about human nature, but I trust in our inherent goodness. No matter where people are on their journey towards sustainability, they're there because of a series of historical contingencies: something happened to them or influenced them. But I never lose faith in the fact that any person can experience an epiphany. I believe that epiphanies come with intimacies—with a teacher, a person who embodies something new, or experiencing nature. I feel compassion for people who haven't had one yet.

The people I work with are in some stage of wanting to clean up their act, and I don't shy away from pointing out to them the magnitude of the shift required to be truly sustainable. Malcolm

Gladwell states that in order to affect change, 18 percent of people have to be informed and riled up, so we're close to the tipping point of eco-awareness. The other tipping point may be that we're too far gone. It's definitely too late for some species. Some of my favorite ecosystems and my sweetest places on this earth are not going to make it. Life will persist but in a very different form than we currently see. Hopefully, there will be another Cambrian explosion on the other end of this. The question is: What role do we play? Do we create conditions conducive to all life or just to our own lives? If you envision life with a capital L then that changes design in a huge, huge way.

Biomimicry (from *bios*, meaning *life*, and *mimesis*, meaning to *imitate*) is a new science that studies nature's models and then emulates these forms, processes, systems, and strategies to solve many of the problems we are grappling with: energy, food production, climate control, nontoxic chemistry, transportation, and packaging—sustainably. It's based not on what we can extract from the natural world, but what we can learn from it. Humans have always looked to nature for inspiration to solve problems. One of the early examples of biomimicry was the study of birds to enable human flight. Nontoxic adhesives inspired by geckos, energy efficient buildings modeled on termite mounds, and resistance-free antibiotics based on red seaweed chemicals are some more recent innovations. As buildings account for 50% of total U.S. energy use, our greatest collective impact will come from applying biomimicry to the planning and design of buildings, communities, and cities. India's planned hill city, Lavasa, will be the world's first metropolis to do this.

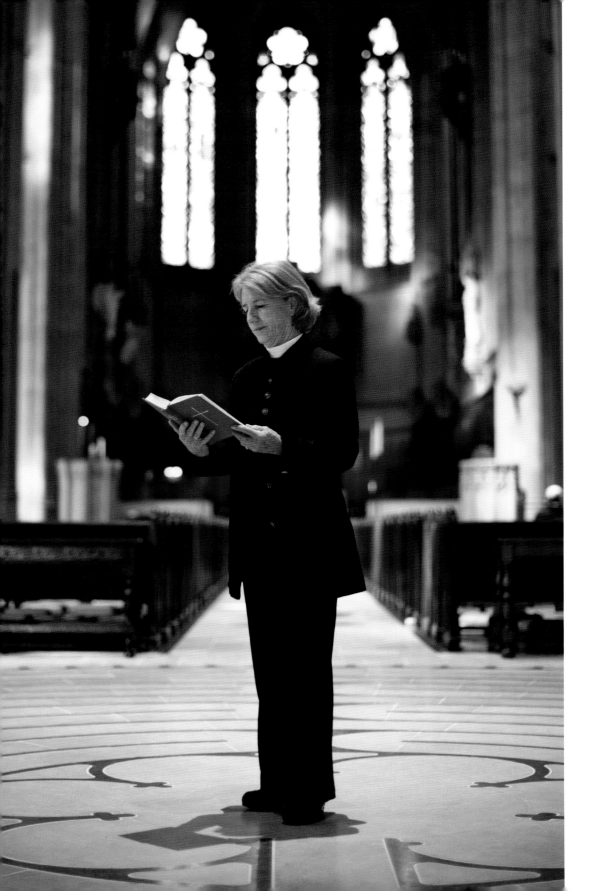

Born March 5, 1941, Woodside, California

The Canon for the Environment in the Episcopal Diocese of California and the environmental minister at Grace Cathedral in San Francisco, Sally Bingham is the founder of the Regeneration Project, a nonprofit organization dedicated to greening faith-based communities. Its primary focus is the Interfaith Power and Light campaign, a national network of over ten thousand congregations that are committed to fighting global warming by reducing their own carbon footprints and advocating for others to do the same. Active in the environmental community for over twenty-five years, Sally serves on the board of directors of the Environmental Defense Fund, the Environmental Working Group, and the U.S. Climate Action Network.

Sally Bingham

Faith and Ecology

My sense of the divine is very personal and came from growing up in the country and living close to nature. I have always felt there was something bigger than humans in charge, because whenever my father was suspicious of my behavior, he'd point to the sky and say, "It's between you and the old man upstairs." For me, nature was the manifestation of that greater being. Even though I attended church every Sunday with my parents, who were Episcopalians, as a kid I wasn't particularly devout.

I married soon after high school and had two children almost immediately, but marriage didn't seem to work for me. While I was with my third husband, a friend asked, "Are you just going to play golf and tennis and do nothing with your life, or do you want to help make the world a better place?" She told me about Environmental Defense Fund, one of the most influential groups in the country. I was elected to be a trustee probably because there was hope that my former husband, an investment banker, could write big checks. At every board meeting, experts spoke to us about over-fishing, deforestation, air pollution, and many other negative things that humans were doing to the planet.

One morning at our local Episcopal church, I was listening to the Prayers of the People. I heard the words, "Give us all a reverence for the earth as your own creation, that we may use its resources rightly in the service of others," in a new way. A light came on: *If Episcopalians have this in our doctrine, how can we be trashing the earth?* I began to question different clergy: *How can we profess a love for God and then destroy God's creation?* Some responded that we were in the business of saving souls and others thought the environmental movement would take care of the planet, but none of the answers satisfied me. One local parish priest suggested that I attend seminary and study the history of the disconnect between what we say we believe in and how we behave, which sounded like a good idea.

When I attempted to apply for seminary, I found out I first needed a college degree. So at forty-five with my three children all in school full time, I entered the University of San Francisco as a freshman. After graduating, I spoke to the Bishop of California, Bill Swing, seeking his support to enter the local Episcopal seminary. He asked if I was interested in holy orders, and I assured him that was not my intention. All I was looking for was a satisfying answer to my question. Since I wasn't going to be ordained as a priest, I didn't pay much attention to the classes in music and liturgy—like the class nicknamed "Magic Hands" where we received instruction on all the motions for performing the sacraments.

While I never truly discovered why the religious community had

abdicated its responsibility to care for creation, I found that environmental stewardship was firmly rooted in sacred texts. The most powerful for me were the first and greatest commandment "Love the Lord your God" and the second "Love thy neighbor as thyself." If you love God, you love his creation; and if you love your neighbors, you shouldn't be polluting their air and water and that includes people in poor neighborhoods, around the world, and future generations. God put Adam in the garden to keep it and till it, which was an environmental mandate; and the first endangered species act was the covenant between God and Noah and every living creature.

Caring for creation is at the center of all faiths. The Torah prohibits harming animal and human life, and wasteful consumption. The Qur'an says that God put the earth in balance and it is a human responsibility to maintain that balance. There is no altering the creation of Allah. And Buddhists believe that everything is interconnected and if one part is hurt, you hurt the whole.

While I was in the seminary, I formed a committee of Episcopal laypeople who shared my interest in asking priests to address environmental issues from the pulpit. After a couple of years of meeting around my kitchen table, they helped me establish the Regeneration Project as a way of formalizing our mission of deepening the connection between ecology and faith through educational programs for congregations and clergy. We also came to the conclusion that the only way to have the church understand that the environment was a responsibility of faith was to operate from the inside. It was this group of people that pushed me into believing that I needed to be ordained. The idea of becoming a priest frightened me, but they persisted.

One afternoon after much soul searching, I went over to Angel Island in the middle of the San Francisco Bay and climbed to the top of the hill where no one could hear me sing or say the Eucharistic Prayer. I mimed all the motions I had been taught in seminary but had never practiced, and it felt right. When I put my hands up as if to break bread, I thought: *What is more symbolic of our dependence on the land then the sacrament I'm holding?*

When I told Bishop Swing that I had changed my mind, he was skeptical. He said, "People don't just decide they're going to be a priest, it has to be a true call from God." As a test, he sent me to the Church of the Nativity in San Rafael to assist with baptisms, weddings, funerals, adult education, Sunday school, and anything else they came up with; and asked me not to talk about ecology. I drove the one-and-a-half-hour round-trip three times a week for three years. When I finished, I was even more committed. In 1997 after having prepared for ten years and surviving breast cancer, I was ordained to the priesthood in the Diocese of California.

Around the same time that I was ordained, California was beginning to deregulate the energy business and it seemed an opportune time to begin transitioning congregations to renewable energy. I went church by church, telling parishioners they were sinners for buying dirty electricity from Pacific Gas & Electric since its power plant (now closed) was polluting the air and water in the poorest part of San Francisco, where people had the highest rates of lung disease and respiratory problems. The response was overwhelmingly positive: a few churches installed solar panels and most of the others switched to Green Mountain Energy. When 2000 rolled around, we had our so-called "energy crisis" and Green Mountain had to pull the plug on its California customers.

To save our congregations from more sinning, I started Episcopal Power and Light with Steve MacAusland, a layperson from Massachusetts. As other denominations heard about our efforts and wanted to join in this good work, we made it interfaith. To form a state affiliate, three different denominations are required to be on the board. We currently have over ten thousand congregations participating in our thirty-four state affiliates. Our goal is a religious response to global warming by helping congregations to become energy efficient and to buy renewable energy.

In the beginning, buying green energy cost more, so teaching about conservation had to be included as a way to make up the difference. We gave out free compact fluorescent light bulbs and parishioners were able to reduce their own energy bills immediately. We also showed them how to perform energy audits of their homes and

places of worship. Today we have hundreds of congregations with solar, some with green roofs, a synagogue with a geothermal system, and even a monastery with straw bale walls.

Beyond the savings, converting to green energy has resulted in other unexpected benefits. In Michigan, for example, the Catholic priest who runs the state's Interfaith Power and Light office had installed a solar panel wired to a wind turbine to supply power to his congregation. When there was a ten-day blackout, his church became a beacon of light and offered cooked food and hot showers to the community.

We initiated our advocacy work because we saw global warming not just as an environmental problem but also as a core moral issue. Being theologically based, we take a nonpartisan position when educating our congregants about key legislation in their state and nationally and when asking them to contact their representatives.

This ministry has brought the religious community together. On our annual lobby day in Washington, D.C., priests, rabbis, ministers, monks, and abbots join together to meet with their legislators. Because we come from a place of deep faith, legislators listen to us. Politicians now seek us out, as they understand the power of the religious constituency.

Many people tell me they wished their clergy preached about the environment occasionally rather than two-thousand-year-old theology. I haven't met a member of the clergy who would disagree that we're the stewards of creation, but they're often afraid of talking about climate change because it's so controversial and complicated. They would prefer that I deliver the difficult message to their congregation and leave. That way they don't have to "take the heat afterwards."

I have also heard many people say that they have had a deeper experience with the divine in nature than within the walls of a church. In my sermons, I start from a position of compassion and healing and ask people to be mindful of all their behavior—from what coffee they drink to what cars they drive—and connect that

to their love for nature. My being a woman priest helps with the message, as parishioners generally see us as more nurturing than men. I don't call them sinners for owning an SUV, but I elude that those huge cars make us dependant on oil. Individuals have walked out when I'm preaching. One big guy who stomped out of Grace Cathedral came back six months later and told me he had switched to driving a Volkswagen.

What we really need are clergy preaching about ecological stewardship from the pulpit and on a regular basis. Environmental ethics have only recently been introduced in some seminaries, so educating clergy about global warming and energy conservation continues to be a priority for me. If they want to have souls to save, they had best put their faith into action to care for our planet. The opportunity for the religious community to push the climate change movement forward is huge.

When I first became a priest, I felt alone in my mission. Other clergy used to tell me I was mixing politics with religion and not being conscious of the separation between church and state. But times have changed, and in 2008, the new Bishop of California, Marc Andrus, installed me as the Canon for the Environment, and I spend much of my time traveling around the country speaking on global warming.

Since I am both a woman and a person of the cloth, the struggle to raise money for the Regeneration Project continues. Many people believe that clergy should work for free and that God will provide. Having been a stay-at-home mom, I didn't have the business connections that others can often use to raise money. What's been rewarding is to have raised a nearly two-million-dollar budget from individuals and foundations that recognize the importance of having a values-based message integrated into the dialogue. They often don't give as much as they do to mainstream environmental groups, but they understand that climate change needs to move beyond the environmental and political spectrum.

At Interfaith Power and Light, there is no longer the need to seek members, but rather the need for more staff to keep up with organic

growth and to support our current affiliates. Sometime soon I will be looking for someone to replace me, so that I can relax and enjoy watching the connection between faith and ecology grow to scale and feel satisfied that I played a role in bringing the moral voice of society into sync what is the most challenging problem of our time.

How cool is your congregation? Interfaith Power and Light's (IPL) Cool Congregations program challenges participants to reduce their energy use. Congregations start by calculating their carbon footprint, which is the measure of the amount of carbon dioxide produced by their activity. The website coolcongregations.com has a calculator designed specifically for congregations and its members to calculate carbon emissions from their energy use, transportation, waste, and goods and services, such as food and cleaning products. Many congregations could reduce their footprint simply by riding bikes or carpooling, sealing old windows, and swapping out old light bulbs for energy efficient ones. More involved measures include retrofitting buildings for energy efficiency, installing solar panels, replacing old appliances with Energy Star products, and planting trees and green roofs. By joining one of IPL's 34 state affiliates, your congregation will receive educational materials and practical assistance and can become part of a purchasing pool for renewable energy.

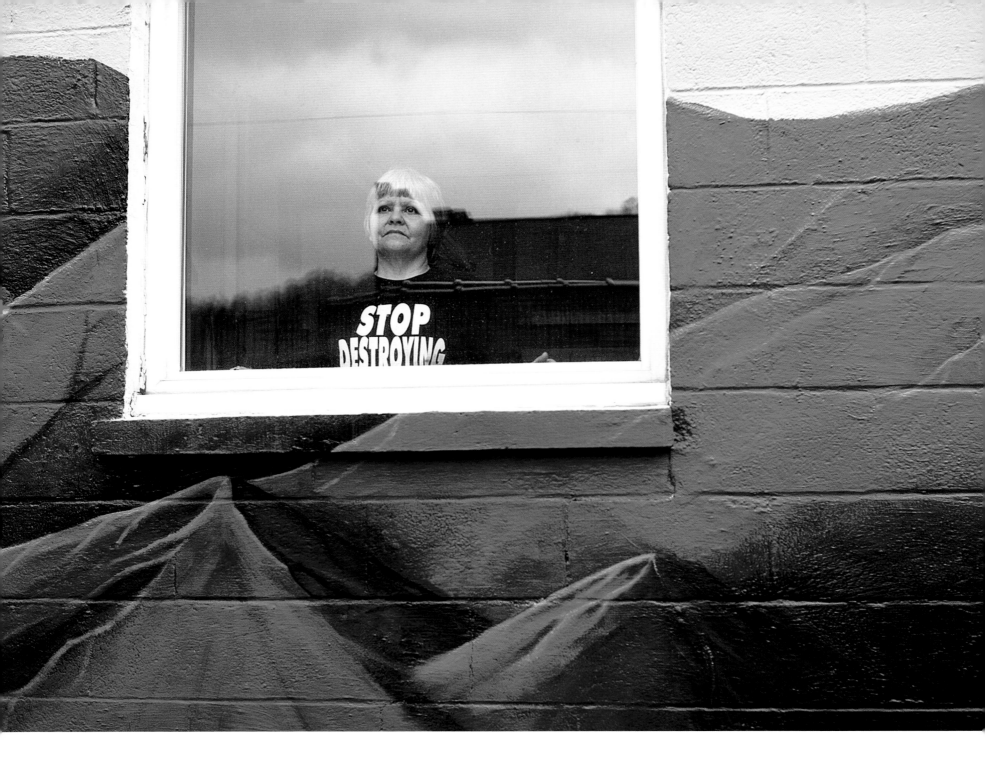

Born August 27, 1952, Boone County, West Virginia

The daughter and granddaughter of coal miners, Judy Bonds is the director of Coal River Mountain Watch. She is an Appalachian American, and her family has lived in the Coal River Valley for ten generations. In 2003 Judy won the coveted Goldman Prize for her work to stop mountaintop removal mining and its destructive impact on local communities and ecosystems.

Judy Bonds

Tending the Appalachian Commons

My earliest childhood memories are of my father and my grandfather plowing the upper field above our home, up in the holler, with our mule. One of my first sense memories was the smell of freshly turned earth. It was overwhelming, and I can still smell it now. If only I could go back to those days. We had a house right up against the hillside. We had chickens and hogs and some cows. There was a creek across the road, which was very clear and clean, and I spent all summer long in a little swimming hole. I was a child free in nature. It was heaven growing up in a holler.

I spell it h-o-l-l-e-r because it has a completely different meaning from the word "hollow." A holler is a sacred place that's coveted and peaceful. It's full of everything you need for life, while a hollow is empty. If you lay your hand flat down on a table, spread your fingers apart a little bit, and imagine your fingers are mountains, then that narrow part between them are hollers. Appalachian mountains are closer to a human body than any landscape I've ever seen; they curl around you like fingers and toes. I've heard some people that come from wide-open spaces say, "I feel real claustrophobic here." The mountains make me feel protected.

I'm eighth-generation Appalachian American. I can trace my ancestry back to Martin Petry, one of the first white settlers on Coal River. He was deeded land on the waters of the Little Marsh Fork, which is the holler I grew up in. Only rough, tough people could settle this area, there were no pansies or landed gentry here.

God provided us with everything we needed to survive. He gave us fresh abundant water, plenty of game to hunt, and medicinal herbs. These mountains are jewels; they're America's miniature rainforest. Only the Amazon has more species than we have. My people didn't come here to mine coal. They just wanted to be free and live off the land. Our state motto is: Mountaineers are Always Free.

There was a seasonal round in Appalachian culture. In the springtime, you dug for ramps and prepared your garden. You taught your kids how to be self-sufficient by growing their own food. Digging for ramps was a celebration of spring for mountain people. They were the first green things you could eat after a long winter of canned goods. Ramps are a tonic to us and detox your entire body. Summertime was when you took your family to pick and can berries and gathered wood to smoke your meat. In the fall, you hunted wild game and went "sanging." "Sang" is what we call ginseng. More than half the world's ginseng comes from the coalfields in Appalachia, and it's quickly disappearing. Our ancestors taught us how to make "sang" hoes to dig it up without

tearing the roots and to rub the berries containing the seeds together before throwing them down the hillside. We mountaineers have a tradition of tending the commons.

Appalachian Americans have a distinct culture based on self-reliance. I'm proud to be a hillbilly. It's not a bad word, but it's what people put in front of it that makes me mad. We've been kept ignorant and stupid by the coal companies who invaded our land saying, "We're here to save you." They stole what made us self-reliant and created a mono-economy so they have a ready-made workforce that's willing to poison their own neighbors to make a paycheck. "King Coal" is probably the most evil entity since the slave-based cotton industry. He has ruled here for one hundred fifty years, brainwashing and oppressing people and controlling every aspect of life—the media, the school systems, and the politicians.

I never thought much about coal mining when I was a child. I knew my dad was gone a lot, and he'd come home from work really, really dirty. I used to play with his kneepads, putting them on pretending I was a horse. Later on I learned what he used them for—they called them "dog holes." It broke my heart to know my daddy had to get on his hands and knees and dig coal in a three-foot hole in order to feed his family. And my mom had an old blue trunk that I snooped through and found pay stubs that showed he worked for fifteen dollars a day and most was taken out for the company store.

What really opened up my eyes to the coal industry and how it had corrupted the entire state was the 1972 Buffalo Creek disaster. The coal companies had built sludge dams and the towns' people kept warning state officials and the local media that they were leaking and were going to give way. When the dams finally broke, waves of black wastewater over thirty feet high bounced from one side of the mountain to the other killing 127 people, leaving four thousand homeless, and destroying three watersheds. The disaster received national media attention. If it hadn't, many of us would have never heard about it. The company was let off with a small fine after the coal industry and the governor colluded together and called it an "act of God." One woman snapped back, "I didn't see Jesus

driving a bulldozer up on the mountain." People still live in fear of those dams.

Around 1994, Massey Energy, the largest coal producer in Central Appalachia, brought their operations to the holler where I was living on my family's place with my daughter and her son, and my neighbors began moving out. Coal dust was all over everything, on our cars and in our houses. It got in my grandson's lungs and he developed asthma. Then their blasting started.

One evening, I was walking with my six-year-old grandson and he got down into the stream and hollered up, "What's wrong with these fish?" He was holding fistfuls of dead fish in his chubby little hands and fish were floating all around him. I was frantic and yelling at him to get away from the water. A couple weeks later there was white, gooey stuff at the bottom of the creek, so there was no chance of allowing him back in ever again. The spills kept happening; I found out that the coal company was poisoning the water supply of all the towns below us.

Directly above my home, Massey was building an earthen dam to hold nine billion gallons of toxic sludge. When I watched my grandson plotting out a path to run up the mountain in case the dam failed—that was the final straw. We were the last family to leave. Massey fenced off the area, and I can only go back up now to visit the family graveyard.

My grandson standing with those dead fish is what slapped me in the face and told me that I had to do something. I called a town lawyer and told him that they were blasting and dusting us to death. He said, "What do you want me to do?" I wanted him to get Massey to cover the trucks and to quit running the coal train after ten at night. He answered, "Mrs. Bonds, this is a coal mining town." I let him know I thought he was a pussy. But it's just a reflection of how coal owns everything in West Virginia—all the way from the dogcatcher plumb up to the senator.

A couple of weeks later, I noticed a flyer on a window about an upcoming rally against the mining companies. The organizer was

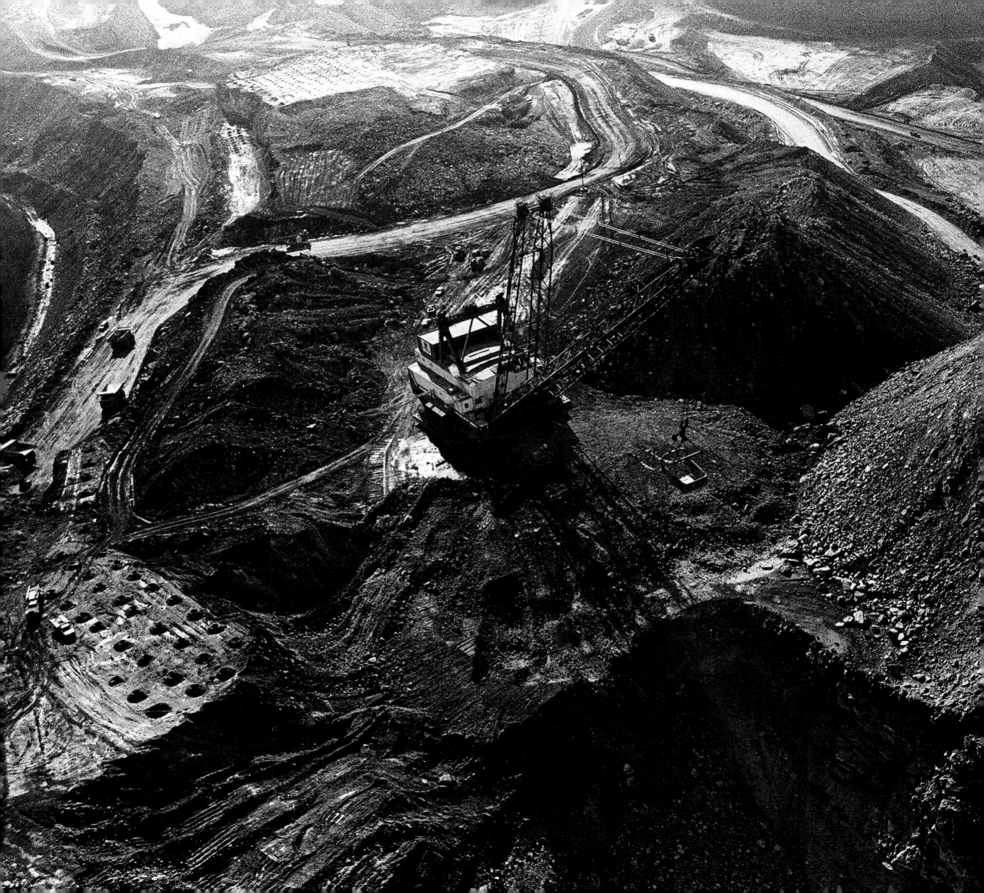

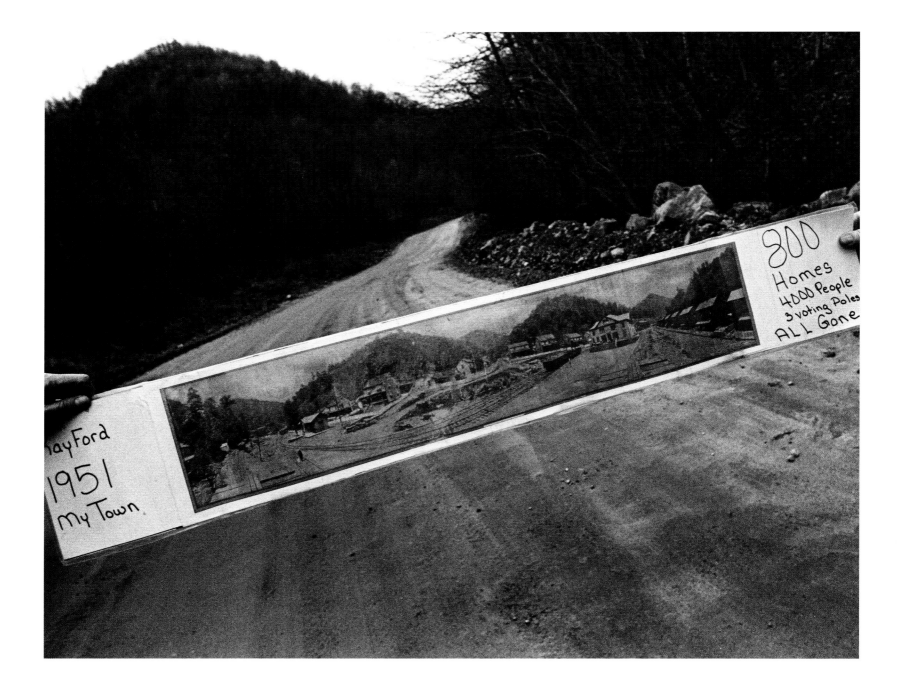

Coal River Mountain Watch. I showed up in their office and never left. They had only opened their doors a few months earlier and we were just a small group of volunteers, but I knew I couldn't do it alone.

My biggest strength is my mouth. I won't shut up. I just won't quit. The only way to get rid of me is to fix the problem or kill me. But every time I stick my neck out, I'm putting my family in danger. My daughter and I have had our lives threatened many times. Recently, I was warned that some miners were plotting to knock me off and throw my body down a mine break. What can I do? My butt's already hanging out. I can't back off, and I don't want to back off. I could never do this work without my daughter's support—I owe her a lot.

Being woman does help in my work. Women tend to keep violence down during rallies and protests, which is why we insist on being on the front line. And if a fight does break out, it looks really bad if the other side jumps a woman first. We are also the protectors of the species, so while I'm working on the local impact, I'm thinking about the bigger picture. Our kids are losing IQ points and motor skills and have autism and behavioral problems because we are poisoning them with mercury, arsenic, and lead. We have to leave a healthy Earth for them, and that includes admitting our guilt in the mess we've created and holding ourselves responsible.

There have been moments when I've thought of walking away, where I was totally disgusted with the system, or I was missing time with my family because most of my life revolves around my work. But that's when I take a deep breath, and I walk into the woods and reflect. Once you've seen what I have, you can't go back to being blissfully ignorant, or to that "protective stupidity," as I call it, because you would betray yourself and everybody else. And God knows you know. When I look at what God, not man, created, it shows me that I'm doing the right thing and brings me closer to Him. It's wrong to destroy these mountains and life-giving streams that He gave us. I often wonder what Jesus thinks about all the poisons and pollutants that we're dumping in these waters that He expects us to be baptized in.

My hope is to rebuild the sustainable communities that existed before King Coal showed up and to help people become self-reliant again by teaching them to garden and dig roots and how to put up wind farms and solar panels so we can have clean, safe energy forever. I want to show the world why we call this area "almost heaven" by making little tourist nooks and crannies where you can kayak and hike in the peace and solitude of the woods.

I wouldn't live any place else. My heart is here in these mountains and hollers.

Mountaintop removal mining involves clear-cutting native hardwood forests and using dynamite to blast away as much as a thousand feet of mountaintop, generating huge amounts of waste. The solid waste is then dumped into the mouth of a hollow, creating a dam. The large basin behind it is filled with slurry, which is a mixture of water, carcinogenic chemicals used to wash the coal for market, and small particles of coal laden with toxic heavy metals, such as arsenic and mercury. Frequent "black water" spills from these impoundments destroy ecosystems and contaminate drinking water supplies. The largest of these dams, at nine hundred feet tall, is located in West Virginia and can hold over nine billion gallons of toxic sludge. At current rates, by 2011 over 1.4 million acres in the United States will be mined this way.

Born October 27, 1966, South Bronx, New York

In 2001, eco-entrepreneur Majora Carter founded the nonprofit Sustainable South Bronx, where she developed restoration projects on the Bronx River waterfront, built green roofs, and created one of the nation's first urban green jobs training and placement systems. She received a MacArthur "genius" Fellowship "in recognition of great future potential." In 2008, Majora launched the Majora Carter Group, a green-collar economic consulting firm that develops investment opportunities in marginalized communities across the country.

Majora Carter

Greening Cities and Jobs

I was the youngest of ten kids. My siblings were all really popular because they played sports and musical instruments. But I was a different story; I wasn't athletically inclined and I was incredibly shy.

Both of my parents immigrated from the South. My father was the son of a slave—making me the granddaughter of a slave. Daddy worked as a janitor at the local juvenile detention center. He managed to pull together enough money to put a down payment on a house in the South Bronx in what was then a mostly white neighborhood.

By the time I was born, a freeway had been built right through the middle of the South Bronx and many of the white folks had left. At seven, I watched my first building burn. Landlords were torching them to collect insurance payouts as the local economy sank like a stone.

By the end of the same summer, my big brother, home from two combat tours in Vietnam, was killed walking distance from our home. Woodlawn, the cemetery where he was buried, was one of the most lush, beautiful, green places I had ever seen.

My only other connection to nature was going out to my aunt's commercial blueberry farm in New Jersey. We had to go someplace else in order to experience nature; it was not in the South Bronx.

My escape plan was college, so I took my education seriously. I was in a high school premed program, spending my Saturdays at various hospitals, and realized it wasn't my passion. I took some acting classes, which, when I look back, is really weird because I was so shy, but maybe that's why I did it.

I got into Wesleyan University and studied film. I wanted to tell stories of people being treated fairly and understanding their power. For me, film and other media had the capacity to move people, beyond traditional ways of organizing.

Growing up in my neighborhood taught me that everything was political—even working—for a black person. I remember expressing my anger over a racial incident on the news and my father saying, "Baby, what . . . do you think you're white?" That threw me for a loop, but it made me understand that life is often different for us . . . a sobering lesson that I keep front and center all the time.

I never wanted to come back to the Bronx, but I was utterly broke and about to start grad school. I moved back in with my parents in a neighborhood I had sworn to leave behind forever.

Two blocks from our house, I discovered a youth arts and development nonprofit called the Point. I couldn't believe there were artists in my neighborhood. I organized projects like an artistic commentary on the lack of greenery in the area, with artists making tree sculptures from scrap metal and found objects. I was hired.

One day I read that New York's Mayor Giuliani was planning to close Fresh Kills Landfill and open up a new waste facility in my community. The article went on to declare that 40 percent of the City's commercial waste already went to my neighborhood and that this would add another 40 percent. I was dumbfounded. I had become blind to the big, open, diesel garbage trucks that continually came through, and I'd never thought about why the place smelled so bad. I began to understand that the reason I felt my community was a place only worth leaving was because it had been designed that way—and all the art in the world wasn't going to change it.

I organized small protests where we'd dress up in recycling bags and make noise with tin cans. Folks would say, "Baby, where you going? The South Bronx been like this going on forever." One of the approaches we took was to find out which issues were important to them. The connection between their kids' asthma and the pollution was a first step.

My artistic and film background helped prepare me for media opportunities. The South Bronx was always a campaign stop for candidates. They would speak about what a blight this area was and how they were going to fix it, but we found people to talk about their grandmother's respiratory health or a child's safe place to play and run. We staged a protest on the waterfront, where the city was planning to build the waste facility, with little kids using old-school fishing poles, dangling their feet over the edge of a piece of concrete. The press liked it too.

We got good at drawing people out of their homes to testify at public hearings. At the last one, we mobilized over seven hundred people. They had to stop the meeting after midnight because the stenographer ran out of paper. We won.

Right after we stopped the waste facility, more than half of New York City's Council seats were up for reelection. I was part of the Organization of Waterfront Neighborhoods, and we decided to try and elect someone who would advance an environmental rights agenda on the Council—which is responsible for land use in the city. And I thought, *I have to run*, like it was a duty. But I was incredibly naïve and believed you ran on a platform that offered positive change. I did receive tons of tiny donations from people who appreciated that I was trying to make a difference. However, political maneuvering is really ugly, and I was shown the door—which turned out to be a blessing.

While I was still working at the arts organization, I received a notice about ten-thousand-dollar seed grants from the U.S. Department of Agriculture for Bronx River restoration projects. I jogged past the river every day, so I knew you couldn't access it from my part of the Bronx because of all the waste facilities and power plants. My seventy-five-pound dog, Xena, proved me wrong when she pulled me into a nasty dump that ended at the edge of the river. It was early, and the sun bounced off the rippled surface of the water as silhouetted ducks flew in for a landing. I found out it was an old street end that was illegally dumped on. I thought, *This could be a park*.

The park showed me that rather than running for office, I could better serve my community by developing local projects. I started Sustainable South Bronx (SSBx) to build big projects where people could be part of the planning process and see the possibilities—in contrast to the other crap that was there. It was more efficient than protesting. Not that there isn't a time and a place for protests, but I wasn't interested in knocking on doors anymore.

When the park development and waterfront restoration started, I noticed that the City was hiring people from the suburbs to do the work. We had a 25 percent unemployment rate. Couldn't we train our neighbors to do it? This led to the creation of Bronx Environmental Stewardship Training (BEST), where we taught wetland restoration, green roof installation, urban forestry, and

a range of life-skills. Over 90 percent of the people served by the program were on public assistance. Most had never been part of the work force and many had criminal records. These were folks who felt they had nothing to offer, and it was amazing to watch them transform, and then go out and get jobs.

We got some grief for focusing on land restoration instead of teaching people to install solar panels. Working with your hands in nature is a different experience. I found it hilarious that people of color said, "Oh, no, you're training our people to become field hands." Ninety percent of black folks at the turn of last century were living in the agrarian South. It is part of our heritage, and I'm not willing to disconnect myself from it or say that the work my grandfather did was less valuable than what I do now. One reason our country is challenged now is because we've severed our ties with the land. I'm not saying don't learn how to mount solar panels, but restoring our natural and built horticulture infrastructures is incredibly rewarding and vital.

Raising money for the BEST program was almost impossible because most funders didn't get what we were trying to do. I'll never forget a rejection letter from a huge foundation that said, "We don't understand how this 'sustainable adventure' of green jobs is helping to alleviate poverty." They weren't seeing how our graduates were not retuning to jail and becoming productive members of society. A few years later, the same foundation announced their support for "green-collar jobs" when it became mainstream.

I believe that my being a woman and black might have affected funders' decisions to invest in my work. I'd been successfully running a green-collar training and placement system longer than anyone else—in a deliberate manner that could be monitored and quantified—yet I had trouble winning a grant over fifty thousand dollars. But when men presented green economic arguments, they were able to command much lager amounts of cash. For example, my good friend Van Jones will tell you that he'd never put anyone in an actual job, but when he stood majestically atop a roof with

some solar panel installation trainees in the background, money came his way and his Green For All staff quickly grew. Obviously there was more to it than that, but I think there are some heavy emotional forces working on all the best efforts at institutional rationality. Many unsung female heroes across the U.S. who do work similar to mine, get little recognition and even less money. Nonprofits run by men statistically enjoy a 20 to 1 funding advantage over those run by women according to Isabel Allende (TEDTalks).

The upside of being a woman is that we're born multitaskers, and that's how I come at issues. Connecting people to their environment addresses their problems on multiple levels. Folks in our programs were often single parents or had a relative in jail, so we had to help stabilize those families. While I was helping the person in front of me, I was also thinking about the tangential. If I trained somebody to plant trees, that person could make money, clean the air, reduce the city's stormwater management cost, cool the hot summer streets, and provide social and health benefits for the community. I connected poverty alleviation with environmental remediation.

Four years after I started SSBx, the MacArthur Foundation called to tell me that I had won their "genius" Fellowship and asked where they could mail the check. I told them to make it out to SSBx and send it to the office. They had to explain to me a couple of times that the money was actually for me. At that point, I was so poor that if I hadn't been living at my boyfriend's apartment, I could have been homeless.

My boyfriend, who later became my husband, first came to SSBx offering his experience in communications and promotion. He saw the value of what I was doing and was brilliant at packaging me through stories and images. I owe a lot to him, and we're now partners in our consulting firm, the Majora Carter Group, LLC.

With the MacArthur Fellowship and professional communications, I became a victim of my own success. Funders thought I was on top of the world and didn't need help any more. And there was tension with some of the other grassroots groups because my work gained

more recognition. With so many other "South Bronxes" around the country, I saw an opportunity to create a business that would allow me to take what I'd learned to a national level and to get paid instead of depending on donors. The minute I left SSBx, money started rolling in.

My plan for the Majora Carter Group is to create investment opportunities for new businesses in marginal communities of all kinds around the country and to connect people with the power of community building as a jobs generator.

Providing green jobs and restoration projects in the South Bronx has enormous benefits for its inhabitants, with 45% of the population living below the poverty line and with a 28% unemployment rate. In 1999, Majora wrote a $1.25 million Department of Transportation Congestion Mitigation and Air Quality Improvement grant to conduct a feasibility study for the South Bronx Greenway. To date, over $50 million has been secured for the Greenway, which will create bike and pedestrian paths connecting Hunts Point and Port Morris waterfronts to other parkland and bring sustained green-collar jobs to the neighborhood. In Spring 2010, the first phase of construction started and includes a new park next to the New Fulton Fish Market.

The Greenway will play a vital role in improving air quality, as well as providing opportunities for physical activity. In the South Bronx, asthma has been linked to airborne pollutants and afflicts one in four children, and 25% of the inhabitants are obese. Green spaces are also shown to reduce crime, lower stress, and inspire pride that translates into less litter and graffiti.

Born January 3, 1970, San Francisco, California
With over fifteen years of experience in community organizing and policy advocacy, Vivian Chang is the director of state and local initiatives at Green For All, a national nonprofit working to build an inclusive green economy. From 2004 to 2009, Vivian served as the executive director of the environmental justice organization, Asian Pacific Environmental Network, which focuses on building leadership in Asian immigrant and refugee communities.

Vivian Chang

Race, Place, and Justice

My parents, who emigrated from Taiwan in 1965, gave me three gifts. One was a deep-seated belief that nothing comes for free; you have to work hard if you want something. The second was the freedom to choose a profession that fulfilled me, a choice they didn't have. The third gift was that they loved me enough to push me to be the best I could be.

I come from a lineage of strong women. My grandmother raised my mom on her own by earning money sewing. My mother went on to enter a very male-dominated field. For twenty-five years, she was employed as a chemist in the public sector. I know she often felt discriminated against, but she never let that set her back.

As soon as my parents were able to scrape up enough money, we moved to the suburbs so that my siblings and I could attend good public schools. It was the mid-1970s, and we were one of the only families of color in the area. I grew up feeling like an outsider and certainly felt my family didn't fit in. While the other kids wore jeans and T-shirts that came from the mall, I had clothes my "Ah-ma" (grandma) made. Like many children of immigrant parents, I played a bridge role in connecting my family to everyday life in the U.S. This shaped my worldview: I was comfortable in many settings but never felt at home anywhere.

We often went on family camping trips because it was by far the cheapest option for a vacation! Thanks to those excursions, I grew to love nature instead of being afraid of the great outdoors. Not having many toys, we would run around outside and make up games. I have wonderful memories of telling stories around the campfire, finding bugs, and trying to catch lizards.

Those trips into nature led me to major in environmental sciences at the University of California, Berkeley. It bothered me that we only studied natural environments and not urban and industrial settings like Chinatown or sewing factories, which were familiar to my family and my grandmother. There were a few other students of color in the program, and we formed a group called Nindakin "Students of Color for the Environment" to talk about the conditions that 99 percent of the world lived in that were overlooked in school. The environmental and social justice leader Carl Anthony did teach one class at Berkeley called Race, Poverty & the Environment that set me on my path.

As I was coming into my own in terms of my political consciousness and an ability to see the world through a framework that included race and class, the national environmental justice movement was crystallizing. Our struggles and issues had been present for

hundreds of years, but in 1991 affected communities from across the country came together at the First National People of Color Environmental Leadership Summit to forge a national agenda. Attending the Summit in Washington, D.C., I was for the first time in a truly multicultural environment and felt deeply in my gut the possibilities of what could be when people united across race.

The crowd at the Summit was incredibly diverse, but there were only thirty Asian Pacific Islanders (API) out of six hundred attendees. In the API Caucus, we recognized that there was a lack of infrastructure to organize and mobilize our constituents to participate in events like the Summit. While Asians had been in the San Francisco Bay Area for a long time, that wasn't the case for many other parts of the country. In places like Los Angeles, until recently the numbers were historically low. That population has skyrocketed so that now in California, Asians are the second-largest growing ethnic group. Those conversations led to the founding of the Asian Pacific Environmental Network to unite our own communities and to represent our concerns to the larger environmental justice movement.

With my grandmother's history as a garment worker and my growing interest in justice issues, after graduating I was drawn to the Asian Immigrant Women Advocates' (AIWA) mission. AIWA was engaged in the high-profile Garment Workers Justice Campaign that held manufacturers liable for the pay and working conditions of the women who were sewing clothes in sweatshops run by subcontractors. It was a historic moment for the Asian community, with multiple generations coming together to successfully challenge the garment industry, and it helped start a national movement around corporate responsibility.

At AIWA, I was looking for ways to help the women and their children move out of their lives as garment workers and other low-paying industries. I was interested in what dynamics locked them into those positions and what the options were for breaking the cycle. One part of the answer related to creating healthy economic alternatives by jump-starting industries that actually provided meaningful employment, while another aspect was to explore opportunities for

changing the garment industry's dependence on sweatshop labor. Seeking solutions, I returned to school to gain a master's degree in Urban Planning with a focus on regional economic and community development at the University of California, Los Angeles.

I intentionally moved because change doesn't occur in California without Los Angeles. If I really planned to affect policy, I needed to understand how politics operated in Southern California. With close to ten million people in just one county, economic factors and immigrant issues play on a much grander scale than in the Bay Area.

While in Los Angeles, I received what I consider to be my formal training in community organizing. For five years I was lucky to train under Anthony Thigpenn, the founder of the organization SCOPE (Strategic Concepts in Organizing Policy Education), one of the most well-respected strategists in the organizing world. I learned the importance of rigorously defining a theory of change and the art and science of organizing. He developed leadership in low-income and disenfranchised communities with specific skills and tools training and was a master at growing a base of five people to a database with five thousand names. Most activists have the right intention and heart, but few take the time to define what the underlying conditions are that lead to oppression and how their efforts are really going to make a difference.

Through SCOPE I engaged with African Americans and Latinos, but I was committed to supporting APIs where I was born. I settled back in the Bay Area and started at Asian Pacific Environmental Network (APEN) as the organizing director. APEN's flagship organizing project is rooted in the Laotian community in Richmond, California. In 1999, the Chevron refinery exploded. Unbelievably, the county did not have a system in place to warn people in their own languages, and this led to APEN's first campaign. Richmond is part of the toxic donut of the Bay Area; Chevron is by far the largest polluter, but there are three hundred fifty other toxic polluting facilities there. Laotians have deep agrarian roots, so they did what they knew best to make ends meet. Trying to put food on the table, folks were fishing in the polluted waters near the refinery and were

literally farming on top of Superfund sites.

From the beginning, APEN had a philosophical and political commitment to develop capacity among those most impacted and an intentional focus on developing the leadership of women. In traditional Laotian structures and customs there wasn't much support for women. We took an intergenerational approach, which allowed young women and elders to learn from each other and to strengthen their cultural roots. We saw the young women, most of whom had jobs that helped provide for their families, as unrecognized leaders who played the same key bridge role I had growing up. Through our program, these young women surveyed their neighborhoods, photographed and documented toxic hazards, and presented their findings at hearings, which not only gave their parents a sense of pride but also helped them overcome their own fears of speaking out.

Even my parents' views on my advocacy work changed as they witnessed some of these women testifying. While my parents were very supportive of me, they would have preferred that I had chosen a financially secure career that wasn't politically risky. When APEN organized three hundred computer chip workers who had been poisoned with gallium arsenide, my mother assisted with translation. As a chemist for the state, her responsibilities included setting maximum limits for exposure to chemicals. When she saw how blatantly the regulations had been disregarded and that we successfully pressured the company to establish a lifetime health-monitoring fund for the workers, she understood that my path was a real vehicle for change.

As an Asian woman and as an organizer, it's far easier for me to think about the broader neighborhood, community, and structures that we need to change, than about myself. While not having much

contact with the mainstream feminist movement, the everyday "sheroes" who were part of AIWA, APEN, and our organizing bases were my inspiration and mentors as they modeled grace and dignity even under extreme pressure.

I never imagined myself as a leader or as the executive director of APEN. Like many women, I lacked the self-confidence to consider stepping into those roles; and like many in the social change movement, I had been drawn to my career as way to rectify an injustice rather than for my own advancement. Fortunately, I enrolled in a yearlong leadership program that completely changed my sense of self by helping me develop personal and management skills. When the executive director's positioned opened up, I was ready to take on the challenge.

Becoming a mother has also transformed my relationship to my work. Having watched my parents struggle, I had a fiery passion that sought justice for what they, and many families like mine, had to experience and endure. When I had my first child, I felt a welling up of a type of love that I had never experienced before and it overflowed into other parts of my life. Now my passion is fueled off of that love and that sense of humanity, which ultimately is a much more positive vision.

What sustains me is community and family. I grew up going to Sunday school, but where I really draw my spiritual strength is from people. Instead of turning inward when I face challenges, I bring to mind my sheroes, and in particular, one woman who participated in our community meetings. She held down two jobs, was raising three kids, and had a husband who chastised her every time she left to attend the meetings, "What are you doing? You didn't graduate from high school, you don't even know how to read and write, do you really think you have something to contribute?" In spite of all the barriers, she went on to meet with the city's mayor to present an alternative to one of his unsuccessful programs. To watch her grow as a leader reconnects me to what I'm doing. If she can stand up like that, I can definitely get up every day and do my part.

The longer I am in the environmental justice movement the more I realize how deeply rooted and systemic the challenges are and that my quest for a just world is a long-term fight. The moments when I've been the most humbled have been on the eves of victories, like the night before a city council votes on a groundbreaking job program, when we know we have the majority. Those successes are bitter sweet—so hard fought for, yet they're tiny drops in a large bucket. We need to be winning programs and policies that create opportunities for millions of people to enter the green economy.

I believe we've been put on this earth to make it a better place and that we all carry within us an inherent wisdom; a wisdom that guides me as I look for the answers professionally and in my daily life, on how to be the best momma and a great partner, and how to continue to be fueled by love.

Forty percent of the API community in the U.S. resides in California. In the San Francisco Bay Area, where APIs make up over 30% of the population, they confront the following environmental health and justice issues:

- Textile and apparel workers—of which 53% are Asian women and 28% are Asian men—work under unhealthy conditions due to overcrowding, poor ventilation and lighting, fire hazards, and daily exposure to chemicals, such as formaldehyde and other dye preservatives.

- A large number of APIs work in microelectronics assembly plants and are exposed to carcinogenic solvents daily.

- A significant number of APIs engage in subsistence fishing, consuming contaminated fish as a result. Language barriers often prevent an awareness of the potential health risks.

- Santa Clara County, which has the second largest API population in California, also has the most Superfund sites of any county in the U.S.

- In Oakland, the 2000 Census found that almost 17% of those without plumbing facilities were API households, even though they only make up 15% of the total population.

Born March 28, 1927, Plainfield, New Jersey

Trained as a pharmacist, Dr. Theo Colborn entered graduate school as a grandmother and earned a PhD in zoology with distributed minors in epidemiology, toxicology, and water chemistry. A *TIME* magazine "Hero of the Environment," she is one of the world's most respected authorities on the effects of synthetic chemicals on the endocrine system of humans and wildlife, especially in fetuses and the young. Theo started the Wildlife and Contaminants Program at World Wildlife Fund and went on to found the Endocrine Disruption Exchange, the only organization that focuses on the consequences of endocrine disruptors.

Theo Colborn

Saving Our Future

I was always asking questions about the natural world. It drove my family crazy. We lived near the Passaic River in New Jersey, which even at that time was a big, polluted waterway. My parents told me not to play there, but something drew me to the river. I remember the density of the dragonflies in the summer, and I wanted to understand how they could fly and stay in one place at the same time. I was afraid of them but my curiosity was always stronger; and that's stayed with me.

I was born during the Great Depression when frugality was not frowned upon. Many people went without food during those years, but because my father was a wholesale food salesman, we always ate well. In our home, food and health came first.

My life has been made up of a series of events that have fallen into place. In the fifth grade, I had a teacher who took us at five in the morning to nearby Branch Brook Park to identify and listen to birds, initiating my lifelong passion for birding, which led to my involvement over the years in environmental issues.

Entering high school in 1940, I was one of the first girls allowed to take what was called the "scientific course," which had previously been limited to boys. I loved chemistry, biology, and zoology and got straight A's. By my senior year, the military academies were drafting the boys out of my class. The registrar at Rutgers University College of Pharmacy called my high school looking for women to apply, as so many men were leaving to fight in World War II. My guidance counselor insisted that I visit Rutgers although I had no money to attend college. I fell in love with all the laboratories and the jars of plants that were used to make drugs. Right after graduation I received a letter from Vick Chemical Company offering me a four-year scholarship to attend the College of Pharmacy.

I met my husband my senior year when he entered the College of Pharmacy. He was in the first class of veterans returning from the war. We had four wonderful children and eventually ended up with three pharmacies in Sussex County, New Jersey. They were open from nine in the morning until the last doctor finished his house calls, often as late as eleven at night. Finding ourselves filling in those terrible, late hours, Sundays, and holidays, we decided to make a change and spend more time with our children.

Following two extensive trips west visiting various campuses, we ended up in Boulder, where my husband and I were accepted as graduate students at the Colorado University School of Pharmacy.

But it was not long before my husband had another idea. He wanted to move to the west slope of the Rockies (which he described as "another world"), to buy a ranch and live a subsistence lifestyle. By 1964 the children and I were making all our clothes, raising sheep, and growing vegetables, berries, and fruits to preserve and eat.

In order to maintain my pharmacy license and supplement our income, I worked as a part-time pharmacist in a number of single-owner drug stores within a hundred-mile radius. The people I served from the ranching and farming communities seemed to have unique health problems. In one valley many people suffered from arthritis. In another town, practically every baby (89 percent) developed jaundice immediately after birth, which the doctors blamed on the altitude. I wondered if the problems might be connected to the drinking water, which came from snowmelt in creeks and rivers above us. Could the vast acres under irrigation be leaching toxic trace metals out of land that should never have been irrigated? Could the mining of coal and the legacy of mining other minerals in the mountains above the towns have any connection?

My passion for birding led to my appointment by Governor Dick Lamm in 1977 to the Colorado Natural Areas Council. I had become renowned for my observations on the birds of the Western Rockies. With the Council's mandate to preserve Colorado's most precious wild habitats, I felt an urgency to learn a lot more about the water and other natural resources in the state. Adding to that urgency was the position the government was taking: sacrificing the valley to produce massive amounts of coal to meet the national need for energy. The coal would have to be washed with water from the only river, which was the lifeblood of our valley.

In 1978 when I was fifty-one years old, I entered Western State College of Colorado for a master's degree in freshwater ecology. I was determined to learn enough so that perhaps I could effect positive change in government policy where our life-support systems—water, air, and soil—were at risk. Dr. Martin Apley was my major professor, and I am deeply indebted to him for his guidance and patience with me as up until then, I had never put my hands on a computer or known what "soft money" was.

At Western State I was asked to teach natural resource conservation. I made my students attend Forest Service and Bureau of Land Management hearings to evaluate each person who testified so they would understand that the most effective people were those who had scientific evidence, not just anecdotes, posters, or who played guitars and sang.

My dissertation focused on the use of the exoskeleton of larval insects in rivers and streams to detect low-concentrations of toxic metals that might be released as a result of mining activity. For two summers I lived at the Rocky Mountain Biological Laboratory and worked under Dr. Stanley Dodson, a professor at the University of Wisconsin. When I completed my master's program, he invited me to do my PhD under him, and we created the first environmental health program.

Much to my surprise, upon completing my PhD, I received a Congressional Fellowship with the Office of Technology Assessment (OTA) in Washington, D.C. My plan was to continue my focus on Western water issues, but instead I was asked to work with the team looking at the state of U.S. air quality in anticipation of the upcoming reauthorization of the Clean Air Act. I was assigned to concentrate on the health impacts of ozone and other man-made air pollutants. When the bill was finally authorized, Congress ignored the evidence about toxic chemicals other than ozone.

Following my fellowship at OTA in 1987, Dr. Richard Layoff at the Conservation Foundation invited me to be the scientist on a report requested by the Canada and U.S. International Joint Commission on the health of the Great Lakes. The results of that study were published in the 1990 book, *Great Lakes, Great Legacy?*

Ironically, while at the University of Wisconsin, I taught limnology, which required that I know something about the pollution in the Great Lakes. At that point, no one was concerned about the impact of the chemicals in the lakes on the animals and potentially on humans. This bothered me, because as a pharmacist I knew what

low levels of toxic trace metals could do, and I had also taken the time to learn about the dangers of PCBs and dioxins.

While cancer was the dominant concern associated with toxic chemicals, after surveying the data, I was clear that it was not the only health problem plaguing the animals around the Great Lakes. Instead, wildlife biologists were finding that the closer animals were to the lakes, the fewer offspring survived and, in some cases, entire populations of particular species had been extirpated. The huge nesting bird colonies on islands across the Lakes provided endless evidence of developmental problems in the chicks and of lack of parental attention.

I created a simple spreadsheet of the top predator animals dependent upon their living from the Lakes. To this I added the abnormalities that the wildlife biologists had reported and noticed that there was a predominance of thyroid, behavioral, developmental, and reproductive effects, all of which could be linked to the endocrine system. As the problems were mainly with the offspring, it was obvious that the females were passing chemicals to their young before they were born.

At the time of *Great Lakes, Great Legacy?* there came groundbreaking studies by Drs. Sandra and Joseph Jacobson looking at children of mothers who ate fish out of the Great Lakes. Their children were born sooner, weighed less, had smaller heads, and exhibited cognitive, motor, and behavioral aberrations in a dose response manner relating to the amount of fish the mothers ate. Today, we have research linking endocrine-disrupting chemicals to attention deficit disorders, autism, abnormal external genitalia in newborn boys, Alzheimer's, and Parkinson's, as well as to a dramatic decrease in male sperm count.

After *Great Lakes, Great Legacy?* was published, trade associations and corporations hired skeptics to challenge the findings in the book and also to harass the researchers whose research we reported on in the book. Dow Chemical Company sent a twenty-page press kit to

refute my findings to every member in the U.S. House and Senate. This was the beginning of an organized effort that continues to the present to raise doubts about, and delay progress of, research on endocrine disruption.

In 1990 I contacted Dr. John "Pete" Peterson Myers, a biologist and avian specialist, after hearing him give a lecture on the decline of migratory shore birds and suggested that perhaps the cause was endocrine disruption. Shortly after our discussion, he became director of the W. Alton Jones Foundation. Again providence stepped in because I knew that I could not pursue this new phenomenon alone. He gave me a three-year chair to focus solely on endocrine disruption.

In July 1991, I brought together twenty-one experts from seventeen different disciplines to discuss "Chemically-Induced Alterations in Sexual Development: The Wildlife Human Connection," in Racine, Wisconsin. As the scientists listened to each other, they began to understand better the implications of their research. The conference presenters were so concerned about what they'd heard that they drafted a consensus statement on the dangers of endocrine-disrupting chemicals and decided to publish a book with their research. But the book was much too technical for most people to understand, let alone policy makers.

With support from the Pew Scholars program, Pete Myers, Dianne Dumanoski (an environmental reporter), and I produced in 1996 the more accessible, *Our Stolen Future: Are We Threatening Our Fertility, Intelligence, and Survival?—A Scientific Detective Story*, which was backed up by the database that I had built over the past decade. Just two months after the book's release, Congress directed the U.S. Environmental Protection Agency (EPA) to establish a program to detect endocrine disruptors. Needless to say the EPA has failed miserably because none of those who know how to do endocrine-disrupting research were invited to the table.

In the summer of 2002, while home in Paonia, Colorado, I hurt my back enough so that my neurosurgeon assured me I could never live alone in D.C. again. Again providence stepped in. Two of my D.C. staff members, Dr. Mike Smolen and his wife, Dr. Lynn Carroll, said they would pack up all the files and would love to come live in Paonia, where we started the Endocrine Disruption Exchange to be a center for this research.

There are times when I feel overwhelmed by the magnitude of the problems we face today and the problems we are handing off to our children. I find that meditation really helps to keep me from fretting and to stay focused on our work.

The underlying problem lies in the fact that corporations driven to make profits control governments. I'm concerned that there may not be enough people with the ability and courage to turn the system around. So many endocrine disruptors interfere with the brain by undermining intelligence, compassion, and empathy. Already there are too many unfairly cheated individuals who require constant care or medication, and that trend is increasing.

But, drawing on my childhood fascination with the dragonflies, discovery is what keeps me going. The more knowledge we have about how chemicals imperil humanity, the better we will be able to protect future generations.

The endocrine system is a series of glands that produce hormones used to regulate essential functions, such as body growth, sexual development, metabolism, intelligence, behavior, and the ability to reproduce. Endocrine disruptors are synthetic chemicals that act like hormones and disturb the body's normal functions. They can be found in the production of almost everything we use, including cleaning compounds, toys, furniture, computers, and appliances. Because they affect the development of the vital organs and hormonal systems, infants, children, and fetuses are more vulnerable to exposure. While many pesticides and plasticizers are suspected endocrine disruptors, the majority of the more than two thousand chemicals that come onto the market every year do not pass through even the simplest tests to determine their toxicity. The Environmental Protection Agency created the Endocrine Disruptor Screening Program to test chemicals, yet it is still using outdated methods with tests that are extremely limited in scope, and the results are not being used for regulatory purposes.

Born May 31, 1931, Budapest, Hungary; lives and works in the U.S.
One of the early pioneers of both the environmental art movement and conceptual art, Agnes Denes addresses ecological, cultural, and social issues through her investigations of science, philosophy, and mathematics. She has been in over four hundred fifty solo and group exhibitions in museums, galleries, and international theme shows on four continents, including Documenta and the prestigious Venice Biennale. Called an artist of enormous vision, Agnes has earned two honorary doctorates, written five books, and received numerous major awards.

Agnes Denes

Restoring the Land through Art

When I was six years old and couldn't write yet, I dictated a poem to my mother. Normally I was a very shy child, but I ordered her to grab a pen, and she was so stunned that she complied. My silly little poem was about how beautiful she was, but this may account as my first creative output.

Because of World War II and its aftermath, at nine years old, I was uprooted from Hungary and transplanted to Sweden, and then as a teenager moved to the United States. Having to learn new languages silenced my creativity as if I had become deaf and dumb, stopping the poetry. Yet the need to express myself was so strong that it eventually surfaced in visual form.

My father had a library, and from very early on, he allowed me to explore any topic. I loved philosophy, which continues to be part of my work. I'm the only person I know who can chuckle with delight while reading it.

My first major experience with nature that ended up as art, was when I took a trip with my parents to Öland, a beautiful island in the south of Sweden. The birds come there from all over Europe to nest before they flew south. I became aware of the power of organization as birds reacted to environmental pressures with alienation or adaptation, while connecting with each other in flight, swirling and undulating as a single form. Individual birds would often kill themselves by falling to earth as they became disoriented and lost their flock. I connected that to people living in big cities, where strangers were forced to live with each other and often become depressed, even suicidal. I created a work of art to compare the two societies: birds and humans. It was a very ambitious project: flying with the birds with methods I invented. But I never received the necessary funding to make it a reality.

I attended Columbia University to study painting but it didn't satisfy me. I couldn't express everything I wanted to in a painting: fighting the edge of the canvas, always needing to go beyond, always having more to say. Why translate an important concept into paint hoping that the viewer would be able to decipher and understand it? Why not communicate directly? Looking to create a new art form, I left the ivory tower of my studio and entered the world of concerns.

Art needed to change in a world drastically changing, when humanity was facing major decisions on how to survive on the planet while striving to maintain moral values and a high quality of life. I wanted to cleanse art from its elitist self-involvement, to achieve greater universal validity. To communicate these concepts, I have planted forests on abused land and fields of grain in the heart of megacities.

My art represents benign problem solving and shapes the future: an egoless art form that calls attention to social concerns and involves people from all walks of life, building pride and self-esteem.

Announcing my commitment to ecological issues and human concerns, I first realized *Rice/Tree/Burial* in 1968. It was a symbolic event that dealt with our relationship to the earth and is considered one of the first works of the ecological/environmental art movement. I chained trees in a sacred forest at Artpark overlooking Niagara Falls where murdered American Indians were buried at the Canadian border, planted a rice field above the gorge, and put a time capsule in the ground to be opened a thousand years from now.

My haiku poetry was included in the capsule. I kept no copies, giving up to the soil something personal and precious, an act that also symbolized the self-denial and discipline required by this new analytical art form. The poetry represented the idea or concept (the abstract, the absolute, human intellectual powers, and creation itself), as well as communication with the future.

The act of burial—or placing into the ground and receiving from it—a cause-and-effect process, marks our intimate relationship with the earth. On the one hand, it indicates passing, returning to the soil, disintegration, and transformation, on the other, generation and life giving, such as is the purpose of planting. It is also a metaphor for human intelligence and transcendence through the communication of ideas to future descendants.

The chained trees in the sacred Indian forest indicated interference with life and natural processes, as we humans interfere with the natural processes of the earth. The act of chaining trees signified linkage, flexibility and restraint, evolutionary mutation, and death, and brought attention to the mysterious life force of an organism and its partial triumph over boundaries and restraints—its uneven, limited transcendence.

In all my work there is the *philosophy* and the *act*: the concept and the realization, the thinking and the doing. The rice symbolized the philosophy: life, initiation, and growth. The rice that grew up mutant, an unforeseen consequence of Artpark receiving contaminated soil from the nearby toxic Love Canal, represented the act.

Affirming my dedication to the risks of making such art, I went out to the edge of Niagara Falls and lived there for seven days and nights, a foot from the torrent spilling over, to incorporate the forces of nature. On this tiny ledge I had a dynamic and spiritual experience, coming face to face with the power of nature and my own entity. To control the retreat of the falls, the slippery ground had been dynamited and shook violently. I had to sign documents for both the U.S. and the Canadian governments that if I fell in, I would not sue them. It crumbled soon after I descended.

Rice/Tree/Burial was my first act of "Eco-Logic," the term I coined to describe my ecologically concerned, environmental and philosophical art. Eco-Logic differs from earthworks or land art in intent, form, and execution. Most earthworks are invasive, wherein their mainly male creators focus on leaving their stamp on the land. Eco-Logic addresses the major decisions that we are facing in order to survive. Instead of interfering, my work rehabilitates the land.

I have never considered my art a woman's work or thought of myself as a woman artist; it's only when these questions arise that certain facts and undeniable double standards become obvious, so that one sees the difference. No one asks a man if his art is a certain way because of his sex, but a woman's work is viewed as being influenced by her experience of being female, which is somehow less valuable. It might take a few more generations to change that. I don't dwell on it, but many of my large-scale environmental concepts have not been realized, perhaps for that very reason. As these projects require knowledge of architecture, engineering, urban planning, and solving difficult design problems, they often wonder if I'm qualified as a woman.

While I was working with conceptual art at the same time as a tight-knit group of conceptual male artists—even before them—my work was never noticed. As I didn't interact with the mainstream, male art

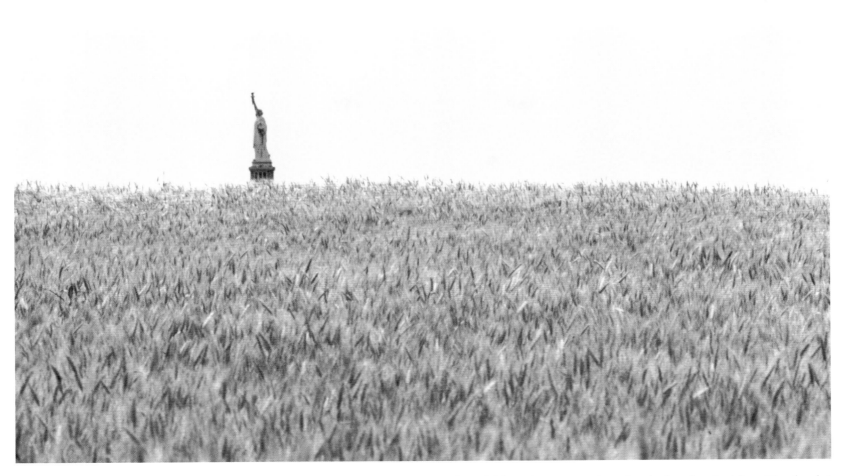

scene, I wasn't even aware that I wasn't getting the same attention until the woman's movement opened my eyes. Only later, as art historians and critics began to write about my art, did it surface that I did conceptual work alongside these men that was perhaps more poignant and richer than some of them. Being a woman ahead of my time, the art world hadn't bothered to understand me, and the work never received recognition or adequate funding.

I did *Wheatfield—A Confrontation*, which is well-known today, on a shoestring: ten thousand dollars from the Public Art Fund and seven thousand dollars of my own money. Needing volunteers to help me, I felt compelled to feed them and made sandwiches for them every day. I would leave the field at nine every evening to buy and prepare the food. Then I was back at six in the morning to organize the project, photograph it, and work on the field. It nearly killed me.

Wheatfield spoke to greed and misplaced priorities. The land I planted was worth $4.5 billion dollars, and I produced $158 worth of wheat on the stock exchange. *Wheatfield* was a symbol, a calling into account, representing food, energy, commerce, world trade, and economics and referred to mismanagement, waste, world hunger, and ecological concerns. We planted the wheat next to the World Trade Center on top of the Battery Park Landfill, which was created with construction debris from the building of the Twin Towers. Over a quarter million people came to the park to watch Fourth of July fireworks, and there was no vandalism of our field. People don't hurt what they love. When we harvested, many who had observed the field grow on their way to work or from their windows, stood around in silence. Some cried. I received hundreds of requests to keep the field going. Today it's Battery Park City, a complex of offices and condominiums.

I began speaking at environmental conferences around the globe. On World Environment Day at the Earth Summit in Rio de Janeiro in 1992, Finland's Ministry of the Environment announced that it would sponsor my project *Tree Mountain—A Living Time Capsule—11,000 Trees, 11,000 People, 400 Years* to call attention to the world's environmental problems. It was the first time an artist was commissioned to restore environmental damage on such a large scale by a government. My works are monumental in order to make a difference, for people to understand the destruction of the land on the global scale.

The site of *Tree Mountain* was the Pinziö gravel pits in Ylöjärvi, Finland. The mountain was created for me according to my design as the retribution of a mine. It took thirteen years from conception to execution. The process of bioremediation restored the land's functionality from resource extraction to one in harmony with nature, in this case, the creation of a virgin forest. Its beauty carried the concept and the philosophy, which made it art and not an average reclamation project. My forest united the human intellect with the majesty of nature. The tree was created by nature, the mathematical complexity by humans.

Eleven thousand people came from all over the world to plant eleven thousand pine trees based on a complex mathematical pattern. While the trees in *Tree Mountain* can never be bought or sold, people received an official document showing ownership of their individual tree. They could pass the title on to their heirs or transfer it to others. The contract reaches four hundred years into the future and was designed to instill a sense of custodianship, creating a community to care for the trees that will expand into the millions over the centuries—the first such contract to reach into the distant future.

As difficult as it is to realize these works, it is vital to create them as examples of what needs to be done to restore landfills, stop erosion on deforested soil, purify the air, protect fresh groundwater, and provide habitat for wildlife. It is also critical to make them in cities to break the nervous tension by affording people an opportunity to stay in touch with nature.

Although my work is deeply rooted in science, technology, and philosophy, I am often told that it has a sense of spirituality, a clarity that is different from how other people see things. It's a spirituality that looks at a blade of grass differently from others and sees its symbolism. In my art, I am seeking the invisible or the unknown. This kind of work has a vitality that sensitizes people, leaving them transfixed, speechless, somehow elevated, and in a cleaner place, where everything seems fresher and more poignant. And it manifests itself in nature, if you have learned to see. It is powerful.

I felt this spirituality when I lived on the edge of Niagara Falls a foot from where twenty thousand gallons spilt over every second, and I could have died in a moment, or when American Indian spirits hovered over me while making *Rice/Tree/Burial*. I had been told that the massacred American Indians had cursed the forest, but I made peace with them and made art from the phenomena, photographing the event for people to believe it. These wonderful, strangely spiritual experiences wouldn't have happened to me cooped up in a studio.

I always find myself on the edge, the edge of a cliff, the edge of understanding, or of assumed knowledge, the edge of possibilities, where I try to take it a step further. It's frightening and exciting. That and my love of humanity keep me going.

Making art for me is synonymous with assuming responsibility for my species and the planet we live on. Art is the essence and a reflection of life. It sees the past and the present and shapes the future. My role as an artist is to create art that questions the status quo, helps the environment, and offers coming generations a meaningful legacy.

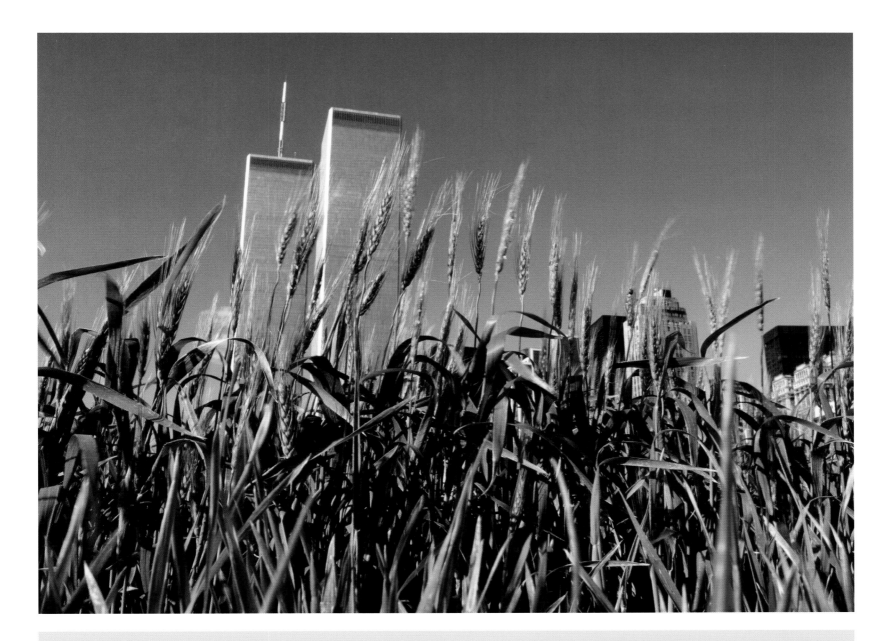

In a time when meaningful global communication and intelligent restructuring of our environment is imperative, art can assume an important role. It can affect intelligent collaboration and the integration of disciplines, and it can offer skillful and benign problem solving. A well-conceived work can motivate people, unite communities and affect the future.

I believe that the new role of the artist is to create art that is more than decoration, commodity, or political tool. This art questions the status quo and the direction life has taken, the endless contradictions we accept and approve. It elicits and initiates thinking processes and suggests intelligent alternatives.

Artistic vision, image, and metaphor are powerful tools of communication that can become expressions of human values with profound impact on our consciousness and collective destiny.

The artists' vocabulary is limited only by the depth and clarity of their vision and their ability to create true syntheses well expressed.

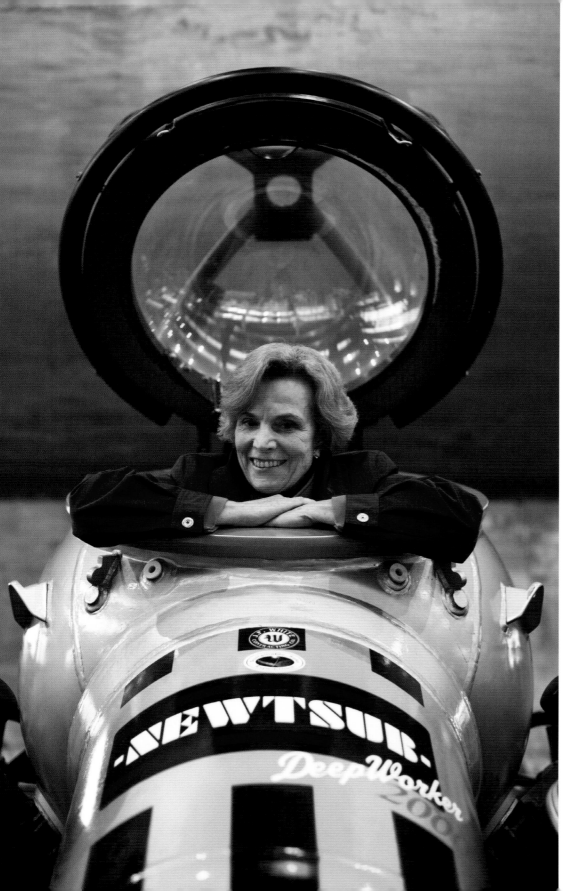

Born August 30, 1935, Gibbstown, New Jersey

Affectionately called "Her Deepness," oceanographer Dr. Sylvia Earle is an explorer-in-residence at the National Geographic Society and leader of the Sustainable Seas Expeditions. Formerly the chief scientist at the National Oceanic and Atmospheric Administration, she has also founded three marine research companies. Sylvia was *TIME* magazine's first "Hero of the Planet" and is the recipient of the 2009 TED Prize for her proposal to establish a global network of marine protected areas.

Sylvia Earle

Protecting the Blue Heart of the Planet

The natural world has diminished profoundly since I was a kid. There were only two billion people on the planet when I was born. Now there's closer to seven billion. There were more birds and fish, bluer skies and cleaner water. Yet still today, 95 percent of the ocean has never even been seen!

My early years were spent on a little farm in New Jersey. Neither of my parents attended college, but they taught me to respect nature and endowed me with a bottomless sense of wonder. One of my favorite pastimes was to sit as still as possible by our pond and observe the activities of critters, which I kept track of in a notebook. I never imagined doing anything other than working with plants and animals.

For our summer vacations, we traveled to the Jersey shore. At three, I remember being knocked over by a wave and not being able to breathe. But once I touched bottom and then broke back through the surface, the experience exhilarated me. My mother found it terrifying. She saw me disappear and was about to haul me out, but when I came up with a big smile on my face, she let me stay. I was hooked on the ocean at an early age.

We moved to Florida when I was twelve to a place right on the water. My backyard was the Gulf of Mexico where I spent my free time exploring the saltwater marshes or snorkeling in the ocean. When I was sixteen, I borrowed from my neighbor, a sponge fisherman, his copper diving helmet, compressor, and pump and made my first underwater dive in the nearby river. Standing on the bottom, I was entranced by the schools of fish and didn't want to come back up.

When I wasn't outside, I was reading about other forms of life. I only liked critter books or biographies about scientists. I couldn't stand fiction because it seemed like a trick. Only the real deal held my attention. My favorite author was the explorer, William Beebe. He had the deep sea diving record at the time and wrote about his expeditions and underwater life that no one else had seen before.

Outside of my family, the most important person in terms of shaping me was Professor Harold Hume. When I attended Florida State University, he bent the rules and allowed me to take as an undergraduate the second class the university had ever offered in marine biology. That's when I was tossed over the side of a boat with a scuba tank, which Jacques Cousteau had invented only the year before, with two words of instruction: breathe naturally. I can still remember the sensation of weightlessness. I could stand on one finger, and do back flips. I couldn't get enough of it, still can't.

Harold encouraged me to focus on marine plants. He believed they provided a foundation for understanding how a whole ecosystem works. He also arranged both a fellowship for me to continue my studies at Duke University and a job as a laboratory assistant. I couldn't get a teaching assistant position, which paid more, because I was told, flat-out, that girls were going to get married and those jobs were reserved for men who would use their education. I wish I'd said to them then what I know now, which is if you educate a woman, an entire family learns.

Even though my parents encouraged me, they pointed out that there

weren't many opportunities for a woman scientist but that a science teacher had a future. I took the appropriate teaching courses, but my heart was not in it. My interest was in being an explorer and not in simply recounting the achievements of others. But I love sharing what I've learned, and in my talks I try to inspire others to go see for themselves, which is what my best teachers pushed me to do.

My first expedition took place in the Indian Ocean in 1964 as the only woman with seventy men. I was already married with two small children. Even though I was gone for six weeks, my husband at the time wasn't concerned because luckily my parents lived next

door and helped with the kids. It was an important milestone for me as a scientist to go diving in a place that had never been explored.

While I didn't travel frequently, the trips would be for extended periods, and it does tear at your heart when you have a family. I tried to combine my career with my roles as a homemaker, mother, and wife. But my calling was as a scientist and explorer. While my three former husbands were all very supportive, they wanted more than I was able to deliver. To spend more time with my children, I brought them with me whenever I could on my research expeditions, where they had opportunities to swim with dolphins and whales and to learn experientially. They were always proud of my accomplishments, tacking articles about me on the refrigerator door, and have all chosen ocean-related careers.

In 1970, I was invited to join the Tektite Project, an underwater habitat near the Virgin Islands where scientists could reside for two weeks. Because the government sponsors, and society at the time, couldn't deal with women and men living together, a separate, all-women team was formed, which I led. The navy representative was opposed to me participating because I was a mother. I countered, "What about fathers?" He thought it was different.

NASA, one of the project's sponsors, was interested in investigating the effects of living and working underwater for prolonged periods of time and monitored the Tektite teams with a twenty-four-hour television system. Fortunately, they provided us with a shower curtain so we had some privacy. The behavioral studies showed that the women performed at a significantly higher level than any of the men's teams in categories such as time spent in the water versus in the dry habitat. We were outside ten to twelve hours a day, and I would have been out more if I didn't need to sleep. The psychologists thought the women would tear each other apart and were surprised that we worked as a team. Of course, we were the best housekeepers.

As a biologist, I am keenly aware that men and women are different. Praise be! It's true of all species. At the same time, on many fronts,

it's equal shares. Some birds undergo long migrations and the males and the females trade off on leading. There are roles that are more appropriate for one sex, but it doesn't mean the other is inferior. Although I resist generalizations, I find that women tend to be more cooperative and more reflective, which isn't necessarily the product of hormones or genes. As a society, we encourage young men to step up and be brave and for women to take a back seat and wait.

The Tektite mission increased my desire to spend longer lengths of time underwater and to get involved in new technologies that would allow travel to the vast unexplored parts of the ocean. In 1979, I set the record for solo diving untethered. I descended to one thousand two hundred fifty feet in a JIM Suit, much like those the astronauts wore, but weighing a thousand pounds. I thought the ocean would be black but instead was indigo and reminded me of twilight, and I witnessed the bioluminescent creatures William Beebe had described in my childhood books.

Graham Hawkes, who later became my third husband, had designed the JIM Suit, and we initially got together over our mutual interest in developing and building undersea vehicles to go to the deepest places in the ocean. On a paper napkin, we drew a rough outline of our first submersible, Deep Rover; and in 1981, we founded Deep Ocean Technology, Inc. and Deep Ocean Engineering, Inc., which in the beginning, we ran out of my house. Deep Rover was designed to descend to three thousand feet, but we dreamed of going down to thirty-five thousand feet.

Using technologies for the first time always involves risk, but my feeling is if you have the chance to make a difference, you weigh the pros and cons, and if the odds are better than even, go for it! My team plans for potential dangers, and we rehearse what could go wrong. Driving on the freeway seems more dangerous to me.

While I worked with the folks at Google Earth to incorporate the oceans into their mapping so that people can travel virtually underwater, I have always promoted the concept of getting out there personally to not only see how beautiful it is down in the twilight

zone but also to witness the profound changes that have occurred in the last half a century. Trash and plastic litter coral reefs and have formed gigantic floating masses, and miles of lost fishing nets and lines drift aimlessly, entangling critters in their wake. If you don't know something exists or you've never experienced it, you don't care about it.

Right now, there are only a handful of submersibles that can take people below where you can go as a diver. In the '70s, there were more. People are shying away from taking themselves underwater and are now using robot cameras.

A chief frustration of mine was the U.S. government's lack of interest in funding underwater research or in protecting marine habitat. I saw my appointment in 1990 as chief scientist at the National Oceanic Atmospheric Administration (NOAA) as an opportunity to weigh-in at a high level. What really appealed to me was that within NOAA, there was a small but promising National Marine Sanctuary program, the underwater equivalent of a national park. My new role offered the potential to shape the sanctuary's agenda and to increase its three million dollar budget.

Though NOAA allowed me to get on the inside of government and see how policies were made, it was also very confining. I came on as chief scientist in the fall of 1990, when the first Gulf War was in full swing, and there were eight hundred oil wells blazing. I was the token scientist sent to the Gulf to develop solutions. But the trips to the Gulf and to Alaska for the subsequent Exxon Valdez oil spill took me off my mark. I stayed at NOAA an extra year to zero in on recommendations for U.S. priorities on new marine sanctuaries. And in 2006, I stood next to President George W. Bush as he signed into existence the Papahanaumokuakea Marine National Monument—one hundred forty thousand square miles of protected ocean.

Even with the sanctuaries enacted by President Bush, less than 1 percent of the sea is protected globally. As the recipient of the 2009 TED Prize, I was offered the chance to make one wish "large enough to change the world." My wish was to create a global network of Marine Protected Areas, "hope spots" large enough to save and restore the earth's blue heart; and in 2010, we launched the Mission Blue campaign to garner public support to call on governments to establish these areas.

This is the first time in our history that we are capable of understanding our effect on the earth's atmosphere, the chemistry of the ocean, and the biodiversity of life. We're the only species on the planet that can do something about it. This is a singular moment in history for people to act in a fashion that will have some hope of securing an enduring future without the cataclysmic consequences of not taking action.

I am convinced there will continue to be life on Earth, at least as long as there's water. What I'm not confident of is the future of our species in ever-increasing numbers. We must learn to live within our means and to realize there are limits to how many people the planet can support and to treat natural systems with dignity and respect in the same way we should treat one another. While we need to make peace among ourselves, we urgently need to learn to live in harmony with the natural world that keeps us alive.

While humans have seen less than 5% of the ocean, our activities are dramatically impacting its ecosystems. Because of intense fishing, 90% of many once-common fish have been extracted and 95% of some species, including bluefin tuna, Atlantic cod, and American eel, have been killed. Oil spills, plastics, sewage, toxic chemicals, pulp mill and manufacturing wastes, fertilizers, detergents, radioactive materials, and insecticides are contaminating the ocean on a daily basis. The largest garbage dump in the world, covering an area twice the size of Texas, floats in the Pacific Ocean. These pollutants and global warming have caused the sea temperatures to rise, affecting its pH balance. With these changes in the water's chemistry, over 400 "dead zones," or low oxygen regions, have appeared along coastlines, the largest one covering 27,000 square miles; and half of the coral reefs are gone or are in a serious state of decline.

Born August 24, 1971, Ely, Minnesota

A third-generation Norwegian American, Kathryn Gilje is the executive director of Pesticide Action Network, based in San Francisco, California, which has a mission of reducing the use of hazardous pesticides worldwide. While living in Minnesota, Kathryn cofounded and codirected Centro Campesino, a nonprofit organization that works with Latino and migrant agricultural workers to improve their lives through community organizing and education.

Kathryn Gilje

From Farm Workers to Pesticides

My grandmother imbued in me a profound respect for people that lived a life that was connected to their values in a deep and meaningful way. She took care of me on the weekends and would tell me stories at night while rubbing my back about the farm she grew up on in Iowa. She was filled with wisdom and knowledge but was ashamed of her roots. On a cassette tape she left, my grandmother spoke of working hard her whole life so that her children would not be forced to do what had been deeply embarrassing to her: to bring vegetables to town in a truck as a country kid and sell them to city folk. So I struggled with that, but farming was in my blood.

Though I felt a deep connection to my agricultural heritage, I also saw my people, Norwegian and Scandinavian Americans, engage in serious injustice. Like the farm workers who toiled on their land, our stories were of lack of employment and too many kids, or famine due to pests or weather, and then needing to rip oneself away from family and country to find work in a new place. We also hung on to our language and had Norwegian churches across the Midwest. Yet in spite of sharing so much in terms of cultural, religious, and family values, my community didn't feel much common cause with their laborers.

In high school, I became aware of systemic racial and economic injustice. We had a diverse student body, and I noticed the difference in the way we were getting tracked. The white kids were being directed toward college, while most of the kids of color weren't. So fairly early on, I became interested in figuring out ways to shift the power dynamics that played out in society.

I was a science geek, but was only interested in applied science where scientific knowledge is transferred into a physical environment, which for me was agriculture and farming. As I sought to develop best practices for food production that would benefit not only the consumer but also the farmers and workers, I decided to go to agriculture school.

When I arrived at the University of Minnesota's College of Agriculture, the environment was racist and sexist. As I had encountered sexual violence when I was younger, I had already connected with the women's movement seeking healing. What I learned was that my experience, rather than being my own fault, came from systemic injustice, which freed me from a lot of internalized anger and rage, and allowed me to direct it in a productive manner.

Another disturbing element at the university was the influence that biotech companies had over the research agenda. The Department of Agronomy had formed a relationship with Monsanto, the world's leading producer of genetically engineered (GE) seeds. They were

developing the Roundup Ready soybean gene that would allow the plants to withstand Monsanto's Roundup herbicide. In spite of scientific studies showing that Roundup was toxic to animals and the fact that farmers had to purchase the GE seeds yearly instead of being able to save seeds from one growing season to another, there was no discussion on campus about the implications for rural communities. The devastation of the 1980s farm crisis was evident, yet here I was being trained in a technology that in my mind contributed to farmer suicides, depression, and health problems.

Farm worker issues were completely absent from the curriculum. To raise awareness, I organized a series of lectures on the working conditions, health concerns, and wage disparities of migrant farm workers. Through university colleagues who were also engaged on these topics, I met Victor Contreras, who had been a farm worker for seventeen years.

As a student graduating from the College of Agriculture, my intent was to leave the place better than I found it, something my parents insisted on. I saw an opportunity for the College to develop programs and classes that spoke to farm worker families' interests and that acknowledged their importance in Minnesota's agricultural development. With Victor, I surveyed the family members to best understand what these needs were. In our interviews, they told us that they weren't as interested in reforming the College of Agriculture as they were in creating an organization to advocate on behalf of their concerns. Based on those discussions, Victor, another farm worker Jaimie Durán, and I cofounded Centro Campesino, alongside many farm worker families.

I was deeply influenced by Dolores Huerta from United Farm Workers and by Baldemar Velasquez, the president of the Farm Labor Organizing Committee, who helped us build our membership. They were both skilled negotiators and strategists, and they expanded the struggle for farm workers rights into a campaign for justice and human dignity, forging alliances with students, churches, and consumers. Because of them, and from my own shift in consciousness through the women's movement and looking at myself as a white person involved in racial justice, connecting community organizing and policy-making became tremendously important to me.

The initial demands that we focused on at Centro Campesino were child care, heat, and hot water. The housing was essentially former prisoner of war camps: concrete block structures with centralized bathrooms, most lacking hot water. When the workers were in the fields, they'd have to leave their kids in the isolated buildings. Later in the season, they would move to the vegetable-canning factory. It ran two, twelve-hour shifts, day and night, seven days a week, so if both parents were on the night shift, there was nowhere for their kids to go.

Chiquita owned the canning company and unfortunately, the surrounding communities offered a very hostile environment. People were harassed just for being Latino. When we started organizing, Chiquita sent their attorneys to intimidate us.

In an effort to discredit me, another vegetable-canning company circulated a piece about me being a lesbian. They then sent people to the meetings to heckle me, trying to get me to react—it felt very KKK-ish. I was out of the closet to the leadership and much of the membership of Centro, which helped me operate with the men in a way that still allowed for powerful relationships with women because there wasn't the tension around what else I could be doing with their husbands. There was one community, though, where we were organizing against housing discrimination, and they had rallied around an evangelical Christian minister. So I had to address my sexual orientation within a religious context, which was something I'd already done, as most of my family is right-wing evangelical.

I'm a Christian and I've struggled with my religion. Atrocities have been committed in the name of Christianity, but I choose to cling to it because the value system really speaks to me. Jesus was a revolutionary person. It's important to me to claim my space

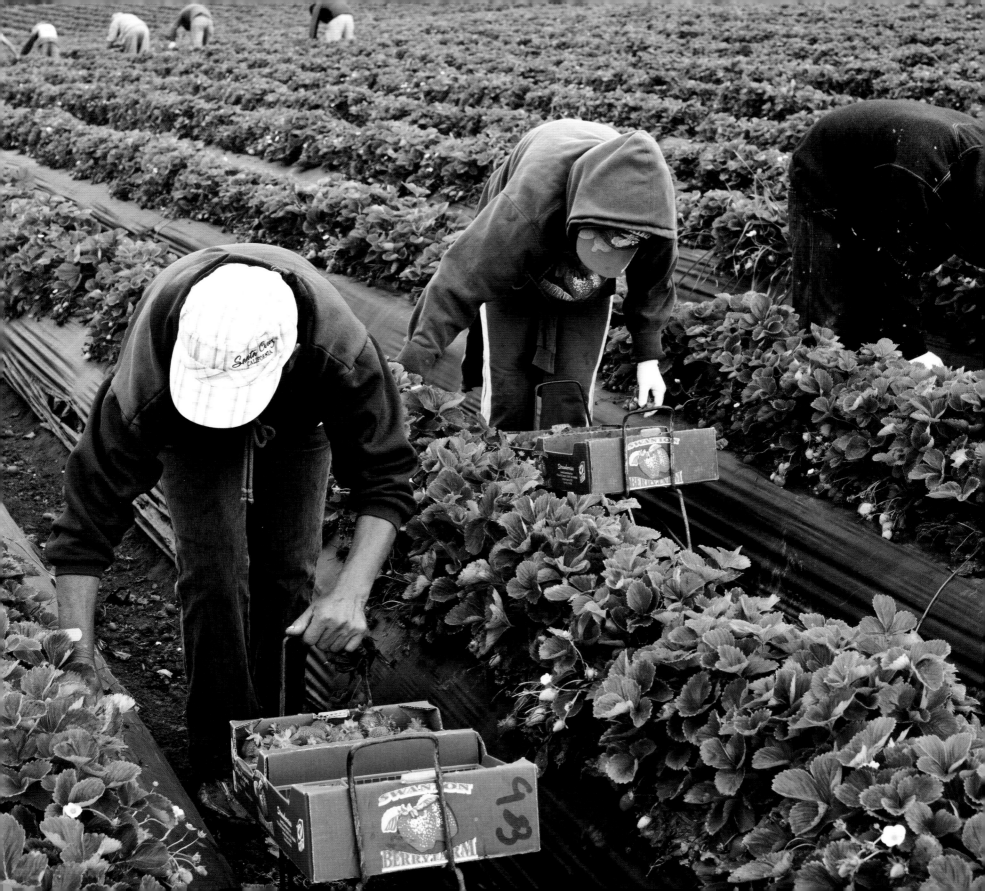

in Christianity and to be in solidarity with those who are facing injustice, poverty, and harm.

Those values were reflected in the community-led leadership of Centro Campesino. It was critical to include multiple voices, with decision-making shared among men and women. Though there were definitely times when we'd calculate that strategically it was better to have a man speak because of the "boys club" mentality in farming and agriculture.

While I was a cofounder at Centro Campesino, in other agricultural organizations where I worked, because I was a woman, I wouldn't have been considered for a director's role. Even though there were plenty of female workers, in terms of visible public roles, those were for men. When I would strategize with women in the social change movement, it would be about how to get a man to address the issue, rather than one of us. I didn't realize I was engaged in that kind of behavior until I arrived at Pesticide Action Network (PAN).

Coming to California and to PAN exposed me to a whole different relationship to gender and sexual orientation, and allowed me to grow as a leader. In my experience, women and men manage

differently. Women are more communicative and consultative in terms of decision-making. Our leadership is intuition based rather than prescriptive, and we tend to have a higher awareness and responsiveness to the variety of issues that individuals need to deal with in their life. My collaborative style has proved to be a benefit at PAN, as we partner with over six hundred organizations in ninety countries to ban pesticides and to support sustainably grown food.

A major influence on my decision to join PAN was being diagnosed with an autoimmune disease. I'll never know for sure, but I believe that it is linked to environmental contaminants like pesticides. While autoimmune diseases are on the rise, particularly in women, research on the links to chemical exposure is sorely lacking. My personal battle with this ongoing condition led to my interest in looking at the intersections of justice, agriculture, and health at the community level, which were not top priorities for farm workers. I was seeking an opportunity to go beyond just finding cures and to focus on the causes of these illnesses.

As PAN's executive director, my goal of connecting community organizing and policy change has expanded to a global level. By

linking local struggles with similar battles around the world, we're able to move legislation nationally and internationally. One of our recent victories is the U.S. decision to end the use of endosulfan, the highly toxic insecticide that has been linked to autism and birth defects, which occurred after years of pressure and our success in banning it in sixty other countries. We're continuing our efforts to have it removed worldwide.

What keeps me from being depressed about the current situation is having the opportunity to affect change. As an organizer I'm always looking for the winnable situations that make a concrete difference in people's lives. And the movement-building side of me says: *We need to speak truth to power.* When I get overwhelmed, I stop and ask myself if I'm going to sit back and be part of the problem, or am I going to do whatever it takes until the day I die to make this world a better place. To ground myself, I read the Bible and pray every morning.

While life for farm workers in the United States has worsened in some ways because of the xenophobia and the criminalization of immigrants that's occurred since 9/11, there's now more interest in food justice, which is linked to workers' rights. Our immigration laws need to change because currently there's no legal pathway for workers to enter the country; yet the industry is dependent on them. Even though there's increasing unemployment in the U.S., citizens are not going to opt to work under such difficult circumstances. Farm workers are still fighting for basic needs. In California, we're trying to enforce access to shade in the fields. A very basic human need in one-hundred-plus degree working conditions. Yet more voices are coming from different sectors, such as the slow food and fair food movements, to advocate for fair wages and better working conditions.

We are at a time when some foundational beliefs that we've been operating under for the last few decades are really being shaken up. Corporations have been using family farmers as their front man, but it's becoming clear that industrial agricultural is devastating rural communities. Policies are being adopted that are more precautionary in nature; and as we're facing increased levels of cancers, reproductive harm, and learning and developmental disabilities, people are realizing that they've been part of a huge, toxic experiment and that the liability should lie with the corporations.

My work is grounded in the value and faith systems that I learned from my grandmother. It continues to be strongly tied to local communities but has grown to making the connections to larger policy changes for good, clean, fair food. I think she'd be proud.

Pesticides are big business. The agrochemical market was worth $38.6 billion in 2007 and is expected to be valued at $196 billion in 2014. The United States is the world's third-largest consumer of pesticides behind China and India.

U.S. Pesticide Facts:
- There are 400 pesticides presently on the market that were registered before being tested to determine if they caused cancer or birth defects. Eighty-three active ingredients in pesticides that result in cancer in animals or humans are still in use. Fifteen pesticides are reproductive toxins. Using present procedures, it takes as many as 10 to 40 years to ban a pesticide.

- Eight hundred eighty-eight million lbs of pesticides are applied each year—nearly 3 lbs per person.

- In 2008, the USDA found 59 pesticides in finished (treated) water. Ninety percent of municipal water treatment facilities lack equipment to remove these chemicals.

- The herbicide atrazine, which in very low doses has been linked to breast and prostrate cancer, is in 94% of tested tap water.

- Fifty-four pesticides were found in the USDA's 2008 test of strawberries: 697 of 741 samples tested positive for residues.

- Systemic pesticides, which work inside a plant, cannot be washed off. They now account for over 60% of dietary exposure risk.

- An average child gets 5-plus servings of pesticides a day when eating nonorganic food.

- By choosing organic produce, Americans can reduce overall pesticide dietary risks by about 97%.

Born June 25, 1951, Grand Island, New York

Grassroots leader Lois Gibbs is the founder and executive director of the Center for Health, Environment and Justice, which has assisted over ten thousand local groups nationwide with training, organization, and information to stop hazardous waste pollution. She became an activist by leading the Love Canal Homeowners' Association's struggle against the toxic-chemical dump located underneath their homes in Niagara Falls, New York. Lois was awarded the 1990 Goldman Prize, and in 2003 she was nominated for the Nobel Peace Prize.

Lois Gibbs

The Activist Housewife

My hometown, Grand Island, was a bedroom community for two highly industrialized cities in New York State: Niagara Falls and Buffalo. I was one of six children; my mother was a homemaker and my father was a bricklayer who worked in the steel mills. With the plunging falls moving the wind around the island, we never smelled the industrial chemicals.

I married my high school sweetheart, had a baby, and couldn't wait to get off the island. While looking for a place in Niagara Falls, we ran into a family who lived in an area called Love Canal who hoped to move to Grand Island, and we traded houses. In our new neighborhood, most of the families were young, so there were thousands of kids; and our sidewalks were bustling with big wheels, bicycles, carriages, and noise.

In Niagara Falls, the smell of chemicals in the air was the sign of a good economy. Chemical accidents happened almost every day. When there was a chlorine release, people would sometimes pass out on the streets. Even though ambulances took them to the hospital, we thought somehow that because they were treated, it wasn't a problem.

Being Miss Dolly Domestic, I did get upset when the sheets on my husband's side of the bed would turn yellow, and if I bleached them they'd darken. When I sent him to the plant to find out why, the response was, "Your little woman shouldn't be complaining. You're working hard for a living. Just tell her to hush up." He was also told that the chemical was like quick-tanning lotion and that it was fashionable to be brown. Turns out it was vinyl chloride, one of the most toxic chemicals out there. During the entire pregnancy of my second child, it transferred from my husband's body to mine.

Soon after we moved in, my six-month-old son, Michael, developed asthma and then a liver problem and issues with his immune system. In kindergarten, he was diagnosed with epilepsy and needed to take heavy-duty medication. My goal in life was to be a good mom, and I couldn't understand what I was doing wrong. My pediatrician told me, "Sometimes God gives sickly children to parents like you, who are willing to sacrifice to care for an ill child."

When Michael was six years old, I read an article in the *Niagara Gazette* that listed all the chemicals buried in Love Canal, and it mentioned that my son's school had been built directly on top of the canal. My brother in law, a biologist, exclaimed, "No wonder Michael is having so many problems!" and explained that some of the chemicals could affect the nervous system. I pleaded with the

school board but they wouldn't let him change schools. I called every government agency listed in the yellow pages asking to move him but no one responded. When Michael was hospitalized, I remember looking at him, sweet and innocent in his little plastic oxygen tent, thinking: *What kind of mother am I that I can't get anyone to help him?*

I was a girl from Grand Island who'd lived a sheltered life. I voted for whomever my mother told me to. My older sister and her husband were working on cleaning up the Great Lakes, but that was all I knew about the environmental movement. Because she went to college, I'd had a little interaction with the women's movement attending a couple women's rights events with her; but I found them offensive. By my choosing to be a full-time homemaker, they rejected me, not Lois, but the persona I represented.

But I couldn't let my child go back to that school. Since I stayed home, students were always at my door with petitions, and I decided to start one to close Michael's school. I was so shy that I practiced on my dog, Fearless, introducing myself and shaking his paw. When I finally got up enough courage to approach my first house, the owner said, "I've been waiting for somebody to knock on my door." People would take me down to their basements and show me the multi colored chemicals that were coming up through their sump pumps. They'd talk about the illnesses and miscarriages in their families, or show me their dogs with burnt noses from sniffing the ground.

Some of my neighbors spoke about the fifty-five-gallon barrels that were buried in the canal. The tops would rust out and collapse, and if you poked a stick in the hole, it would come out covered with

black sludge that smelled of gasoline. The kids joked, "It's like the Beverly Hillbilly's—we struck oil!" When the holes appeared in the school playground, they were just covered up with dirt. Many of the chemicals were 100 percent pure, and here were these tiny kids with their apples and candy falling on the ground that they'd pick up and put back in their mouths. If they got the gunk on them, the teachers would strip the kids down, wrap them in a towel, and call their parents to bring new clothes. But when I expressed my concerns to the superintendent, his reaction was, "We're not going to close a brand-new school." He only cared about liability and cost, so what if a few kids were sacrificed.

I was so proud of my petition with 161 signatures and drove the five hundred miles to the state capital to present it at a public Health Department meeting. While I was going door to door, the Health Department had been collecting data. A Health Commissioner announced that pregnant women and children under the age of two in the first two rows of homes on the canal were to be relocated. I was so shocked that I jumped up and started cussing for the first time in my life. What did that mean for my two-and-a-half-year-old daughter? Had she been damaged? But they wouldn't respond.

When I drove home, hundreds of people were in the street. Pregnant women were hysterical, their husbands crying. These men were the protectors and providers, they never showed emotion. But I couldn't tell them anything different from what they'd seen on the news. Love Canal Homeowners' Association was formed right there because we were all seeking answers. As people knew me from the petition, I was named president.

Women tried to get pregnant so they could be evacuated. Because they could save their family, they became the protectors, which hurt the men. Women weren't only sacrificing their bodies but also their future knowing the child would likely have special needs. Nine of the sixteen children born in the previous four years had birth defects.

Most of our men didn't want to be out front. The chemical industry was waging a huge negative campaign, and they were afraid of losing their jobs. My husband would go to the bar to have a beer with the guys and get in a fistfight almost every time. He had to leave his bowling team because they harassed him. I know it doesn't sound like a big deal, but it was for him.

The women were in charge and we had our own approach to leading; I call it "mommy style." We drew our lessons from raising our kids, and we treated the community the same way. When they did something well, we publicly recognized and applauded people, like when your kid gets an A. And we delegated responsibility as we did chores at home: Joey cut the grass, Cathy cleared the table, Mary washed the dishes.

There were times when I thought of quitting, feeling that someone else should take over because I was exhausted or my family needed me; but they were just moments and I would move on. Marie Postniack, one of our key leaders and one of my best friends remarked, "At least it gives us something to do, otherwise we would just be sitting at home full of anxiety and fear." It was survivor syndrome; otherwise you went inward and got depressed, which happened a lot in Love Canal.

My saving grace was that I found a mechanism to release some of my anger, frustration, and stress. I kept a diary and still have boxes filled with them. As a leader, I couldn't say publicly "I think we're going to lose." Or if I'd mention it to my husband he would have responded, "Then come home and make dinner." But in my diary, I could write about my fear that we were going to be stuck here, or about my neighbor's seven-year-old son dying and how I didn't know what to do for his mom. I kept giving her hugs, but they seemed so inadequate.

Over the years it took to get relocated, I acted in ways I never could have imagined. I held EPA officials hostage in my office when the funds to permanently relocate us were at a logjam, releasing them

only when FBI agents threatened to break in, because I was worried about the women and children being hurt. And when President Carter was willing to do more for the Vietnamese boat people than for us, I took a group to the Democratic Convention with toy dinghies and made signs saying, "LOVE CANAL BOAT PEOPLE." The media loved it, and I was invited on ABC's *Good Morning America* show. Ten days later, the president agreed to appropriate the fifteen million dollars to buy all the homes.

Our homeowners association still kept getting callers from around the country asking, "Where did you find a scientist? A lawyer?" The same questions I started with. I wanted to answer them but knew I couldn't do it in Niagara Falls or by myself. There was one woman in particular, from Brownsville, Texas, who told me her son was dying from a brain tumor that she believed was caused by pollutants in the Rio Grande and that after he passed she planned to help organize. She sealed the deal.

I moved to Washington, D.C. with my two children—my husband had had enough—and set up the Center for Health, Environment and Justice. In my position, I have the privilege of helping women, who run almost all the local organizations, to become strong leaders. They are the ones who make huge changes in their community that also affect us nationally.

The tragedy of Love Canal is not over. The original plan, driven by the chemical companies, was to resettle the homes. I can't verify this, but I believe their goal was to show that hazardous waste could be cleaned up and neighborhoods revitalized without costing the government billions of dollars. But mainly, the chemical industry was concerned about the big push for residential exposure standards that ended up getting squashed when Reagan took office.

Resettling Love Canal set a precedent for what is now determined to be safe, just based on people moving back in. With faulty studies, sections of the neighborhood were judged "habitable"—not to be confused with "safe." The government spent one hundred fifty thousand dollars to rehab homes that sold for forty thousand, where

no clean-up measures were taken and that were still contaminated. And twenty thousand tons of toxic chemicals are still in the canal, "contained" under a clay cap that doesn't stop them from leaching into the groundwater.

A number of single moms from the housing project in downtown Niagara Falls moved to Love Canal. One woman said to me, "I used to see gunfire, prostitutes, and drug dealers. I have two little girls. They might get cancer here, but not everyone dies from it." Then she started crying. Why does she have to make this choice?

Corporations, and the government they control, deliberately want people on the lower rungs of society to think change is hopeless. But I believe in democracy because I saw it firsthand. Nobody at Love Canal had any political training. Most had a high school education or less, but we came together because we knew it was wrong. Not only did we successfully relocate nine hundred families, but we also helped pass the Superfund legislation to clean up contaminated sites. People across the country who saw what we were doing, looked in their own backyards and began organizing, in spite of being poor and having to work two jobs or being a single parent with multiple children. That's how change happens.

Love Canal is not the only neighborhood where people have been forced to relocate because of poisonous chemicals. The government purchased Times Beach, Missouri, for $32 million and evacuated its 2,000 residents in 1983. Waste oil had been sprayed on the roads to control dust that contained levels of dioxin 2,000 times higher than the dioxin content in Agent Orange. In 2002, American Electric Power agreed to buy out the inhabitants of Cheshire, Ohio, for $20 million. Sulfurous gas clouds and acid rain from the nearby coal-fired power plant plagued the town. In the summer of 2009, the residents of Picher, Oklahoma received federal checks to relocate because their houses were considered too contaminated to be habitable. The area is part of the Tar Creek Superfund site and has over 70 million tons of toxic tailings left over from the mining industry. In Centralia, Pennsylvania, 7 people are still holding on to their homes in spite of the governor's efforts to evict them. An underground mine fire has been burning there since 1962 that may continue for the next 100 years.

Born January 27, 1944, Fort Yukon, Alaska

A Neetsaii Gwich'in who lives in Arctic Village, Alaska, Sarah James is a spokesperson for the protection of the Porcupine caribou herd and the chairperson of the Gwich'in Steering Committee. The Committee was formed by the elders and leaders of the Gwich'in Nation in 1988 in response to increasing threats to open the Sacred Place Where Life Begins, the coastal plain of the Arctic National Wildlife Refuge, to leasing for oil. For her continuous efforts to educate Congress and the public about preserving the refuge's protected status, Sarah won the 2002 Goldman Prize for excellence in protecting the environment.

Sarah James

Protector of the Caribou

Most of my childhood, we were out on the land because my parents didn't have eight-hour-a-day jobs. Everyone in the family had to contribute to survive. There were no 7-Elevens. We lived off of what we gathered and trapped and from hunting the caribou. Called *vadzaih* in our language, I grew up honoring them. We used every part of the caribou for our food and clothing. We never threw anything away, and I learned you could live a good life with not very much.

I grew up in two worlds. Before we moved back out on the land, we lived in Fort Yukon. My mother made crafts and beadwork, and my father sold furs and snowshoes. They worked hard to put food on our table. Sometimes our cupboard would be empty, and I didn't know what we were going to eat, but somehow my mother always came up with a meal. Maybe it was just white rice with raisins and a little sugar.

My siblings and I were forced to attend school, otherwise the government threatened to take us away. My attendance was poor since our house was on the edge of town. Being the youngest, my mom wouldn't let me make the long walk because it was too cold in Fort Yukon most of the time.

When a school opened in my parents community, Arctic Village, we moved up there and lived in a small cabin with no water or electricity. The school only had a volunteer teacher with a few books and almost no supplies. Sometimes we shared one pencil, and we had to ration our paper. So school learning wasn't a high priority.

I learned from the stories my elders would tell. They talked of the old days, when springtime was so noisy from all the wildlife that they would have to yell at each other and of how the birds used to come in so thick that they'd form a giant shadow over the land.

I also was taught to be afraid of white people. When we would pass a trapper's cabin, my mother warned us, "Don't go near there, it's dirty." She said white people had bad "medicine"—we didn't have a word for poison, which is what they used to trap the animals. They killed so many that if it weren't for the migrating caribou, my people would have starved to death.

Our school only went to the eighth grade. When I graduated, the Bureau of Indian Affairs (BIA) sent me to an Indian boarding school in Chemawa, Oregon. Even though I was one of the oldest kids when I arrived, I could only read at the second-grade level. I studied from

the moment I woke up to when I fell asleep, because I wanted to get out of there so badly. It took me six years to graduate.

As part of the BIA relocation program, I went to a small business college in San Francisco and was certified as a clerk typist. I was hired by Blue Shield insurance and lived paycheck to paycheck. It was a difficult existence, but I was in the Bay Area when Indians of All Tribes took over Alcatraz in 1969, and I went over to the island and hung out with the activists.

When my father died in 1970, my mother borrowed money from a friend to bring me home for the funeral. Once I was back in Arctic Village, I couldn't afford to leave. Hoping to help young people avoid my terrible education experience, I started a Head Start preschool, and since we never had enough teachers, I became a teacher's aide. I noticed that a lot of our kids were classified as having special needs. It wasn't that they were slow or couldn't learn, they just needed encouragement and to learn to trust. They were growing up in two worlds and felt bad about themselves, like I had.

Because our kids were always performing below the national level, I joined the board of the school district within the Gwich'in nation and looked into the apparent funding problem. It turned out that we did receive money, but the teachers association controlled it and negotiated for their own best interests. Whatever was left over went to education.

Frustrated with the school board, I became a member of the tribal council. We fought many battles. We went to trial against the state of Alaska just to have control of our school and to gain title to the 1.8 million acres that we lived on. We also decided to ban alcohol and drugs in Gwich'in villages and checked the luggage of people who flew in, which the state also fought us on. Every time we exercised our tribal rights, they tried to stop us and our funding would be cut off.

With the council, I was developing a caribou management agreement to protect our herd. Since the caribou didn't see a border, the agreement needed to be signed by both Canada and the United States. While we were in discussions with the Canadian government that already had it's own internal plan, the Alaska Department of Fish and Game and the U.S. Fish and Wildlife Service were totally uncooperative.

During that time, oil companies began threatening to open the coastal plane of the Arctic National Wildlife Refuge, the sacred birthplace of our Porcupine caribou herd, to oil and gas exploration. It was all over the news, yet they never asked us. This alarmed the elders; they knew the caribou needed a quiet place to birth their calves and that the trucks and drilling would disturb them. They called for all the villages to come together, like in the old days when the nation was threatened. We had not had a Gwich'in Gathering since before "the contact," which is how we describe white people coming to our land.

The Gathering felt like a rebirth of the nation: everybody coming together and getting to know each other. People traveled from the fifteen villages by plane and by boat. In our traditional way, we spent the first day of the Gathering praying and singing and speaking of our past leaders. We then talked about our four main issues: alcohol and drug use in our nation, keeping our language, international border problems, and concerns about the caribou. We had the talking stick and could only speak in our language with no note-taking. After three days, the fifteen chiefs said, "This is good, but the world need's to know about it." Understanding that it had to be in black and white, they drafted a resolution to protect the Sacred Place Where Life Begins (the coastal plain of the Arctic National Wildlife Refuge) and formed a steering committee. I was picked as one of the members. So we wouldn't get distracted from our purpose, they made it a lifetime commitment.

The chiefs chose us not because we were men or women, but because we had already been leaders in our villages. In Gwich'in culture women do everything that men do. We were a nomadic people before we were colonized into villages. If I waited for my husband to bring me wood to keep me warm or food to eat, I wouldn't survive. And he

had to know how to sew his boot if it tore while he was hunting or else his foot would freeze.

My mom did teach me that the Creator bestowed on women a power that men don't have, unless you give it to them. We can control men because as women we give life, and that's the most powerful thing, but we have to be humble. Women have to help men feel strong and not misuse our power.

My work has a strong spiritual foundation that comes from prayer, song, and dance. My duty is to our people and the caribou, that's how I was raised. I'm always asked, "When did you become an activist?" I don't like that question. We are *Athabascan* "caribou people." We depend on them for our survival, and we are who we are because of them. The Creator put us here to take care of this part of the world and gave us a voice to speak for the caribou. It's our responsibility.

I believe in the Creator and in Christianity. My grandfather started the first church in Arctic Village. Most Gwich'in are Episcopalian because Hudson Stuck, an Episcopal Archdeacon, came to our Fort Yukon trading post in 1913 on his way to climb Mt. Denali. When he saw so many orphans and people dying from starvation and diseases, he opened a mission and a hospital, so we honor him. The teachings of true Christianity and the Creator are very close, they both tell us to be respectful and to love one another. If it weren't for the caribou, I wouldn't be where I am today. I can't separate myself from that. If you don't appreciate where you came from, you don't know who you are. We can't return to the bow and arrow, yet we can't go all Western. I try to find a balance and work with tools from both worlds. I speak at conferences and to the media, but I bring my drum and my caribou songs.

I talk about why we say no to oil. The Sacred Place Where Life Begins will never be completely safe until it has permanent wilderness designation. It is not just about land and the environment; it's also about human rights. Our cultural survival depends on us being able to take care of our families by hunting and living a traditional subsistence life like my people have for thousands of years. Because we believe these issues are connected, we don't join up with environmental groups like The Wilderness Society or Sierra Club, because that's not who we are, but we respect the work they do. Yet we are few, so to increase our voice, we forge alliances with churches, and justice and civil rights organizations.

While I tell the story of our relationship with the caribou all over the world, I also educate our people, especially the next generation. Too many of them have gone to the cities and have drug and alcohol problems. They are coming back to live the life and learn from their elders. We teach the young people our language and make camps in the summer so they can be out on the land with the caribou and become proud of their heritage. And when I can, I bring some of them with me when I travel to places like Washington, D.C. to testify.

Right now I'm turning to renewable resource development. The Creator put sunlight, water, and wind here for us for free. We've already put up two solar panels in Arctic Village. I'm also showing my people how to recycle, reuse, reduce, and refuse, but it's hard because of Western education and pressure from society. Now it's tough to live a subsistence life, and we need to fly provisions up in small packages by plane, creating a trash problem. And like everyone else, we need to curb our dependence on oil.

Even though our footprint is small—we still live in cabins with no running water—we are the first to feel the impact of global warming. The permafrost on the tundra is melting, which is causing land erosion and displacing animals like the caribou. They have not migrated close to our village in many years. Even my favorite glacier lake, which I visit when I get depressed and need to recharge, is draining because of climate change.

If each of us does our part, the planet will heal. I was taught that every day is a good day, and you're the only one that can make it even better. We all have children, drink the same water, and breathe the same air, so we need to come together and care for *Nan*, the Earth. It's just common sense.

The Arctic National Wildlife Refuge in northeastern Alaska is often called the "American Serengeti" because of the richness and diversity of its ecosystem. It is home to more than 180 bird species, 36 types of fish, and animals such as grizzly bears, wolverines, moose, and dall sheep. The narrow coastal plain of the refuge is also the birthplace and nursing grounds of 130,000 Porcupine caribou.

As the largest protected wilderness in the United States, the question of whether to open the Arctic Refuge for oil extraction has been an ongoing political controversy since 1977. Oil exploration and drilling risks high-impact environmental disturbances for the sake of a very limited supply of petroleum. Requiring hundreds of miles of roads and pipelines and massive production facilities, these activities would interfere with the migration and birthing patterns of the Porcupine caribou that have been the foundation of Gwich'in culture and subsistence for 20,000 years.

Born January 25, 1935, New Orleans, Louisiana

While living in Altgeld Gardens, a public housing project in the middle of a toxic donut of more than a hundred industrial plants and landfills in the South Side of Chicago, Hazel Johnson discovered that her area had the highest cancer rates in the city. Named "Mother of the Environmental Justice Movement" at the First National People of Color Environmental Summit, Hazel founded People for Community Recovery (PCR), one of the oldest African-American, grassroots, environmental organizations in the Midwest. Since 1982, PCR has been applying pressure on corporate polluters and government officials to reduce toxic waste.

Hazel Johnson

Mother of the Environmental Justice Movement

I never imagined that I'd live in a place that would hurt my babies. In 1955 when I was twenty years old, my husband and I left New Orleans and moved to Chicago. I wanted to be a secretary but I had seven children and was too busy babysitting. In 1961, we moved to Altgeld Gardens, a housing project for African-American World War II veterans on the South Side of Chicago. A sign over the entrance read: *Garden Spot of America*. When we arrived there were flowers and trees everywhere, and we had competitions to see who could make their block the most beautiful. But that was only on the surface.

Things changed when new management came in. They stopped fixing our apartments, the paint was peeling and the ceilings leaked, and we were always having problems with the water: we never had enough pressure and it came out brown and stunk like a rotten egg. I went to housing meetings to complain but they would try to stop me from speaking. I reminded them that we had freedom of speech in this country. We were living like slaves on a plantation, and I'd had enough. With a couple of women friends, I started the nonprofit People for Community Recovery (PCR) to fight against the Chicago Housing Authority.

When my children got up in age, I saw a story on the news about the South Side of Chicago having more cancer then anywhere else in the city. I had seen a pattern of it in the people around me, including my husband, who had died of lung cancer. But it wasn't only older people; there were a couple of little girls that I knew that had passed. To find out what was going on, I went to Health Department and Environmental Protection Agency (EPA) meetings and made them send me reports. I learned that Altgeld Gardens had been built on the old Pullman Company dump and was right in the middle of a toxic donut with a chemical incinerator, a water sewage treatment plant, steel mills, paint factories, three abandoned lagoons, and more than fifty landfills surrounding us.

I began documenting the health problems of my children and those of my neighbors. They all suffered from asthma, allergies, nosebleeds, headaches, dizziness, and fainting spells. My daughter Cheryl, who had studied chemistry in college and was working for Argonne National Laboratory, helped me research the effects of air pollution and the other toxins that were coming from all the industry in the area. With the women at PCR and Cheryl, who came to work with me, we did our own health survey of the community. The men didn't

help; they don't have the same instinct mothers have to protect their young ones. We found that everyone had either cancer, skin rashes, kidney and liver problems, or all types of lupus. And many women had miscarriages, like my daughter-in-law, who had stillborn twins.

Not only were we being harmed by the industry around us, but also our buildings had high levels of asbestos and lead. We launched campaigns to have the toxic paints, insulation, and pipes removed and to educate the community about the impacts. Eventually, we pressured the Chicago Housing Authority to address the lead problems in their nineteen public housing projects.

At first nobody listened, but I kept talking about the cancer and the pollution over and over again, and finally the media started paying attention. I was on TV and in magazines and newspapers and that's how the environmental movement found me.

Greenpeace helped us organize a demonstration to stop the expansion of Waste Management's landfill. Seventeen of us chained ourselves together in front of the entrance and over the course of six hours blocked fifty-four trucks from entering. As soon as the press left, Waste Management had us arrested.

One of the scariest times at Altgeld Gardens was when we were evacuated after an explosion at PMC, a chemical manufacturer. When some sulfur trioxide was being transferred from a tanker truck into a storage facility, a leak occurred that allowed it to come into contact with water. Mixing the two creates sulfuric acid, which caused the explosion. The forecast for that day was rain, which would have caused a huge acid cloud. Even though it stayed dry, the fallout from the air affected people. When they washed their cars, the paint peeled, and when they took showers, the water burnt their skin. No one explained the dangers to the community until we organized a meeting.

I never got angry when these things happened. I just spoke my mind, but I was never nasty. Like the guy on the Gillette commercial on TV used to say, "Never let them see you sweat." Every morning around five o'clock, I pray and ask God to direct me to do the right

thing. If it wasn't for my faith, I don't think I would've made it this far. My work is a gift from God. I didn't have the education, but I taught myself.

The Reverend Benjamin Franklin Chavis Jr. came to Altgeld Gardens to see what we were doing. He was the first person I heard use the words "environmental racism." I told him we didn't have enough black folks involved with the environment and that what was being done to us was a form of genocide. He answered, "Sister, I'm going to get it together."

The Reverend was one of the organizers of the First National People of Color Environmental Leadership Summit in 1991. It was a beautiful experience to come together with so many different kinds of people and hear them talk about what was happening in their communities. Because I was the eldest, they named me "Mother of the Environmental Justice Movement."

At the summit, we talked about trying to get the EPA to work with communities that were being hurt by pollution. Back then, the EPA had no authority over what industries did to us and mainly gave resources to academic institutions. It wasn't until 1994 that we got President Bill Clinton to sign the Environmental Justice Order, which required the EPA and other federal agencies to help poor and minority communities with their environmental problems.

I started going around the country telling my story. I testified in front of Congress and even went to the White House, twice. Bush Sr. gave me the President's Environment and Conservation Challenge Award in 1992. My daughter came with me wearing a navy blue suit and a seventy-something- year-old lady said to her, "Take my coat." We were the only black folks there and my poor daughter's outfit looked like the servants' uniform. When Clinton honored PCR as one of the top hundred environmental groups in the country, there were only a couple of us. I'm used to that. I was speaking in front of a group one time and someone asked me, "How do you feel being the only black person here?" I told him I didn't feel bad and that it takes the same thing for both of us to survive. They gave me a standing ovation.

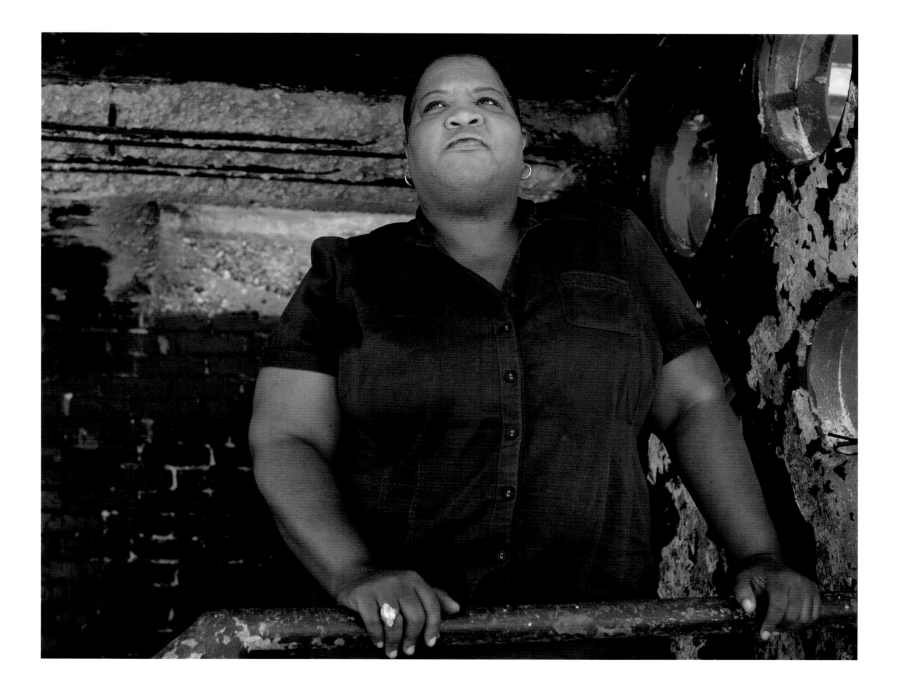

We had a much better time at the White House with Clinton than with Bush Sr., who was very stiff. Clinton had a spread with the biggest shrimp I've ever seen and all kind of desserts. Bush only had tea with bitty sandwiches. When Clinton and Gore came around to shake everybody's hands, Cheryl whispered to me, "Mama, let's be the last two. That way we'll get the chance to say something." Sure enough, we waited and were able to have a conversation with both of them, and to touch their hands—they were so soft. My daughter said, "Mr. President, I hope you get the opportunity to look at some of the issues on the South Side of Chicago." And he turned to Gore and said, "Al, we need to do something for these people." They sent fifty million dollars to the City of Chicago for environmental remediation. We didn't get one nickel of it, but the point is, the money came.

After we saw Bush Sr. in the White House, it seemed like everything went downhill. It became more difficult to raise money, and we had problems with some people in the community. They thought I was doing better then them because he gave me a gold metal. Funders told us that we shouldn't go back to them. We used to get money for organizing protests and demonstrations and doing health trainings; but they didn't help with the cleanup of the toxic PCBs in Altgeld Gardens or any of the other pollution problems.

In the middle or our housing project there was a storage shed area that had been contaminated with PCBs. The EPA and the Chicago Housing Authority first identified it in 1984 but never notified the residents. They quietly attempted a cleanup but only went six inches into the soil. The PCBs came from barrels of oil that the local electric company had paid Altgeld Gardens' management to bury. We heard about it through the grapevine and had a lawyer from the legal clinic investigate. In 1995 through the Freedom of Information Act, we found out the truth. PCR pushed the EPA to clean the site down to twenty feet, but they only did the remediation where the hole had been dug. By that time, the oil had spread. The groundwater had been disturbed, and the public drinking fountains had to be removed. All the local people who had been hired to dump the PCBs died from cancer.

We operate now on close to a zero dollar budget, so we focus on educating the community, individuals in industry, and young people. If I can show folks who work in the chemical plants that their health is also being impacted, they might try to change things. We have university students working with us, and they are our future decision-makers and chemical-makers. I teach them to think about community first when they go work for corporate America.

We're trying to get our people exposed to green job opportunities. They could become the environmental remediation workforce to clean up these messes. Abandoned facilities could be converted to build solar panels and folks trained to make them or to install and maintain them.

I plan to stay in Altgeld Gardens until I die, because I want to continue to fight. If I moved, I wouldn't know what's going on, so I couldn't help. My wish for my community is for them to learn to stand up for their rights. We have meetings, but when it's time to speak up, I'll turn around and nobody's there. A lot of us still have that fear mentality from slavery time. I would love for a center to be built here to educate our children and their parents, too, because most of them don't know anything about the environment. What makes me feel good is that my daughter Cheryl will make sure that People for Community Recovery keeps going.

Africans Americans are 79% more likely than whites to live near a hazardous waste facility. One of the five worst concentrations of toxic waste in the nation is on South Side of Chicago. Altgeld Gardens, with a population of 95% African Americans, 65% living below the poverty level, is surrounded by 90% of the city's landfills. The known pollutants that exist in the area include mercury, ammonia gas, lead, PCBs, DDT, and heavy metals. Lead poisoning, from old paint on walls and from drinking water that comes through lead pipes, is still one of the greatest environmental threats to children in the community. Even very low exposure can cause decreased IQ, mental retardation, and hearing loss. Residents of Altgeld Gardens continue to suffer from cancers, lung ailments, heart problems, asthma, birth defects, and miscarriages. Health studies have connected their illnesses to carcinogenic chemicals in the soil and groundwater.

Born August 18, 1959, Los Angeles, California

A member of the Mississippi Band Anishinaabeg from the White Earth Reservation in Minnesota, Winona LaDuke is the founder of the White Earth Land Recovery Project, which buys back nonnative land, and the executive director of Honor the Earth, an organization she cofounded with the Indigo Girls to raise awareness and financial support for Indigenous environmental justice. Winona ran twice for Vice President of the United Sates as the nominee of the Green Party, and in 2007, she was inducted into the National Women's Hall of Fame.

Winona LaDuke

Native Struggles for Land and Life

I was born in East Los Angeles and hung out with the Mexicans, but I always identified as Native. I'm Bear Clan from the White Earth reservation in Minnesota, and I was raised to help my people. Both my parents were political, and my early socialization was the anti-war and farm workers' movements, and then the poor people's march.

My father was Anishinaabe and my mother was a first-generation Russian/Polish Jew from New York. My dad hitchhiked across the country wearing a full headdress, selling wild rice, and talking about Indian issues. When he arrived in the Big Apple, he knocked on my mom's door looking for some guy named Frank, and she ended up running off with him to Los Angeles. He was going to make his fortune starring in Westerns.

My parents split when I was five. My dad had started a tribal news magazine, and my mom and I traveled with him to powwows and reservations around the country. He had planned to settle down on the White Earth reservation, but my mother felt that living there was way too tough. After completing art school in Los Angeles, she was hired as an art professor at Southern Oregon University in Ashland, and I moved with her. My dad continued his activist

work on a reservation in Klamath Falls, Oregon, and he'd come over and visit.

Ashland was a small, racist town, and I was a nerd, which made it even harder. What saved me was joining the debate team in high school. The topic my sophomore year was: *What should the national energy policy of the United States be?* Thanks to my parents, I had a knack for energy policy, and I knew the one case you could never beat was the Navajo uranium mining issue, because there's no safe way to extract it. My team won the state championship three years in a row.

I really wanted to leave Ashland. When a Harvard University recruiter came to my school, I saw that as my ticket out. My guidance counselor didn't encourage me, even though I had high SAT scores, a great grade point average, and was on the debate team. I was accepted at Harvard, Yale, and Dartmouth and chose Harvard.

Jimmie Durham, the Cherokee political organizer for the American Indian Movement (AIM), caught my attention when he spoke at Harvard. He said, roughly, there wasn't such a thing as an Indian problem; the trouble was with U.S. colonialism that had deprived us of our rights. Jimmie was also the director of the International

Indian Treaty Council, which pursued legal and political avenues to address violations of these agreements.

I had a campus job at the library of the School of Government and asked Jimmie if I could be his research assistant. After hearing a presentation about the U.S. government's nuclear weapons program, I discovered that the uranium used to make the bombs came mainly from Native lands. Mining uranium caused radioactive pollution, but the U.S. government wasn't acknowledging how dangerous it was to people who lived nearby. I began researching the health impacts on Native people.

In 1977, the United Nations was planning its first conference on the rights of Indigenous peoples in Geneva, Switzerland. Jimmie was to represent the Council, which was the first indigenous group to be recognized as a Non-Governmental Organization with consultative status to the United Nations. Right before leaving, Jimmie and some of AIM's founders disagreed on the purpose of the trip. They wanted to protest; he saw the conference as way to address Indigenous peoples' grievances on an international platform. One of the issues was the effect of uranium mining on Native people. Unable to reconcile, he sent me instead with his notes to testify. I was only eighteen years old. It was baptism by fire. I missed my first two weeks of school my sophomore year but I thought: *There's only one time to make history, I can go to class anytime.*

I spent the next couple of summers on Navajo reservations in Nevada working on uranium mining issues. My job was to convert government documents into Basic English. Then they would be translated into Navajo, which was when I realized that there was no way to inform a Navajo that their land was going to be radiated because they didn't have a word for radiation. I was outraged. How did the government and corporations have a right to do this? I began testifying at hearings, talking to the press, and demonstrating at just about every nuclear power plant in the country.

In the early 1980s, I organized on the Pine Ridge Reservation in South Dakota, which also suffered from the health and environmental effects of uranium mining in the surrounding Black Hills. We battled off twenty-six corporations that intended to mine in the area. Vernon Bellecourt, an AIM leader who lived on the White Earth reservation, said to me, "Winona, you've worked in everyone else's community, why don't you come home and work in your own?" His words resonated. With my degree from Harvard, the White Earth Tribal Council thought I'd make a good high school principal. As it was the only job available, I took it.

When I arrived, the struggle to recover lands promised to the Anishinaabe by an 1867 treaty was just coalescing. The U.S. government was documenting the number of people who had lost their property, and I was part of a project that interviewed elders to find out the history of ownership. Not surprisingly, the Bureau of Indian Affairs hadn't properly recorded the deals and many of them were illegal. Conversations with the government were never about returning the land, but rather what the price should be to buy it. The Tribal Council was offered $17 million dollars or the 1910 value of the land.

Those of us who opposed the deal formed Anishinaabe Akking, which means, "the land to which the people belong." When the Tribal Council, whose members ended up going to jail on corruption charges, voted for the land rights settlement, Anishinaabe Akking brought a lawsuit representing forty-four plaintiffs in a class action suit. After seven years, the courts ruled against us. They agreed that the land had been taken illegally but that it was too late to give it back.

Fighting in court was obviously a waste of time; I was looking to set up a different mechanism. In 1989, I won the Reebok Human Rights Award for my work on land rights and used the twenty-thousand-dollar prize to start the White Earth Land Recovery Project (WELRP), with the idea of buying back land and restoring our way of life. Our reservation was almost entirely clear-cut at the turn of the twentieth century by people like Frederick Weyerhaeuser, and 90 percent of our land is still owned by non-Indians.

Anishinaabeg are people of the forest. Our land reaffirms us and gives us instructions on how to lead our lives based on the tenets of reciprocity and cyclical thinking. We've been here for eight thousand years, singing the same songs to welcome the spring, to bless the plants, and to signal the bears returning home. Our migration story puts us here; our prophets told us to go to the place where the food—wild rice—was in the water, in our language *mahnomen*: a gift from the Creator. That's why we struggle so hard to keep our land, it's not just a place where our old people are buried, but it's where all our stories and the medicines that the Creator gave us come from.

What drives my work is thinking about our future generations. WELRP funds Ojibwe language classes for kids as a way to restore our culture. They can then sing and participate in our ceremonies, continuing our traditions. When my son Gwekaanimad was eight years old, I noticed he was eating prepackaged food for his school lunch. We started a program to feed the students buffalo and other local foods and for them to grow their own. I always tell the children they're making history.

I love raising kids. When I visited White Earth in my youth, I would spend time at Winifred Jordan's house. She had fifty-three children—obviously a lot of foster kids—and was always telling us stories, our oral history. My goal was to grow up and be just like her. My children are part of everything I do, they help at the office, come to rallies and learn how to harvest rice.

Like most women, I excel at multitasking. I used to date a guy who would say he needed complete silence to work, and I would laugh, thinking that's a male privilege. When you have children you can tell if the tone of the cry is urgent, otherwise you just zone them out and keep doing everything else.

As a woman and a person of color, I also come at issue's differently. It's really hard to get a piece of the pie, so why fight for that one? I'm not looking for another piece; I want a whole other pie—a different world.

A new pie is the reason I decided to be Ralph Nader's running mate in 1996 and 2000. We first met when I was fighting nukes. His people asked me to be on a list of potential Vice Presidential candidates, which sounded innocuous. Two days later Ralph asked me to run. At the time, I was like the majority of people, I didn't vote. I believed in change, but I litigated, protested, and bought back land. But this was an opportunity to make a difference on the national level. My intention was to give people something different to look at and think about. I proposed an amendment to the U.S. Constitution based on one of the teachings of the Six Nations Iroquois Confederacy: in every deliberation, we must consider the impact on the next seven generations.

Campaigning was hard. I had to go door to door and get my own signatures. It politicized me to the inequalities of an electoral system that punishes you if you're not a Democrat or Republican. Ralph and I weren't allowed to debate because we didn't have consequential numbers, yet we were blamed for the election.

The pie that I want is not one that is owned by British Petroleum. I'm fighting for a green economy that is local and that people feel connected to. Seventy percent of our economy is based on consumption, so we think we can solve the problem by buying green. Native people have grown to be consumers, too. Our people don't even know how to grow corn anymore.

At White Earth, we've developed strategies that are community driven to relocalize our food and energy, because that's how you create a durable economy, not by transporting stuff around the world to Wal-Mart. We've set up a mill for processing wild rice gathered from the lakes, and we're planting traditional hominy corn. Most of the land we've purchased is maple sugarbush, and we make syrup instead of cutting down trees. Through WELRP's Native Harvest label, we sell these products after paying the tribal farmers a fair price.

In order to move from where we are now to where we need to go, we need to build intellectual capital. On my reservation we have a

lot of wind and 60 percent unemployment. When I first proposed a windmill, people looked at me like I was nuts, now they want in. WELRP is training our guys to install and maintain the wind turbines; otherwise, we'd have to hire folks from some firm far away. I'm helping people liberate themselves from their fears and to become self-reliant. You can spend a lot of time saying what's wrong but never what's right. I'm offering real, local solutions. No one else is going to do it for us.

Spirituality is the foundation of my work. Many indigenous teachings consider the present to be a time of change. Anishinaabeg teachings tell us to retrace our steps to where we find a split in the road; in one direction there is a green path and the other a scorched path. In my culture, we believe we have the ability to right the wrong. We have no language for the end of the world, instead we have *mino bimaatisiiwin*: a cyclical system of continuous rebirth.

Honor the Earth and the White Earth Land Recovery Project (WELRP) provide much needed support to Native communities on both the local and national levels. Native groups are on the front lines of environmental protection, mitigating climate change, restoring biodiversity, and bringing back local food economies. Yet only .05% of 1% of philanthropy goes to indigenous issues, and the majority of those funds are directed to non-Native organizations. To address these disparities, Honor the Earth partners with foundations to increase financial resources for organizing and change, with funding decisions made by Native people. Honor the Earth's program priorities include creating a new energy economy, sacred site protection, promoting Native youth leadership, buffalo restoration, nuclear waste policy, and encouraging tribal commitment to the Kyoto protocol. WELRP works to recover the original land base of the White Earth Indian Reservation and preserves and restores traditional practices of land stewardship, language fluency, and community development. Through its label, Native Harvest, WELRP buys local products, such hominy, wild rice, buffalo sausage, and chokecherry jelly, for a fair price from tribal members and sells them.

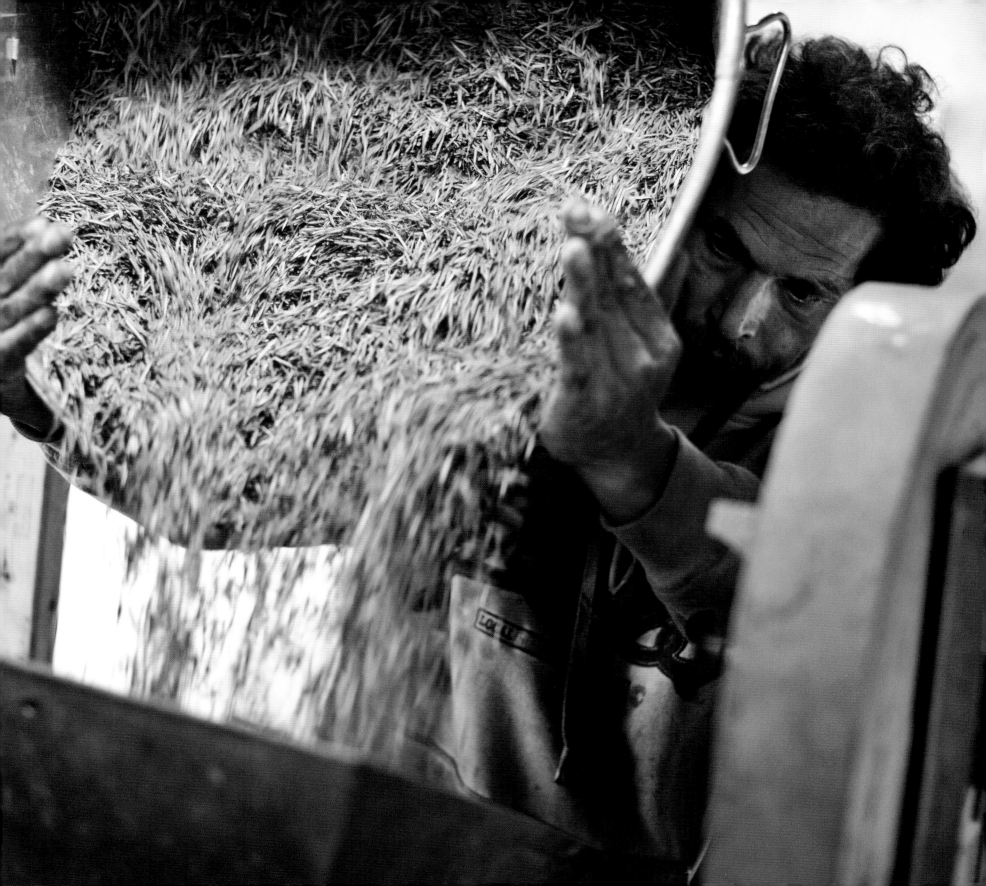

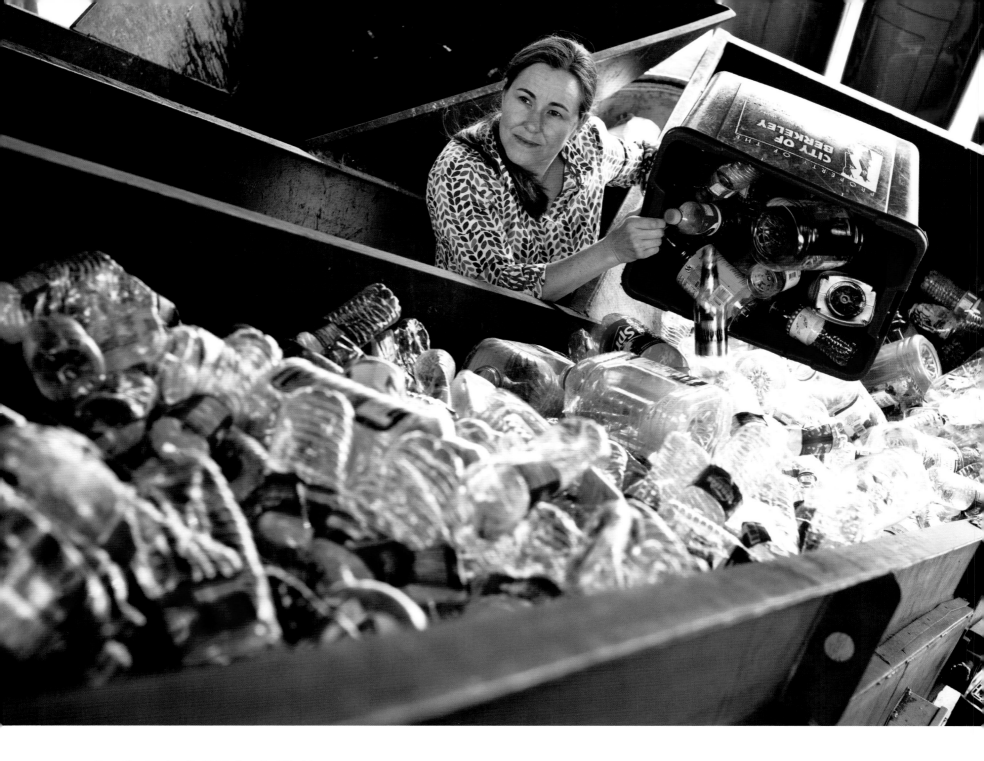

Born September 8, 1964, Seattle, Washington

A 2008 *TIME* magazine "Hero of the Environment," Annie Leonard is an expert in environmental health and justice issues, with more than twenty years of experience investigating factories and dumps around the world. As the director of the Story of Stuff Project, Annie creates online films that expose the connections between environmental problems and human consumption. Her first film, *The Story of Stuff*, was an Internet phenomenon generating over twelve million views in two hundred countries since its launch in December 2007.

Annie Leonard

Minding Our Stuff

To my mom I owe my sense of stewardship about materials and to my dad my interest in far-off places. My mom was very frugal and sensible. My dad was an accident investigator at Boeing and went wherever a plane crashed. He would always bring me back little trinkets and stories from his travels around the world.

Growing up, I spent a lot of time in the forests of the Pacific Northwest, camping with my family and on annual school hikes on the coast. We would drive by clear-cuts on the windy mountain roads, and logging trucks would pass us filled with huge, freshly cut logs. I remember feeling a pain inside me even though I had no idea why. I just knew something was really wrong.

Loving nature, I wanted to be the first female Secretary of the Interior. I planned to study environmental science, but I chose Barnard College purely because New York City seemed exciting.

Every morning, I would walk the six blocks between my dorm and campus, past piles of garbage as high as my shoulders. In my hometown, Seattle, we didn't have heaps of trash strewn on the streets, and I had been raised in a family where we didn't waste. Even though my mom grew up poor, I never connected it to hardship. I just didn't know that some people wasted so much.

There's a reason why garbage bags are black: they don't want you to look inside them. I couldn't help wondering though, what all that stuff was. Finally, one day, I climbed up one of those heaps and opening a bag, I saw it was filled with mostly paper. That's where those logs were going! Even today with recycling, 40 percent of our garbage is still paper.

Not too long after that, I took a field trip to the Fresh Kills Landfill on Staten Island. Along with the Great Wall of China, legend has it that it is one of the two man-made structures you can see from space. I'll never forget looking out, and in every direction as far as I could see were appliances, furniture, plastic bottles, and packaging. I realized that we'd built our entire culture and economy on waste. It was a big dirty secret that was kept hidden from view. I became obsessed with garbage and the systems that produce it.

My eyes were opened to another dirty secret on my trips to Mexico. During winter vacations in college, I would head out to California for the Grateful Dead New Year's shows. Afterward, I'd still have three weeks left, so, being a broke college student, I'd travel south. I saw factories belching their filth into the air, pipes spewing waste directly into rivers, and workers spraying pesticides with no protection—none of which would have been allowed at home.

I observed firsthand the double standards that occurred in Third World countries, as many of the companies responsible for the pollution were either U.S. owned or were making our goods.

Driven by this knowledge and my garbage obsession, I went to work on Greenpeace's campaign to stop the export of waste to developing countries. In the early '90s there was a rush to build new landfills and incinerators in the United States. Community opposition stopped more than 75 percent of these disposal facilities and real solutions like curbside recycling programs were initiated.

What Greenpeace didn't foresee was that a bunch of schmucks would put garbage on ships and send it overseas. There were all sorts of scams to export waste. Sometimes waste traders lied about the content or bribed people in importing countries. In one infamous case, hazardous waste was exported to Nigeria, where waste traders rented land from a farmer for fifty dollars a month, onto which they proceed to unload the barrels. Some of the villagers actually dumped out the barrels and used them for drinking water storage—it was a public health disaster!

My job was to travel to the importing countries to gather evidence of toxic violations and to work with local communities to stir up political resistance. After finding out where the waste was being transported, I would take soil and hair samples and document the damage. Wherever I traveled, most people knew about Greenpeace, were tired of having garbage and hazardous waste dumped on them, and were ready to take action.

I developed a reputation for being able to sneak into any factory. Sometimes I'd wear a business suit and had business cards stating I was a waste trader. I'd request to inspect the facilities to make sure the standards were high enough to receive the waste I wanted to export. Or I'd dress up as a schoolgirl and pretend to be doing a research project on how cool it was that India was benefiting by recycling our waste and ask for a tour. Then I'd sneak samples and pictures. This was before digital cameras, so I had a clunky video camera in my side bag with a little hole I'd made for the lens. I

had come up with a great trick to hide my camera: I'd put a box of tampons on top to embarrass the guard in case he opened the bag.

Being a woman was a bonus for my work. Because there's an assumption that women are dumber and less threatening, I was able to gain entry into many more factories than my male colleagues, and waste traders were far likelier to open up to me about their operations. And while much of the organizing revolved around men, I connected with women who otherwise would not have been reached by conventional environmental groups. In places like Bangladesh, the women garbage pickers were considered untouchables and didn't come into contact with any men other than in their immediate families.

The job did come with some risks. In the mid-1990s, the United Nations was attempting to ban the export of hazardous waste from rich to poor countries. All the developing countries were in agreement supporting the ban, when we got a tip that India might break ranks and decide to keep importing waste. Its officials argued that India should be allowed to continue to take waste for recycling because they handled it responsibly.

To stop them from derailing the process, I was sent to uncover toxic violations and discovered one of the worst factories in my career. Greenpeace made a movie called *Slow Motion Bhopal*, which included the photos I had taken inside the factory and showed it at a major international meeting. The Indian government was so embarrassed that it withheld its opposition to the ban, which has since become international law. I was living there at the time and started to receive death threats. Even though Greenpeace hired a bodyguard for me, I wouldn't let him carry a gun because I was committed to nonviolence.

I've traded a bit of my smile for the things I saw. One Bangladeshi farmer stands out for me. He was an old man wearing a blue-checked lungi and a long white kurta who had bought a bag of fertilizer in which a U.S. company had mixed in hazardous waste. When we met, he was so gracious and introduced me to his granddaughters

who had applied it by hand all over their fields. After I explained to him why I wanted to take soil samples, he smiled and said, "Now that you found it, your country will come and clean it up." I felt so ashamed when I had to tell him that it wouldn't.

My solace was that I was trying to do something about it, even though the solution—an international treaty banning the practice, offered no immediate help for this farmer, with his heavy metal contaminated rice fields. I had to turn off part of my compassion just to be able to function. Sometimes the feelings were too much to bear.

Not only were we dumping our garbage on Third World countries, but we were also exporting our dirty technologies—like waste incineration. While in the U.S. we had successfully stopped the building of incinerators across the country, the industry had merely

relocated and was targeting Asia, Africa, and Latin America. In order to stop the invasion, I cofounded the Global Anti-Incinerator Alliance (GAIA), a membership organization that now works in over eighty countries to close incinerators and landfills and promote environmentally safe solutions.

Soon after I helped start GAIA, I gave birth to my daughter and my priorities shifted. Wanting to spend time with her, I moved back to Berkeley, California, my home base during my travels. As the U.S. was one of the main exporters of waste, I became interested in shifting our consumer habits, which I realized were driving so much of the environmental destruction around the planet and costing our own communities at home.

After hearing one of my presentations on garbage, Idelisse Malavé, the executive director of the Tides Foundation at the time, suggested

making a video to reach more people. I didn't see the point since no one seemed to be listening to the live version. But she kept encouraging me to figure out how to capture this story about over-consumption. Eventually, with Free Range Studios, I wrote and narrated *The Story of Stuff*.

We were taken completely by surprise with *The Story of Stuff*'s success. In the six months following its launch, some three million people viewed it. The video worked because we made it accessible without dumbing down the message. People who felt trapped by their stuff saw their experiences reflected in it. They related to having to continually upgrade their computers, and women connected to the part where I spoke about needing to buy new shoes every year because the heel shapes kept changing.

Environmental groups have been selling the public short. Much of the information they put out assumes an eighth-grade level of education, and they're afraid of saying anything that could risk alienating supporters and the public. But I believe the public is ready for a tougher conversation. People are unsatisfied with huge pronouncements of the problem and then being told to change a light bulb. They understand that those kinds of solutions are not commensurate with the scale of the crisis. The goal is not to recycle or to save a forest but to redesign our entire global economic system so that is respects people and the planet.

The controversy around *The Story of Stuff* was also astonishing; a small but vocal group of critics attacked my message as anti-American and anticapitalist. Right-wing blogs wrote virulent articles, and I even received death threats. It didn't make sense. On so many levels—health, education, environment, equity—our country is not on a good trajectory; it is a disservice to refuse to explore these issues and address the role over-consumption plays in all of them. It's like we're on a sinking ship and those who point out the leak are attacked as enemies. We need to throw away the old mind-set and come up with sustainable and equitable solutions.

I worry about our inability to think creatively and collectively about how to address the environmental and social problems we face today. Even when humanity is facing its biggest crisis, all most people can think up is how to shop differently. But the solutions are not for sale at the store! I like to tell people that if they really want to make a difference when they go shopping, they should turn to the person next in line and get to know them and share ideas about how we can work together to get this country on track.

Sharing is a great antidote to over-consumption and social isolation. I live in a community of six houses where our families share one pickup truck, one scanner, and one barbecue. We share everything. Sharing means less waste, less money spent, and also builds community.

I've come to realize that there are two different parts of our identity: the consumer and the citizen. The consumer part is spoken to, validated, and nurtured from day one, yet our citizen-self has atrophied. We need to reconnect to that citizen-self, since being engaged citizens in our democracy has the potential to make far more change than just stressing out about responsible shopping. There are so many places to get started. If you're really into food, start a Community Supported Agriculture program; or if transportation appeals to you, promote bike lanes.

What's exciting is that what makes us most happy helps reinvigorate our citizen muscle and rebuilds our communities. Scientists in the field of happiness have proven over and over that once our basic needs are met (i.e., a roof and food and other necessities), what provides happiness is not things. Number one on the list is the quality of our social relationships, the second is having a sense of meaning beyond yourself, and number three is coming together with others towards a shared goal. Being engaged in our communities and our democracy provides all of those things. How lucky we are that the very things we need to get this country on a sustainable, fair, and healthy path contribute most to our happiness.

Little and big things you can do to promote sustainability and justice from *The Story of Stuff*:

Power down! A great deal of the resources we use and the waste we create is in the energy we consume. Ways to reduce energy use are: drive less, turn off lights, buy local, seasonal food (food takes energy to grow, package, store, and transport), wear a sweater instead of turning up the heat, use a clothesline instead of a dryer, buy used or borrow things, and recycle. And see if you can switch to alternative energy by supporting a company that sells green energy to the grid or by installing solar panels on your home.

Waste less! Per capita waste production in the U.S. keeps growing. Nurture a zero-waste culture in your home, school, workplace, church, and community. This takes developing new habits that soon become second nature. Use both sides of the paper, carry your own mugs and shopping bags, get printer cartridges refilled instead of replaced, compost food scraps, avoid bottled water and other over-packaged products, upgrade computers rather than buy new ones, repair rather than replace, and share.

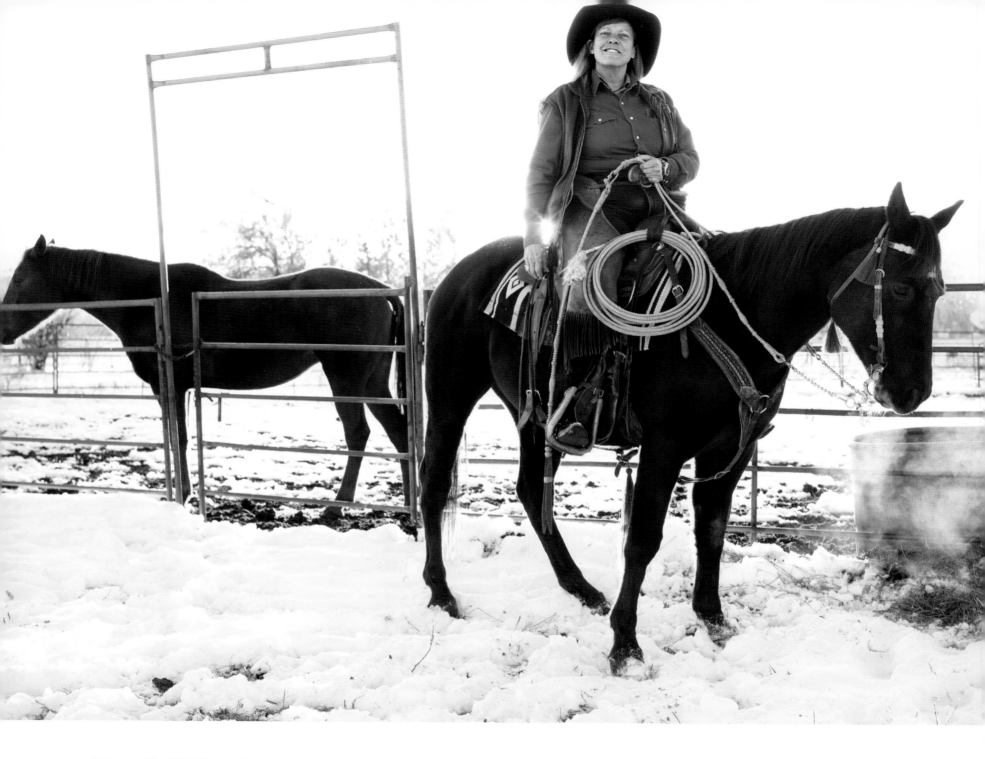

February 26, 1950, Ripton, Vermont

Named a *TIME* magazine "Hero of the Planet," and dubbed by *Newsweek* a "green-business icon," L. Hunter Lovins has been a champion of sustainable development for over thirty years. As president of Natural Capitalism Solutions, she educates business and government leaders on how to implement profitable and practical solutions for infusing sustainability into their operations and culture. Hunter is also a founding professor of business at the Presidio Graduate School, one of the first accredited programs offering an MBA in sustainable management.

L. Hunter Lovins

The Sustainable Cowgirl

I grew up believing I had a responsibility to make a difference. From an early age (five), I was working on issues such as fair housing and civil rights, to draft resistance against the Vietnam War.

My parents were both activists. My mother was born in the coalfields of West Virginia and organized with John L. Lewis—even against her own coal-mine operator father. She went on to get a law degree and tried to shut down the U.S. nuclear program during World War II. My father, raised in the logging camps of northern Michigan, became an urban sociologist with a degree from Harvard. While chair of the Department of Sociology at Occidental College, he mentored both César Chávez and Martin Luther King, Jr. I still remember the day my mom gave notice that we wouldn't be eating grapes anymore.

As a youngster, I didn't get on well with authority—I suppose nothing's changed.... In third grade, I wound up in the principal's office after scuffling with my teacher over refusing to say the Pledge of Allegiance. My mother decided that before I got in real trouble, she'd start her own school. Rather than have classes in the traditional sense, we traveled. We studied history by going to where it happened, biology by being out in nature, and science by doing it.

My mother's program stopped at the sixth grade, and I fought my way through a school per year until my parents, in some desperation, sent me to boarding school in Colorado, where we believed I might find the space to be different. I found more than that—I found home. It's also where I learned to cowboy.

I always cared about the environment. As David Brower said, "Everybody who lives in one, ought to." In 1968, I joined the Sierra Club to work with him. David molded everyone he came in contact with. He was our generation's John Muir or Thoreau. David was one of the first to point out that the environment isn't just a white, middle-class issue—it's about everybody; and he brought people of color and diverse constituencies into the movement.

He also got himself fired because he turned the Sierra Club into the fighting environmental organization it is today, saving the Grand Canyon. He took out full-page ads in *The New York Times*, equating damming the Grand Canyon to flooding the Sistine Chapel. He won the campaign, but Sierra Club lost its tax status. So he created Friends of the Earth, and I transitioned with him.

The summer after my first year in law school, I was wrangling horses at a summer camp in the San Bernardinos when this kid, Andy Lipkis, showed up asking us to plant smog-tolerant trees because

the forest was dying. I challenged him, "If the problem is smog, why don't you go back to the city and talk to people about cars?" He asked how I'd do that. I told him you find something they care about, start talking about that, and pretty soon you get round to cars. He answered, "That's trees. People care about trees. If they plant one, they'll have a stake in this forest." I became his assistant director and we created the California Conservation Project (aka TreePeople), which is still flourishing today.

Still, to me, smog was just a symptom. The real problem was the misuse of energy. I set about trying to teach myself energy policy, which there wasn't much of at that time. But in 1973, the Arab oil embargo hit, and suddenly energy was a hot topic. In 1976, a friend handed me the article "Energy Strategy: The Road Not Taken?" by Amory Lovins, saying this was what I'd been looking for.

Trouble was, it was written in Martian. I literally went through the damned article line by line with a ruler and a dictionary. When I figured out what it said, I realized my friend was right: this was the first internally consistent approach to energy policy.

It asked why we wanted energy, not, which big, costly, centralized supply to build. None of us want raw energy. We want cold beer, hot showers, and the comfort that energy makes possible. When you look at it that way, no kind of new power plant makes any sense until all cost-effective efficiency aides have been implemented first. It is far cheaper to use good design, so that buildings need no external energy to keep us comfortable. Electricity is a very expensive form of energy, new power plants especially so. After I translated Lovins' analysis into English, I set about teaching it to the kids, corporations, and citizens in our environmental education program.

ARCO's chief economist liked what I was doing and knew Amory, so he introduced us—thank you, big oil! Together we worked as policy advisors to Friends of the Earth, traveling the world, consulting, and lecturing. Somewhere along the line, Amory suggested we get

married. We subsequently discovered we weren't very good being married but still enjoyed working with each other.

In 1981, David's board of directors at Friends of the Earth got pissed at him. After growing the organization for ten years, he had been borrowing to pay operating costs and that frightened timid board members. We sided with David, so we were fired along with him.

We were offered a teaching gig at Dartmouth College, and as we were driving across the county, started talking about what we were going to be when we grew up. We didn't want to work for another non-profit or for the government because they all had the same internal squabbles and creeping bureaucracy. Somewhere in one of those big, flat states I said, "Why don't we create our own institute? We've been saying all along that it's not just about energy. If the solution to Middle East arms control is Midwestern attic insulation, energy clearly has a relationship to national security. It all interrelates with water, agriculture, economic development..."

Amory answered, "Horrors, administrivia!" I told him I'd worry about that and he could focus on the quality of the research. We brought a quarter of our Dartmouth class west that summer, along with a hundred other volunteers and built the first passive-solar, super-insulated, semi-underground "bioshelter" in Snowmass, Colorado, and the Rocky Mountain Institute (RMI) was born.

The German scientist and politician, Ernst Ulrich von Weizsäcker, asked us to author a book with him called *Factor Four: Doubling Wealth, Halving Resource Use*. We wrote the half showing that using natural resources more efficiently is profitable, better for the environment, and a solution to many of the world's problems. We sent it out for a peer review, and our friend Paul Hawken called to say, "Rats, you just wrote half of my next book." I told him, "Write the other half, we'll bring it out as the North American edition of *Factor Four*." He rightly argued that no one understood what a "factor" was, so we should call it *Natural Capitalism: Creating the Next Industrial Revolution*.

Over the next three years, as we all did a lot of other things, we put that book together. It occurred to me that I was going to have to stop running RMI day to day if we were going to finish it, so we hired RMI's lawyer to become executive director. Amory and I transitioned to co-CEOs.

As we neared completion, our publisher told us nobody was going to read the book and that they were going to orphan it: print 2,000 copies and quit. Since the publisher had abdicated all responsibility, I went to my friend, Norm Clasen, who had marketed Marlboro cigarettes. When he agreed to help, I guessed I was going to have to take off my cowboy hat. He said, "Not on your life. That's your brand."

The next two years I went on the road flogging the book. The phone began ringing off the wall with people looking to hire RMI to help them implement the book's principles. We created the Natural Capitalism consulting group at RMI. Life was good.

In the spring of 2001, unbeknownst to us, sitting up in the mountains, the tech stocks and the economy crashed and the calls stopped. We didn't notice. We had all these projects. The executive director walked into my office one morning to announce we were losing a hundred thousand dollars a month running the consulting group and we needed to fire half the staff. The same exact argument that David Brower faced at Friends of the Earth. I argued, "No, we need to grow revenue." But while we knew how to operate a nonprofit, we had no idea how to run a business. We needed a businessman.

He appeared in the form of David Elliot. He'd grown and sold a number of businesses and was interested in doing something more worthwhile. Volunteering, he helped us build a sales forecasting tool showing we'd make our revenues four times over.

I went into the board meeting that was to cut RMI in half and presented our plan, only to encounter the most venomous meeting I have ever sat through. But in the end, they couldn't argue with the numbers. They gave us six months. David and I worked eighteen

hours a day; people thought we were sleeping together. He lined us up a company to pitch in London, and we walked out with a contract that erased the losses and put the place on a growth path.

While we were working to save RMI, the executive director had gone behind our backs. A week after we returned, the chairman of the board walked into my office and told me that I was terminated, effective immediately, and to leave the building and speak to no one. Various board members who had been excluded from the decision asked why. The only answer any of us ever got was, "Hunter's disruptive." Dr. David Orr, now on my board, answered, "Damn straight. She was the only one who ever got anything done."

David and I looked at each other and said, "Want to go again?" And we started Natural Capitalism. The Presidio World College, just forming, hired us to build its curriculum, which integrates sustainability throughout all its courses. We subsequently became its founding professors. Natural Capitalism is now a team of about twenty great folks, educating companies, communities, and countries around the world about the principles of sustainability.

I keep bumping into people that I partner with in business who have deep spiritual practices, including the Afghan people. David Elliot's brother had written a book called *An Unexpected Light: Travels in Afghanistan,* and when I cracked the covers, I plumb fell in love with a part of the world I'd never seen. David and I had a chance to do economic development work there, to try reframing it to empower people to solve their own problems using the world's best sustainable practices to deliver energy and meet basic human needs. In the process, an Afghan family adopted me. They taught me to be fully present in every moment, to appreciate what I have, not to want what I might get tomorrow or mourn what I lost yesterday, but to be here right now, with who I'm with, and to love fully, even if it's going to crash and burn. *Insha'Allah.*

I did find myself a good cowboy, Robbie Noiles. We've been together over twenty years. He trains and sells horses and serves as Natural Capitalism's chief of staff. He's that rare man who does not have to

be the dominant one, the famous one. But I could not do my work without him.

Sure, I get mad every now and again that things aren't moving faster. But the times when I'm most effective are when I'm kind, and when I hear what the other side's concerns are and find a way to meet them in ways that enhance the earth's capacity to create conditions conducive to life.

Now places like Goldman Sachs and McKinsey are releasing studies showing that companies that are leaders in environmental, social, and good governance policies have the fastest growing stock value, and are better businesses. The worst performing companies are most likely to not have a sustainability program.

Our message is getting out.

At the same time, the recent *Global Biodiversity Outlook 3* shows some of the world's major ecosystems tipping into collapse.

We've work to do.

The Four Principles of Natural Capitalism

1. Radically increase resource productivity: using natural resources far more efficiently is both profitable and better for the environment.

2. Shift to ecologically inspired production models and materials: using nature as a model produces superior design solutions that eliminate waste, loss, and harm. In closed-loop production systems, based on nature's designs, every output is either returned harmlessly to the ecosystem as a nutrient, like compost, or becomes an input for another manufacturing process.

3. Move to a "service-and-flow" business model: the business model of traditional manufacturing depends on the sale of goods. In the new model, value is instead delivered as a continuous flow of services—such as providing illumination rather than selling light bulbs. This shift rewards both provider and consumer for delivering the desired service in ever cheaper, more efficient, and more durable ways.

4. Reinvest in natural capital: A company that depletes its own capital is eroding the basis of its future prosperity. Sustaining, restoring, and expanding stocks of natural capital will help reverse planetary destruction, so that it can produce more abundant resources.

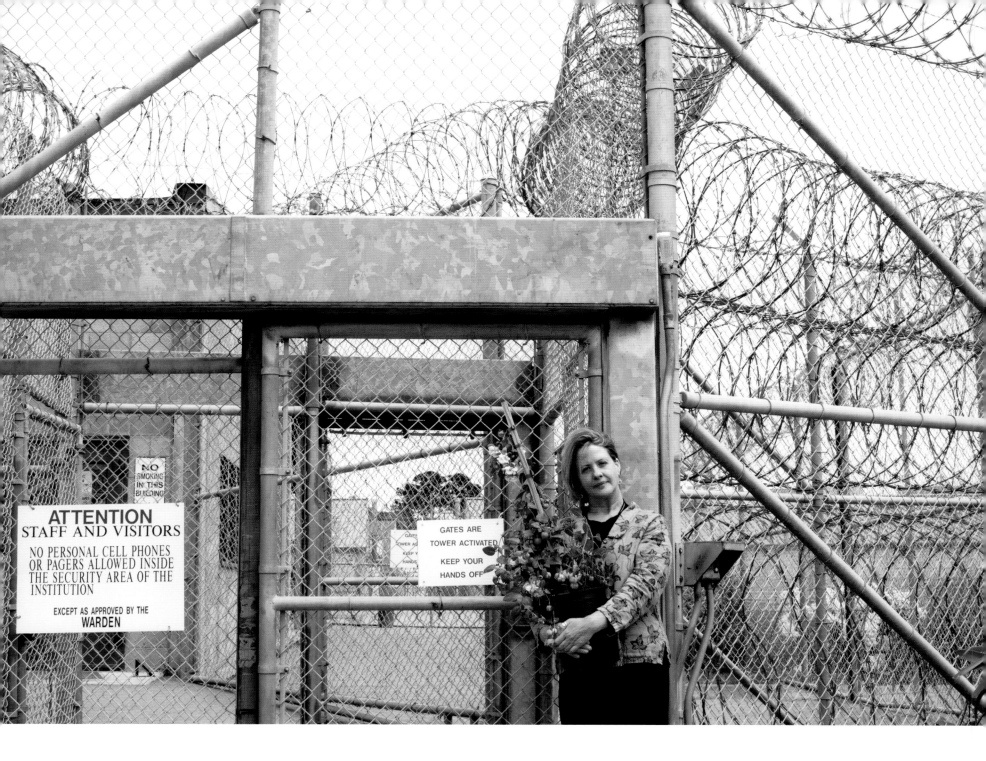

Born March 28, 1961, New York, New York

A lifelong gardener, Beth Waitkus is the director of the Insight Garden Program at California's San Quentin State Prison. She helps prisoners transform their lives through organic gardening to become productive members of society when they leave prison.

Beth Waitkus

The Prison Gardener

My grandmother was my garden influence; she was my flower lady. When I was two, I moved in with her for a couple of years after my parents separated. She was from the Dutch side of my family that settled in New Jersey in the 1600s and kept that heritage alive by planting tulip bulbs in her front yard. As soon as I could walk, I was out digging with her in the garden.

Both my parents remarried wonderful people and my mom and stepdad moved to the foothills of the Berkshires in Connecticut. I spent much of my free time there playing in the woods, blazing my own trails. Nature was my refuge from what was a stressful and busy home and school life.

When I was sixteen, Ralph Nader visited my high school. This was back in the '70s during the oil crisis, and as a consumer advocate, he spoke of the abuses of oil companies. I'd never heard anyone expose the human and environmental consequences of the oil industry. His riveting talk woke me up.

In college, my eyes were opened even further, and I became an activist. Delving into a political science major with a minor in Middle East studies, I was incensed at the lack of balanced dialogue about the Arab-Israeli conflict. When my favorite professor was denied tenure because of his political beliefs, I joined five hundred other students and took over the administration building for more than a week. After graduation, I struggled to figure out how I could make a difference in the world.

Intent on using my political science degree, I moved to Washington, D.C., and worked as a political assistant to former U.S. senator, Jim Abourezk. Having been the only Arab-American in the U.S. Senate, he had pressed for Palestinian self-determination. His ability to speak truth despite enormous opposition taught me to stand up for what I believed in—even if it was unpopular.

My next career was at a management-consulting firm that created social marketing campaigns for the government, where I continued to advance social justice issues. One of our clients was the Department of Labor's Job Corps program for disadvantaged youth. I ran their national outreach efforts. The most meaningful part of the work was being around the students and witnessing their transformation.

During my time at Job Corps, I read the book *The Celestine Prophecy*, which shifted my thinking around ecological consciousness. Nature

had always soothed my soul, but as a society, I felt we had lost that basic and necessary connection. Based on my own childhood experience in nature, a vision evolved of taking inner-city kids into the wilderness.

Then when I was thirty, I took a business trip to San Francisco. While sightseeing in nearby Muir Woods, I was so inspired by the giant redwood trees that I decided to eventually move to the Bay Area. It was seven years before I finally bought a one-way plane ticket, took my leap of faith, and said good-bye to my life on the East Coast.

My next period of transformation occurred after the 9/11 attacks, which pulled the ground right out from under me. With family still in New York City and a friend who died in the World Trade Center, I went into deep shock. Up to that point I had never been particularly religious or spiritual—the natural world served that purpose—but 9/11 made me question everything. I embarked on a journey to rediscover good in the world. I spent time at a meditation center and studied Buddhism. I also went to a career counselor and decided to shift careers to organizational development as a way to facilitate change. As I developed my spiritual practice, I was accepted to Pepperdine University's business school for a master's degree in organizational development.

My career counselor introduced me to Bob Flax, the community partnership manager at San Quentin State Prison. Bob invited me out to the prison to see if I'd be interested in working with him. At a volunteer training session, I met Jacques Verduin, the founder and director of the Insight Prison Project (IPP) that offers meditation, yoga, and restorative justice classes for the inmates. As we toured the prison—one of the most barren, gray, colorless, lifeless places I'd ever experienced—we talked about how therapeutic it would be for them to have some color and plants there. After sharing my love of gardening, Jacques said, "Why don't you build a garden here?"

A month later, we launched the Insight Garden Program (IGP), as one of IPPs program offerings. I began developing a curriculum and redesigning the prison yard with the inmates who had joined our class. We planned to transform the entire yard into a landscaped garden, but when we realized it would cost a quarter of a million dollars (triple the size of IPP's annual budget), we scaled back.

I also started graduate school. Prison and organizational development went hand in hand because there was so much opposition in the beginning to growing the garden. The skills I was learning in school helped me figure out how to manage the resistance and create new openings for change. I had to build relationships with all the key stakeholders, including the prison administration, the officers, other program providers, and inmates and then bring them together at the table. What was significant was including inmates in the decision making process.

The initial worry about building a garden on a prison yard was that weapons could be hidden there (which to this day has never happened). Every tool—especially the sharp ones—would have to be cleared through security. If one was ever lost, the entire prison would be locked down until they found it. However, once the prison staff was on board, they said, "We're not going to worry; we'll just take a metal detector through the garden." But I've never seen them do it.

After a year and a half of planning, we finally built the garden with our men over four days during winter solstice. Starting with a plot of mud in the corner of the yard, we planted seedlings that have now matured into a thriving, organic flower garden.

At IGP, our mission is to reconnect men to themselves, their communities, and the natural environment through organic gardening. The curriculum is partially based on the Buddhist principle that everyone has a heart, and all we need to do is help unfold that capacity for feeling. Since building the garden, we have hosted talks by professional landscapers, gardeners, permaculture experts, and speakers on broader environmental issues, such as climate change, green jobs training, and how healthy food can change lives and communities.

Gardening allows the men to connect to their feelings. By growing plants, we also "grow" people. At the beginning of each class, I ask

the men to describe how they're feeling. One new participant said, "I don't feel anything." A year later, his adjectives started to change. Another inmate, Ronnell, once burst into tears—"Oh, my God! I've never cried before. I can feel my heart." In the garden, often men with no previous connection to nature would start to pet the bumblebees and give the bugs names. For the first time, they had a safe space to feel.

My graduate school thesis focused on the impact of the garden on the social climate and physical environment of the prison yard. Because of the prison's social structure, inmates generally segregate, but a main finding, which I hadn't seen in any other literature, was that the garden was the only part of the yard where the men mixed without fear of retribution. Nature models diversity and cooperation, and that seems to have manifested in their interactions in the garden.

People have often asked me if I'm afraid of the men. The answer is a resounding *NO*. I'm more worried about them cutting themselves with the pruners than their using them as weapons. But as a woman in an all-male prison, I do have to set boundaries. San Quentin has very strict rules about interacting with the prisoners. I must be careful about what I wear and the personal information I divulge. The "no physical contact rule" is the hardest for me because I'm a very warm and tactile person.

The men actually look out for me. Early on in the program, an officer yelled at me for planting a rose bush in the wrong place. When I turned sheet white and was about to burst into tears, ten of the guys encircled me, put their hands on their hearts and said, "Beth, it's time to breathe into your anger." It seems when I treat the men with respect and care, that's what I get back.

Jacques Verduin has often suggested that one of the reasons I've been so successful is that I'm a woman working in a primarily male system. He thinks women have a softer side that taps into everyone's humanity. Sometimes, in our deeper class work, I will shed tears, and the men realize its OK to feel. By nature, I tend to be collaborative and flexible, and those qualities have also helped me handle the system's resistance to change.

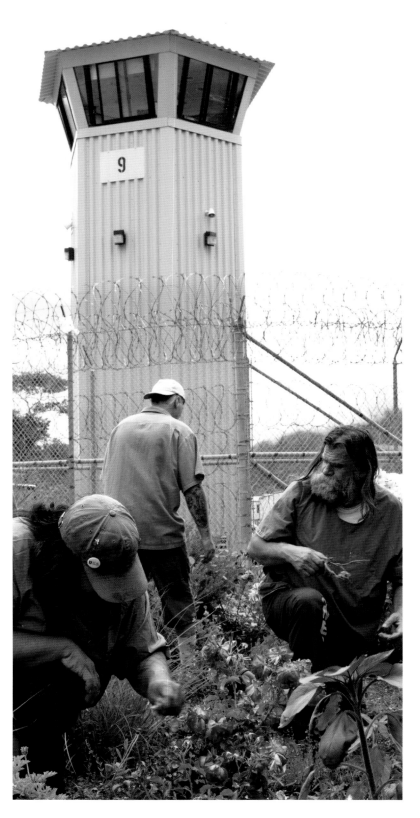

The most challenging aspect of working within a prison system is that it is so retributive and opposed to new ideas in the name of "security." Not everyone believes that prisoners can be rehabilitated. I also think there's much deeper-seated, unconscious fear that if we are successful, we won't need as many prisons and people will lose their jobs. California's recidivism rate is 70 percent, and California taxpayers spend fifty thousand dollars a year to incarcerate an inmate. I run my entire program on less than the cost of keeping one guy in prison.

Three years ago, we wanted to plant a vegetable garden. By growing and harvesting food, the men could learn about healthy nutrition and potentially get jobs in sustainable agriculture when they leave. The first proposal for our vegetable garden included using an old dilapidated greenhouse on the prison grounds that still had raised beds; but with a change of administration, this proposal was shut down because of security issues. Though somewhat despairing, I remembered the Buddhist teaching: with every contraction, there's expansion; with every expansion, there's contraction. We are continuing to work to make this program a reality.

Because everybody's supposed to have equal access to resources in prison, the men won't be able to eat the vegetables, since we won't be able to grow enough for five thousand inmates. Instead, we collectively decided to make it a community service project and give the food to shelters.

Our next goal is to start a re-entry program to help the paroled men find landscaping, gardening, or green jobs. Van Jones, President Obama's former green jobs czar, inspired many of the men when he visited San Quentin and told them that they could be leaders in the green movement. Some of the men decided they wanted to mentor young people about healthy food and cooking as a positive and meaningful way to reintegrate into their communities.

I don't aim to change these men's lives; instead, I facilitate the space so they can be empowered to change their own. One said to me, "I used to dump truck loads of trash on the side of the road. Now that I understand the impact, I'll never do it again." Or the time I ran into an ex-inmate at Whole Foods and I asked him how he could afford shopping there. He responded, "I learned a lot about food when I was in prison, and even though I don't have a lot of money, I try to buy local and organic." It's moments like these that make me realize its all been worthwhile.

Through the garden program, the faith I lost on 9/11 has returned. I have truly experienced the human capacity to change, even in the most difficult of circumstances. All it takes is getting our hands in the earth. That's my faith now.

The Insight Garden Program's (IGP) mission is to rehabilitate prisoners through organic gardening so they learn vocational and life skills to practice constructive relationships between themselves, their communities, and the natural environment. The program is only available to 1,000 inmates on a medium security prison yard at San Quentin. IGP reflects both a spiritual and systems approach to understanding the interconnectedness of all living things. According to research on people-plant relationships and horticultural therapy, the act of caring for plants includes the qualities of responsibility, empathy, and discipline that also transfer to the interpersonal realm. The holistic curriculum tends to both the "inner" and "outer" gardener. "Inner gardener" classes integrate transformational tools such as meditation and emotional process work. In the 1,200-square-foot organic flower garden, men practice "outer gardening," where they learn the basics of landscaping and ecological systems. The program participants also learn about sustainable agriculture, earth literacy, and "green jobs" training so they can be part of the "green" economy when they leave prison.

Born April 28, 1944, Chatham, New Jersey
Pioneering restaurateur and food activist, Alice Waters is a champion of locally grown, seasonal ingredients. Through the Chez Panisse Foundation, Alice develops and supports educational programs that use food to instill the knowledge and values needed to build a humane and sustainable future. Her vision is to integrate a nutritious daily lunch into the academic curriculum of all public schools in the United States.

Alice Waters

The Food Revolutionary

My senses have always driven me. My childhood was spent in the garden. We had a big backyard and during World War II, my parents had planted a Victory Garden with fruit trees and vegetables. My earliest memories are of tasting our own fresh asparagus and strawberries.

My mother, who had grown up in the Depression, impressed on my three sisters and me how fortunate we were to have food—though she wasn't much of a cook. She could make applesauce and rhubarb compote, and that was about it.

In high school, my father's job took my family to Los Angeles, where I discovered boys and parties. When I applied to college, my parents had me choose from the University of California system—it only cost ninety-six dollars a semester then! They hoped I would attend the prestigious Berkeley campus, but I enrolled at Santa Barbara because it seemed more fun. But after one year, two sorority sisters who were tired of the party atmosphere talked me into transferring to Berkeley with them—and I am so glad they did. We arrived in 1964, when the Free Speech Movement was in full swing, and joined the protests. It was a tremendous political awakening for me.

In spite of feeling that history was being made in Berkeley, I had a romantic notion of studying in Paris and enrolled at the Sorbonne my junior year. Never having traveled to Europe before, my senses were awakened by the way people lived their lives. I was struck by how different the experience of eating was in France. Sitting down and having a meal was a ritual—from the way the table was set to the timing of the courses. I was not dining in fancy restaurants, just neighborhood places—but I saw the way the owners took care of their customers and that they all knew each other. I fell in love with the culture, especially the food.

Returning to the United States as a bona fide Francophile, I missed eating those delicious meals, so I started cooking. I watched Julia Child's television show and made every recipe in Elizabeth David's *French Provincial Cooking*. But the ingredients in the grocery stores didn't match up with what I had tasted abroad. Remembering my trips to the French outdoor markets, I began visiting Chinatown in San Francisco seeking fresh produce and meats. I spent all my money on food. I lived in an apartment with two girlfriends and we constantly had dinner parties—always trying to replicate the welcoming atmosphere I had encountered around the table in France.

I dreamt of owning a restaurant, but since I didn't have any money, I took a job as a teaching assistant at the Berkeley Montessori School and then went to London to study at the International Montessori Center. The Montessori philosophy was about educating the senses —touching, tasting, smelling, and opening the pathways to the mind. My training became a frame for the way I thought about food.

My plans to teach were fortuitously derailed when I was introduced to a French couple, Martine and Claude Labro, who had moved to Berkeley. Martine personified the French elegance I already admired, and she hugely influenced my aesthetics. Through the Labros, I met Tom Luddy, the manager for the Telegraph Repertory Cinema in Berkeley, who showed me the Marcel Pagnol film trilogy, *Marius,*

Fanny, and Cesar. I was so moved by the stories of this small group of friends and relatives—all of life took place in a little bar-café— that I became single-minded in my desire to open a restaurant.

The restaurant needed to be a very social, political place—to awaken people, the way I had been in France—with the same warm, intimate feeling of community as Cesar's café, while embodying the Montessori values of the senses. With a ten-thousand-dollar loan from my parents and some friends who came in as partners, we purchased an old craftsman style house in 1971 and turned it into Chez Panisse—named after Honoré Panisse, a character who took care of Fanny in the Pagnol films.

I was committed to serving honest, fresh food. Because it was so difficult to find quality ingredients, we started going out to the local farms. Once I learned how hard it was to produce food the right way, it awoke in me a sense of responsibility. I questioned purveyors about what their animals ate and where they were kept, or how they grew their crops. They thought I was crazy at first—particularly the farmer who provided our lamb! But I was willing to pay whatever the farmers needed to make it worthwhile and invited them to Chez Panisse, and we built friendships on mutual dependence.

Chez Panisse was never about making money, but rather about the quality of the food and providing a sensory experience for the diners. The restaurant didn't turn a profit until ten years after it opened and survived many difficult moments. I often worried about making payroll, and we were never sure what food would arrive on any given day. But I am lucky; I look at beautiful things all day long and work with people I admire—the farmers, artists, and producers. There were times when I was completely exhausted, but I always felt I was being led down a path. I knew the restaurant would work. I just had to get the delicious food into people's mouths, and they would come back.

I had no idea how to manage employees; I just behaved toward them as I would want to be treated. I hired artists and other people that I simply felt a connection with. We were like a family—after the customers would leave, we would drink wine and dance. In the kitchen, we were always experimenting. I would never tell the chefs what to cook, I just tasted. The chefs were paid for five days, but only worked three so they wouldn't burn out and could visit the farmer's market on an off day to gather inspiration and explore the seasonal produce. As we grew, I gave my long-time employees shares in Chez Panisse, so now I only own about an eighth of the restaurant.

While Chez Panisse had become my family, I still wanted my own. In 1982, I met Stephen Singer, an artist who knew everything about wine, and we had a daughter named Fanny. Fanny changed me. I became acutely aware of her future and the world she would grow up in. I could no longer live on my little idealistic island with my restaurant, my thirty farmers, and the people who came to eat at Chez Panisse. The politics of food became more urgent. What somebody did upstream affected what was happening at the farm, and I made the connection between fresh food and a healthy planet. My philosophy around the restaurant had always been to connect people with the sources of their food and its seasonality—but after I had Fanny, I began to look to have a greater impact.

I have always believed education is the best way to reach people; you can open up children's minds when they're little, and teach them that we need to live on this planet together. But there is a breakdown in our culture. Today, families rarely eat together, and information and values are no longer being passed on to our kids around the table. So I wanted to take the Montessori teaching model and connect it to food. My vision was to create a school lunch program where the kids would grow and harvest food and then learn how to prepare it and serve it to their schoolmates. It's not a new idea; I have a book from 1909 that describes how gardens in schools teach children about cooperation and responsibility.

On my daily commutes to Chez Panisse, I would drive past the Martin Luther King Jr. Middle School, a depressing, run-down place. When I finally went inside, I saw that the cafeteria didn't even have a kitchen—just a microwave. After I complained about the state of the school in a local newspaper article, I received a note from the principal asking for help. He liked my idea of planting a garden, but was overwhelmed by my vision of developing an integrated food-based curriculum, which I called the Edible Schoolyard. Math classes could measure the garden beds, science classes could study drainage and soil erosion, and English classes could write recipes. After many long lunches at Chez Panisse with the principal, teachers, and parents, the asphalt was ripped up, and in 1995 we planted a one-acre garden and refurbished a kitchen classroom.

We're not trying to tell kids what to do—rather, we're trying to bring children into an experience of food where they can have a choice. It's just showing them: these are almonds; these are walnuts;

these are pistachios. This is what they look like inside. This is what they taste like. And which one do you like best? Once the children experience this, they have the ability to make conscious, informed decisions about food.

A year after the groundbreaking, I created the Chez Panisse Foundation to fund the Edible Schoolyard and to develop other models around the country. I was still determined to develop a free school lunch program with healthy food. In 2005, the foundation partnered with the Berkeley Unified School District and brought on Ann Cooper (the Renegade Lunch Lady) as the director of nutrition services for the district. Within three years, we eliminated nearly all processed foods and introduced local and organic ingredients to the lunch menu for the sixteen schools.

Providing healthy food on current public school food budgets is practically impossible. The government pays $2.88 for every meal the schools serve. When payroll and overhead are factored in, there is only about eighty cents left for food. The Berkeley Unified School District now spends about $4.85 on each lunch and uses its general fund to make up the difference.

But I wasn't willing to stop with the Berkeley schools. The year we planted the Edible Schoolyard, I wrote my first letter to the Clintons to present my ideas on sustainability and nourishment. And I never let up. My fantasy was that President Clinton would come to my restaurant, where I would feed him a perfect peach, and he would reevaluate his relationship with food. While peaches were out of season for the president's first dinner at Chez Panisse, we talked about growing a vegetable garden at the White House to set an example of healthy eating. I could never persuade him, but I continued to feed him my ideas about the Edible Schoolyard, and by the end of his second term, President Clinton was becoming more and more supportive of better nutrition and gardens in schools.

I was trying to open the biggest doors and find the most eloquent orators to carry the message about the relationship of food to culture, agriculture, and health. In Carlo Petrini and his Slow Food Movement, I found a kindred spirit. We both sought to bring people to these political ideas of supporting communities and the environment through the pleasure of eating.

The Slow Food Movement was a way to bring these values to a global level. While having a huge membership in Europe, it hadn't yet hit the United States. After Carlos visited the Edible Schoolyard, he agreed that Slow Food should promote school gardens, and we opened a national office in New York. In 2008, over fifty thousand people attended our first Slow Food Nation event in San Francisco.

I believe we can solve so many of the problems we are facing by considering how we nourish ourselves. My hope is that our government makes education in ecology and gastronomy a priority for this country. By learning through the senses, people will choose the sustainable way. It's simply more delicious.

In 2003, the Centers for Disease Control declared obesity the most important public health issue in the United States. It's estimated that one in five children in the U.S. is overweight. While 30.6 million students eat school lunches, only 6% of school lunch programs meet the requirements established by the U.S. Department of Agriculture. The USDA also supplies schools with the same commodity foods as prisons.

A 2010 study of middle school students found children who ate school lunches compared to those who brought lunch from home:

- Were more likely to be overweight or obese (38.2% vs. 24.7%)
- Were more likely to eat two or more servings of fatty meats like fried chicken or hot dogs daily (6.2% vs. 1.6%)
- Were more likely to have two or more sugary drinks a day (19% vs. 6.8%)
- Were less likely to eat at least two servings of fruits a day (32.6% vs. 49.4%)
- Were less likely to eat at least two servings of vegetables a day (39.9% vs. 50.3%)
- Had higher levels of LDL "bad" cholesterol.

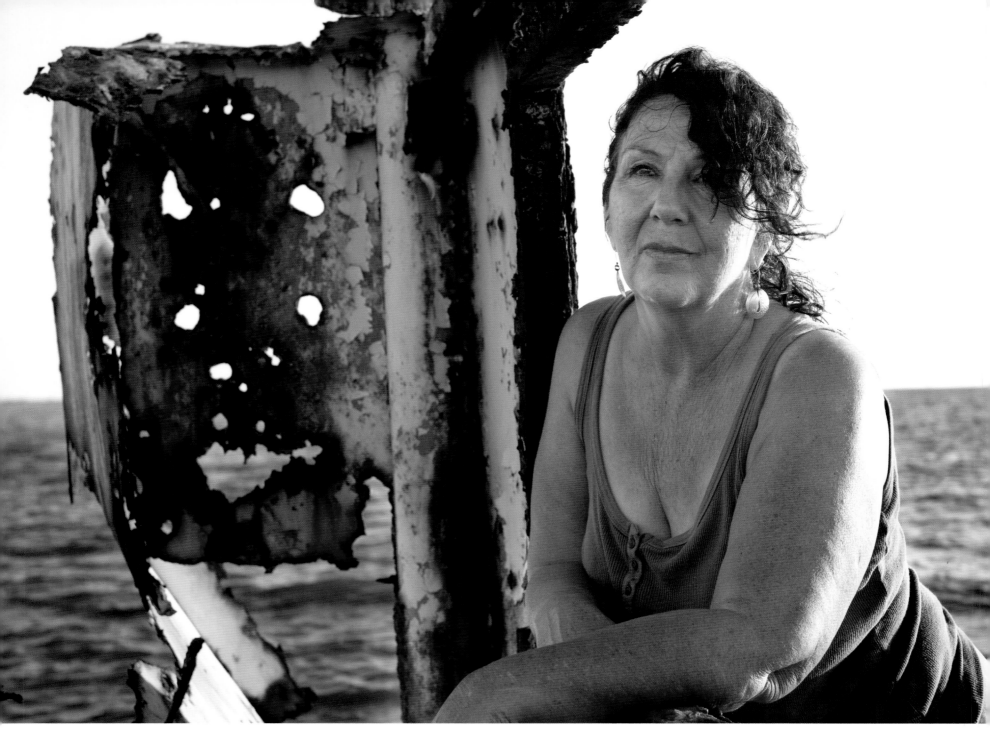

Born October 17, 1948, Seadrift, Texas

A fourth-generation fisherwoman and a mother of five, Diane Wilson waged a campaign to stop toxic pollution from chemical and plastics manufacturers on the Texas Gulf Coast and wrote the book, *An Unreasonable Woman: A True Story of Shrimpers, Politicos, Polluters, and the Fight for Seadrift, Texas*, about her experience. She helped found CODEPINK: Women for Peace and continues to lead the fight for environmental justice.

Diane Wilson

An Unreasonable Woman

I have always been something of a mystic. At five years old, I knew the physical world was not the answer.

As a child, the bay appeared to me as an old woman with flowing gray hair and a long dress that merged with the water. She had a strong-grandmother personality. I called her the Water Lady. Once I started going to school, I stopped seeing her. They just drum that right out of you. When we're young, we can sense the aliveness of everything. But then you find out that it is not appreciated and your parents say you did not see it, so you learn quickly to not talk about it, not to believe it.

I was a strange, quiet kid. For a long time I didn't talk at all. Even now, speaking is physically hard. I had three sisters and three brothers. I was the middle one, the one that falls through the woodwork. We grew up in a Holy Roller family. Since I was so subdued, they thought I'd make a good missionary. That scared the fool out of me.

Shrimping is my blood. My dad, my uncles, my grandfather were all shrimpers. Struggling as a family fisherman, my dad raised all of us kids to be deckhands. When he would come in at three in the morning to wake us, I was always ready to go. I knew how to handle the wheel and I was a hard worker. I never cried, never complained.

Once in a blue moon I saw other women shrimpers. The clincher was that I had a knack for patching and building nets. If you're good with nets, the other shrimpers don't question you.

By the time I had my own boat, algae blooms had started to cover the whole bay. The first was velvety brown, then a green kind the consistency of pea soup, and after that the red one with fumes that made me sick. All the creatures started dying. I'd see something that looked like a blanket on the water and it was a three-hundred-pound dolphin disintegrating; they were all over the place. Birds and fish were floating up, too, and the buzzards were thick in the sky.

When the shrimping got real bad, I worked at my brother's fish house. The fin fisherman would bring me fish from the rivers they'd find at the surface going round in circles. The alligators were doing the same thing. I tried to get biologists to test the fish, and they'd always say, "Freeze 'em." They never came.

When times were hard, the only way some fisherman could survive was if they took a job as a truck driver or pipe fitter for one of the many chemical companies in the area. They always had wild stories. One guy told me, "Diane, last night we dumped a big barrel in the creek, and you should have seen the emissions." But it was never on the news.

Then I had a dream about my life. I was standing at an intersection and in the background there were nasty black pipes. My face had a strange knowing look. I understood the dream signified a crossroads for me, but at the time I didn't know they were chemical pipes.

About a week later, a shrimper with three different types of cancer handed me an article about the first-ever report of the Toxics Release Inventory. It blew my mind. Calhoun County had a population of fifteen thousand people at the most. The only thing the county ever claimed for fame was that Bonnie and Clyde came down there and hid out awhile. And yet here we were, number one in the nation for toxins, with my county producing 50 percent of Texas' entire waste, thanks to our very own Alcoa plant.

Alcoa also gave us a mercury Superfund site. In their own documentation, it said they lost one million two hundred thousand pounds of mercury in the bay. It was from the chloralkali process, which is how they make chlorine. The workers had it in their hair and on their skin, and were taking it home, washing their clothes, so it was getting on everything else. But nobody knew about it. When I found out, it really hit home. My son is autistic, and there's a clear link between mercury and autism: for every thousand pounds of mercury in the air, the autism rate rises 17 percent.

I believe that everybody has a destiny. At some point in your life, you're going to get a piece of information and what you do with it will determine the rest of your life. That article was mine. My normal response would have been to go on being my quiet, little self, working on the boat and being with my kids, but I did something totally out of character.

Fate must have led me to call Jim Blackburn, an environmental lawyer who had represented shrimpers. He told me to call a meeting. As soon as I set a location, I started getting harassed. Then a letter arrived in the mail. In it was a public notice about Formosa Plastics with a note on top, which read: *Are you aware of this?* I didn't understand what the notice meant; but later Blackburn explained to me that Formosa, one of the biggest violators of the Clean Water Act, was planning to expand its plant in Calhoun County to make it the largest PVC producer in the country.

At the time, I didn't know anything about politics or even what the EPA [the U.S. Environmental Protection Agency] was. I found out real fast that the regulatory process doesn't work when politicians are in bed with corporations. The state gave Formosa two hundred fifty million dollars in tax breaks and incentives and one hundred million was promised to our little school district. The EPA wasn't even going to require Formosa to do an environmental impact statement for the expansion, even though it had caught the company years before with very high levels of ethylene dichloride and vinyl chloride in their storm-water basin—the kind of stuff that can cause spontaneous abortions, internal hemorrhaging, and cancer.

I started talking with the Formosa workers, who told me about unreported releases and about their health problems. They spoke of breached toxic basins that bled across fields, killing everything and contaminating the ground water, and of vinyl chloride leaks that were so constant, they'd turn the alarms off so the workers could get some peace. Many of the workers had neurological damage and cognitive impairment, and there had been several deaths from brain cancer. Formosa had brought in a doctor who told them there was no link between vinyl chloride and cancer, and if they complained they got fired.

As a woman, I do think I have a different approach than men. The workers opened up to me because I tried to help them with their illnesses. When we had meetings or I'd go to demonstrations, I would bring my kids and it would really change the dynamic. I come at things intuitively; men are much more linear in their thinking.

When we needed unions, the male leadership took a practical outlook. They considered the money and decided they weren't going to win, so they didn't even try. On the other hand, I'll jump right in and have no idea how I'm going to do it, but I trust.

When I heard that the EPA was going to exempt Formosa from doing the environmental impact statement, the idea for my first hunger strike just popped in my head. I know enough about human nature to know that if you wait too long with a thought like that your rational brain will kill it. Especially if you talk to anybody, "Oh no, we don't do that in Texas." We ram our truck into something or we'll get a gun and blast out some windows, but not hunger strikes. So I put it in action fast. On the twenty-ninth day of my strike, Wang Yung-ching, Formosa's chairman, showed up in my lawyer's office to negotiate.

I made death an ally. Embracing death is extremely liberating. Maybe my lack of fear comes from being a fisherman. I've been out many times when a blue blaze northern blowing about sixty/seventy miles an hour came through. One of the scariest times for me was when my shrimp boat was sabotaged and it started sinking. I got real panicky because I can't swim and I had to get to my engine

that was down below in the water. But I wasn't ready to die, so I plunged in.

My biggest worry was that they would hurt the kids. My house was shot at from a helicopter, and they killed my dog. But I realized the more I was in the public eye the safer I was, because if anything ever happened, I could immediately point the finger. And if I found out one thing, it's that those companies do not want bad press.

I've had dark moments when everybody was so angry about what I was doing. My brother, who was on the school board, ended up firing me from the fish house because he thought the place was going to get fire bombed. Then he took a job at Formosa. And one of my cousins got bought-off and was paid sixty thousand dollars to follow me around. But I never worried over what people thought. I am directed by an internal voice and have to live with integrity.

The rug was really pulled out from under me when my lawyer decided to make his own deal with Formosa. We had a huge lawsuit going on and Blackburn wanted to quit. I had been fighting Formosa intensely for six years; I was so tired but I couldn't give up. So what do you do when you can't stop and you can't go? I decided to kill myself Marilyn Monroe style. I went to the grocery story, got a cheap bottle of Boone's Farm and two big packs of sleeping pills. I was totally at peace. Whatever my kids asked for that day, I gave them; we went to the mall, had hamburgers, and rode the carousel. Then I took my boat out in the middle of the bay and downed the pills. I laid out on the stern of the boat right on the edge so I could just roll off into the bay. I couldn't imagine a better death, except I couldn't go to sleep. While I had my eyes closed, I saw a huge white light and heard people talking. When the light slowly faded away, I understood that I wasn't going to die that night. I got up and started all over again.

The final straw was when I called to check in with the EPA's lawyer. When she got on the phone I said, "Hi, this is Diane." She started talking about Formosa's ongoing discharge into the bay until I stopped her, "You're talking to the wrong Diane." Diana

Dutton was Formosa's newest lawyer and it meant that they were discharging without a permit and the EPA knew it. I discovered the meaning of outrage.

The most outrageous thing I could think was to sink my boat right on top of their discharge. People who don't understand a hunger strike or sinking a boat don't get the big picture. For a farmer, it's burning your farm. My boat is nowhere near the value of the bay, but it was all I had, it was my livelihood. I was arrested as an eco-terrorist, but eventually Formosa agreed to zero-discharge of its wastewater.

All you need is a cause that will take you down to the pits, and I guarantee you that it will. I lost my boat, my marriage, my house, my job, but I never liked myself so well. I have never felt so happy, so rich, or so free. My values about the meaning of life have gone through the roof. I was raised Pentecostal, Holy Roller, devils, snakes, the whole bit, so I don't even like to use God or Jesus because they're so contaminated, but there's an energy that I personify. It's my mysticism that has given me strength, and I feel like I've come out way ahead.

Two of the largest corporate polluters of the Texas Gulf Coast are Alcoa, the world's leading producer of aluminum, and Formosa Plastics. In the 1970s, Alcoa dumped over 67 lbs of mercury a day into Lavaca Bay, turning the area into a Superfund site. The plant also uses bauxite, which is converted through a toxic process to alumina, the raw material for making aluminum. For every ton of alumina produced, three tons of waste product known as "red sludge" is given off that can poison water supplies and kill vegetation. Formosa produces polyvinyl chloride (PVC), the most environmentally harmful plastic. It can be found in building materials, medical devices and everyday products. In the production of PVC, highly polluting chlorine and cancer-causing vinyl chloride monomer are used causing dioxin, one of the most toxic chemicals, to be released into the air. In 1991, the EPA fined Formosa a record $3.7 million after the discovery of massively contaminated groundwater under its facility. In 2009, the U.S. Department of Justice reached a $13 million agreement with Formosa for "extensive" violations. Since then, EPA investigators have continued to find Clear Air Act violations at its plants.

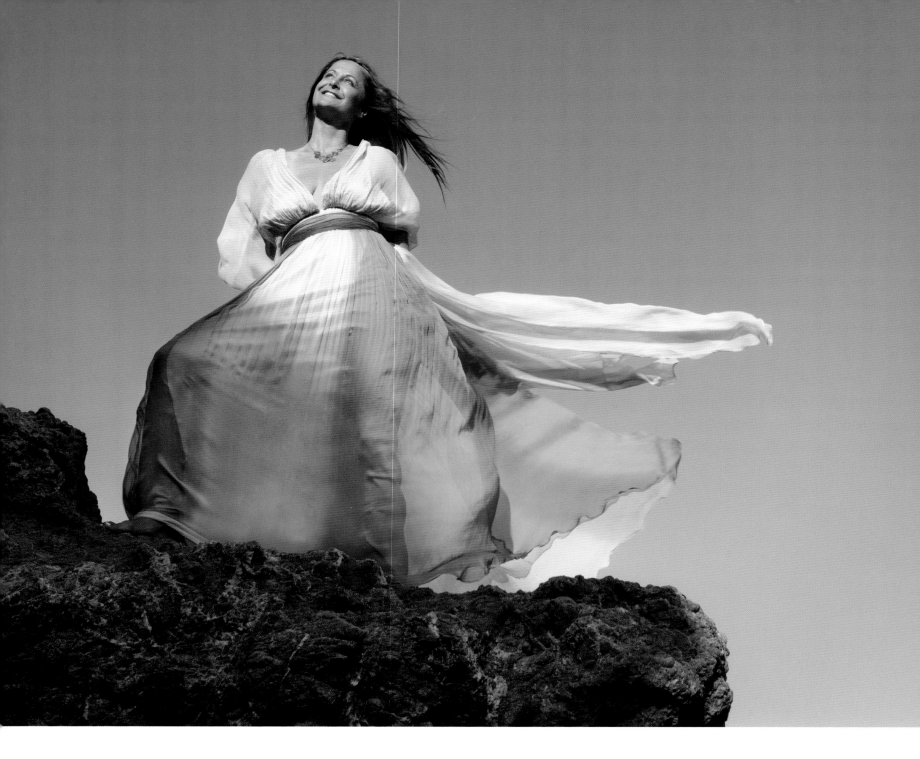

Born December 13, 1967, Philadelphia, Pennsylvania

A pioneer in sustainable textiles, clothing, and home products, Marci Zaroff is a leader in the eco-fashion movement. In 1996, she founded Under the Canopy, one of the earliest organic apparel companies, and in 2011 launched FASE, a cutting-edge sustainable lifestyle brand. Marci was a key driver in the creation of the Global Organic Textile Standard and of the first fair trade textile certification program in the United States, which both require compliance with environmental and socially responsible principles.

Marci Zaroff

The Eco-Fashion Innovator

Nature fuels me. Growing up, I was always outside. When I was twelve years old, my dad moved his dental practice from Philadelphia to Florida so he could fish and boat twelve months a year instead of three. Now I can't imagine living away from water—as long as it's eighty-five degrees! We all come from the ocean and there's something about reconnecting to that birthplace that continues to regenerate me.

My mom was very progressive for her time. She studied computer science when computers were the size of an apartment and then worked for NASA. Like many women of her generation, she gave up her career to raise children, but she constantly encouraged me to manifest my ideas, both in business and as an artist. My first moneymaking effort besides my lemonade stands was a calligraphy business.

When I was fifteen, I met Patricia Kilpatrick (who now goes by "Surya"), in a shopping mall. I believe people come into your life for a reason and there are no coincidences. Walking up to me, she said, "You have a special energy," and we became lifelong friends. She cooked macrobiotic meals that made me feel so good that I embraced the philosophy. She also gave me the book *Living in the Light: A Guide to Personal and Planetary Transformation* by

Shakti Gawain and turned me on to Aveda when it only had one product, both of which significantly influenced my life path.

After going on a college campus tour, I chose the University of California, Berkeley, experiencing there the enlightened atmosphere I longed for. Like my mom, I entered as a computer science major but then applied to the Haas School of Business. Intuitively, I knew that business could be used as a vehicle for driving awareness and transformation, and before the term was coined, I had a vision of creating a triple bottom line company: ethically profitable, environmentally sustainable, and socially responsible. Having been exposed to the health and wellness movements through Surya, I saw an opportunity to merge my passion for business with my love of a conscious lifestyle.

Seeking finance experience, I took the exams to sell securities, and while in college, I was an investment banker at a brokerage firm in San Francisco. I worked New York stock market hours and attended university classes in the afternoon. While my friends couldn't afford pizza, I was making six figures. The experience was invaluable in terms of learning how to manage money, as well as having the opportunity to study the business models of many of the young NASDAQ companies I was trading.

Already inspired by Aveda founder Horst Rechelbacher's pioneering use of healthy and natural ingredients in his hair and body products, I was not surprised when we connected at an environmental conference while I was in college. We've been immersed in each other's lives ever since. We share a similar passion for the planet, plus an intrinsic attention to details and aesthetics, and he is someone who really walks his talk. He empowered me to surround myself with the best people to support my vision, but most importantly to trust my gut and stay true to my path.

I moved to New York to pursue my vision of creating a health and wellness center and to be with my former husband, who worked in my firm's Manhattan office. The inspiration for the center came from the book *Gulliver's Travels*, and the idea was to take people on a "journey to the land of health and self realization."

In a macrobiotic restaurant in New York City, I met my third great mentor who helped me with my business, the artist Peter Max. I had been a fan of his since I was a teenager. He invited me to join him for lunch, where I shared my vision for the center. Peter showed me how to harness the power of creative marketing and storytelling, as he was a genius at promoting his art and expressing his passion for people, the environment, and global consciousness.

Fusing business and community was key for me. Once the center was up and running, we brought in thought leaders for lectures and workshops in everything from shiatsu and yoga, to natural foods cooking, and Eastern philosophy. The school also had a macrobiotic café, a store with products that embodied the lifestyle, and thanks to Horst, one of the first Aveda concept salons in the country. Offering a world-leading holistic health certification program, the

school is now called "The Institute for Integrative Nutrition," and it's still thriving today.

Having developed a natural, whole-food curriculum, I had studied organic agriculture and learned about conventional farming's impact on the environment. Spraying pesticides on plants has the same effect as giving humans antibiotics. It works as a quick fix, but over time both parasites and bacteria build resistance and need stronger doses. And pesticides don't just kill bugs; they also destroy the soil's entire ecosystem.

I began to see the interconnection between food and fiber. Feed for dairy cows, for example, contains a high percentage of cottonseed, so to make organic milk, you need organic cotton. Plus, 60 percent of a cotton plant enters our food stream as cooking oil for breads and snacks. Conventional cotton is one of the leading causes of air and water pollution. It represents less than 3 percent of the world's agriculture, yet 20 percent of the most harmful insecticides are used to produce it.

As part of the curriculum, I was consulting on nutrition and teaching cooking classes. The assistant of a Saudi princess called one day and said that the princess had been unsuccessfully trying to get pregnant and had heard that changing her diet might help. As we changed her eating habits, she did get pregnant. After that success, her sisters and cousins sought my advice for various health reasons. Sometimes I'd go shopping with them and one asked, "What about organic and natural clothing?" and a light went off in my head. I realized there was a missing link in the wellness equation.

People came to the center because they were looking at food as a way to help heal their cancer or other illnesses, but the conditions that caused them to get sick still existed. The textile industry was a major culprit of pumping enormous amounts of chemicals into the environment through toxic runoff in our waterways, noxious fabric sprays in the air, and all the fuel that's burned to create synthetics.

With the extraordinary impact to human health, the environment, and future generations, and understanding that the issue was bigger than what we put in our bodies, I left the center to start an organic apparel and home fashion lifestyle brand. The premise of the company, which I named Under the Canopy, was that we all live "under the canopy" of the planet's ecosystem. Through stylish clothing and home textiles, I wanted to tell the story of the connection between the cotton farmers who were being poisoned by the pesticides, the factory workers who were getting sick from the fumes, and the consumers who were buying the products, and to offer an alternative.

To bring the worlds of ecology and fashion together, I coined the term "eco-fashion." People thought I was insane and told me, "Marci, that's a paradox." The environmentalists were prejudiced against the fashion industry because of the toxins and materialism; and the fashion designers didn't want to compromise their style by using organic or "eco-friendly" fabrics.

As organic clothing at the time was crunchy, frumpy, baggy, boring, and beige, I recognized I had to focus on style, quality, color, and fit. With few options in organic and sustainable textiles, I partnered with the Rodale Institute and nonprofits in India to help convert farmers and factories from conventional to organic cotton, and designed my own fabrics. Having limited resources, I would make one or two of an item of clothing and wear one. My test market was the princesses, since they shopped at all of the high-end department stores.

Under the Canopy began as a grassroots mail-order company. Separating from my husband in 2001, I moved back to Florida and operated the company out of my house. My sister and sister-in-laws were the catalog models. While I was raising two kids, I grew the company organically to where we were mailing over a million catalogs a year.

My greatest challenge at the beginning was raising capital. I had a great proof of concept and a thriving business, but the men I pitched didn't understand the connection between the environment and why women bought my fashion. Ninety percent of consumers

making the decisions for the household are women, and I spoke their language. Women are more emotionally driven; they like to feel good about what they're buying. Under the Canopy allowed women to not have to compromise—to do the right thing while not giving up being stylish—and through our baby and home lines, they could also have a positive influence on their families.

There's prejudice against women in business, not only with financing but also on not being at home with the kids. Society can make you feel like you're less of a mom if you're running your own business, but I believe there's no greater gift for your child than being a happy mom doing what she loves. When you're an entrepreneur, it's not just a job, it's your life; and finding a balance with being a parent is not easy. It's true, I'm not always waiting for the school bus at the end of the day, but I come home with a world of ideas and inspiration. I'm offering my children tools for life through my business, and they live the lifestyle. They're healthy, green, organic kids that almost never get sick. And they motivate me. As a parent, I believe I have a responsibility to leave the world at least as good, if not better, than it is now.

The greatest challenge I face in my work today relates to credibility and authenticity. *Sustainability*, *eco*, and *green* are still perceived as buzzwords used to sell a product versus actually adding value and standing for something. In the global textile world, people who buy cotton that is supposedly organic but isn't certified, compromise the whole industry. Because of this, I'm a diehard in terms of regulation and compliance standards. I was on the team that helped write the organic fiber standards for the United States and worked on the Global Organic Textile Standard, which is an international collaboration that includes ecological and social criteria and is backed up by independent certification along the entire supply chain.

I'm embracing a third platform because sustainability is not just about the environment or health issues, it's also about community: the local to the global. This is a story of us sharing the responsibility for the planet's well-being and all its inhabitants. My new brand, FASE, which stands for Fashion, Art, Soul, and Earth, allows

for all of the elements to come together, creating a "fase-to-fase" connection. *Fashion* always comes first, there's no compromise on style or quality. *Art* becomes one of the vehicles for inspiration and experience. At FASE stores, local artists will show their products and lead art salons. *Soul* stands for FASE's commitment to fair trade and to creating community. We'll develop educational campaigns and opportunities for local-to-global engagement. And *Earth* is about being responsible to the planet by using sustainable production methods.

My goal is for organic, fair trade, and sustainable fashion and textiles to move from a niche concept to the mainstream. Textile companies, retailers, and apparel manufacturers are starting to think differently about the way they're buying, producing, and developing products. My personal calling is to continue to drive that progress by being at the forefront of new ideas and innovations and to serve as an industry educator and spokesperson. I feel very optimistic that we're moving in the right direction.

The textile industry is one of the largest polluters on the planet. Almost 20% of industrial water pollution comes from the treatment and dyeing of fabrics. Seventy-two toxic chemicals used in the dyeing process are found in water and 30 of them cannot be removed. The manufacture of polyester and other synthetic fabrics is an energy-intensive process requiring large amounts of crude oil and releases toxic emissions and acid gases. The EPA considers many textile factories to be hazardous waste generators. Environmental health problems occur not only with synthetic fabrics. Cotton is considered the world's "dirtiest" crop, due to its heavy use of insecticides, the most hazardous pesticide. Cotton covers 2.5% of the world's cultivated land, yet uses 16% of all insecticides, more than any other major crop. In the United States, the largest exporter of cotton in the world, it accounts for a quarter of all pesticides used. While In 2010, sales of organic cotton fiber grew by 20% from 2009; organic cotton represents only 0.76% of worldwide cotton production.

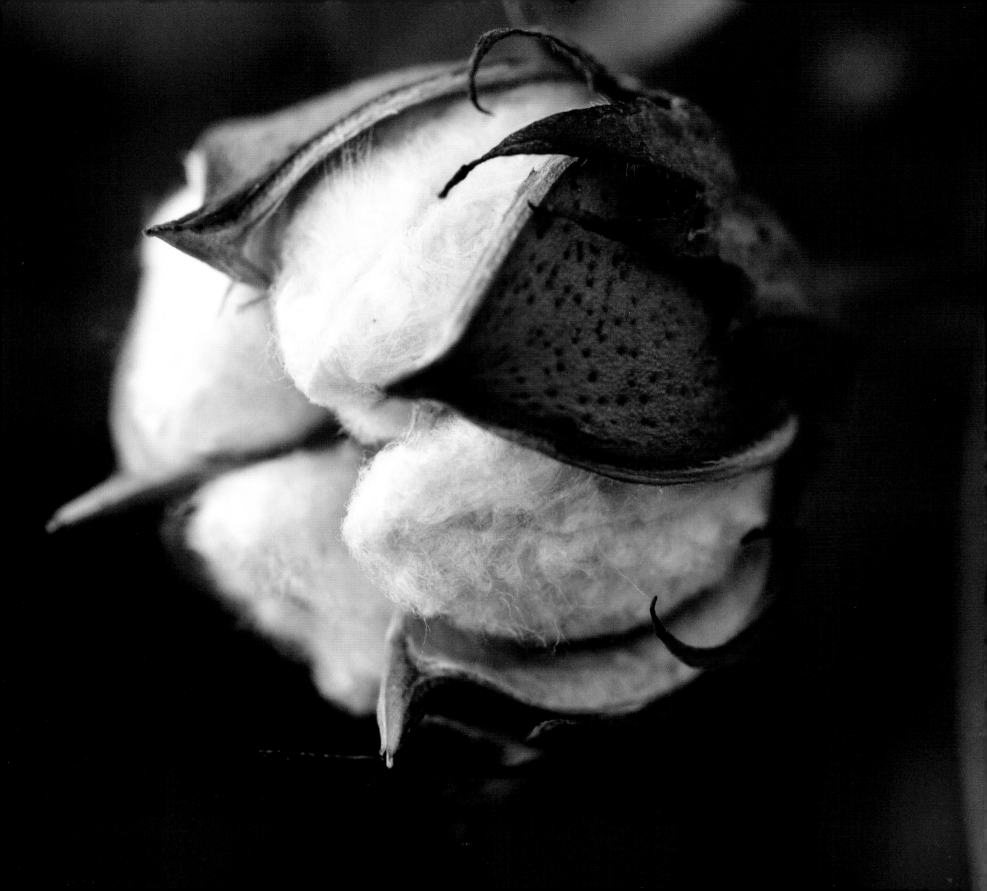

Plates

Frances Beinecke: Defender of the Earth

16. Frances Beinecke kayaking on the Hudson River, New York, New York

18. Family of polar bears, Arctic Circle, Alaska

The polar bear was listed as a threatened species under the Endangered Species Act in 2008. Global warming is considered the most significant threat to the polar bear, primarily because the melting of its sea ice habitat reduces its ability to find sufficient food.

21. Glacier, Antarctica

Ninety-nine percent of glaciers are retreating. Glaciers deflect almost 80 percent of the heat from the sun, so when they disappear, the exposed earth absorbs that heat, increasing global temperatures. Disappearing glaciers cause freshwater shortages, flooding, and a rise in sea levels, as well as habitat loss for humans and animals.

Janine Benyus: Inspired by Nature

22. Janine Benyus observing carpenter ants in the woods behind her home, Stevensville, Montana

24. Toucan beak detail

"The structure of the toucan beak teaches principles of composite material design for lightweight strength and stiffness. Despite its large size (a third of the length of the bird) and considerable strength, the toucan beak comprises only one-twentieth of the bird's mass. Toucan beaks are built lightweight and strong, thanks to a rigid foamy inside and layers of fibrous keratin tile outside. There is a synergistic effect of the shell layer and interior elements that together gives it greater strength than the sum of the strengths of those individual parts." —Asknature.org

27. Butterfly wing detail

"The wings of butterflies and many other large-winged insects remain dirt-free, an obvious advantage for effective flight, and they do so without using chemical detergents or expending energy. This is accomplished by the interaction between the multiscale micro- and nano-topography on their wing surfaces and the physical properties of water molecules. Micro- and nano- surface finishes inspired by the wings have now been applied to paints, glass, textiles, and more, reducing the need for toxic chemistries and costly labor." —Asknature.org

Sally Bingham: Faith and Ecology

28. The Reverend Sally Bingham in Grace Cathedral, San Francisco, California

31. Solar panels at Protection of the Holy Virgin/St. Seraphim of Sarov Church, Santa Rosa, California

33. Solar panels on Bethel Lutheran Church and School, Cupertino, California

Judy Bonds: Tending the Appalachian Commons

34. Judy Bonds at her office in Boone County, West Virginia

37. Mountaintop removal mining, Boone County, West Virginia

38. Abandoned town, the result of toxic coal mining practices, Mayford, West Virginia

Majora Carter: Greening Cities and Jobs

40. Majora Carter in Hunts Point Riverside Park, South Bronx, New York

The park, on the site of the dump she discovered, will eventually connect to an eight-mile greenway that will run along the Bronx River from Westchester to New York City.

43. A Hunters Point Family participant watering trees to be planted by Friends of the Urban Forest (FUF), San Francisco, California

Located in the primarily African-American Bayview community, youth are provided with training and employment opportunities by working at an urban organic farm. FUF's youth program trains young people from underserved communities in planting and tree care.

45. Organic rooftop farm, Brooklyn, New York

Farms like this provide produce to local restaurants and farmers markets.

Vivian Chang: Race, Place, and Justice

46. Vivian Chang with her children near her home, Oakland, California

49. Three generations of a Laotian family farming in their backyard next to the Chevron Richmond Refinery and the United Heckathorn Superfund site

From 1947 through 1966, several companies used the site to formulate, package, and ship pesticides. Although actions were taken to reduce the risk, the site is still contaminated with pesticides, primarily DDT and dieldrin. Levels are high enough to pose a threat to wildlife, and to people who subsistence fish and farm in the area.

50. Chevron Richmond Refinery, Richmond, California

In April 2010, the California State Court of Appeals ruled against the expansion of Chevron's Richmond Refinery, citing violations of state environmental laws. Richmond residents have long suffered increased rates of ailments such as asthma, other respiratory diseases, and cancer that have been linked to exposure to chemicals commonly emitted by refineries. In 2009 the State of California released figures that showed Chevron's Richmond Refinery was the single largest industrial emitter of greenhouse gases in the state.

Theo Colborn: Saving Our Future

52. Dr. Theo Colborn on the North Fork River near her home in Paonia, Colorado

54. Pregnancy ultrasound photo of fetus, used to detect abnormalities

57. Dead fish, Salton Sea, California

The Salton Sea has been the site of an unprecedented series of die-offs of fish and water birds. This has been associated with critical combinations of high temperature and salinity, low oxygen tension, and toxic algal blooms. The combined effects of increasing wastewater inflows from the New River and agricultural runoff have resulted in elevated bacterial levels, which are also believed to be a cause of death of the birds and fish.

Agnes Denes: Restoring the Land through Art

58. Agnes Denes in her studio in SoHo, New York, New York

61. *Wheatfield—A Confrontation*, Battery Park Landfill, Downtown Manhattan, with Statue of Liberty across the Hudson, (detail) 1982
Two acres of wheat planted and harvested by the artist on a landfill in Manhattan's financial district, a block from Wall Street and the World Trade Center, summer, 1982. Commission of the Public Art Fund, NYC. Photo: © Agnes Denes

63. *Wheatfield—A Confrontation*, Battery Park Landfill, Downtown Manhattan, green wheat, (detail) 1982
Commission of the Public Art Fund, New York City. Photo: © Agnes Denes

Sylvia Earle: Protecting the Blue Heart of the Planet
64. Sylvia Earle in a submersible at DOER Marine, Oakland, California

66. Jellyfish, Monterey, California
They are found in every ocean, from the surface to the deep sea.

69. Dragon horse, Long Beach, California
Sea horses are mainly found in shallow waters throughout the world in sea grass beds, coral reefs, or mangroves.

Kathryn Gilje: From Farm Workers to Pesticides
70. Kathryn Gilje milking a goat at Slide Ranch in Muir Beach, California

73. Farm workers at Swanton Berry Farm, Davenport, California
The first organic farm in the United States to sign a contract with the United Farm Workers of America AFL-CIO and to carry the union label.

74. Farm worker, Coastways Farm Ranch, Santa Cruz, California

Lois Gibbs: The Activist Housewife
76. Lois Gibbs near her office in Falls Church, Virginia

78. Abandoned church seen through the window of a condemned house, Picher, Oklahoma The city was considered to be too toxic to be habitable. By July, 2009, all of the residents had been given federal checks to enable them to relocate.

81. Mine waste, Picher, Oklahoma
Mining in Picher, Oklahoma, ceased in 1967, leaving 70 million tons of mine tailings and 36 million tons of mill sand and sludge that have formed lead contaminated mountains, some as high as 100 feet, that look like sand dunes.

Sarah James: Protector of the Caribou
82. Sarah James cooking dinner in her catch where she stores meat and fish for the winter, Arctic Village, Alaska

85. Male caribou, Anchorage, Alaska

87. Grizzly bear, Katmai Peninsula, Alaska
Grizzlies are normally solitary animals, but in coastal areas congregate alongside streams, lakes, rivers, and ponds during the salmon spawn. They are listed as threatened in the U.S.

Hazel Johnson: Mother of the Environmental Justice Movement
88. Hazel Johnson outside her office in Altgeld Gardens, South Chicago, Illinois

91. Cheryl Johnson, Hazel's daughter, Altgeld Gardens, South Chicago, Illinois

93. Altgeld Gardens' future generation, South Chicago, Illinois

Winona LaDuke: Native Struggles for Land and Life
94. Winona LaDuke with one of her horses at her farm on White Earth Reservation, Minnesota

97. The first mid-sized (75 kW) wind turbine on the White Earth Reservation, behind teepee poles

99. Processing wild rice at the mill on the White Earth Reservation

Annie Leonard: Minding Our Stuff
100. Annie Leonard at the Berkeley Recycling Center, Berkeley, California

103. Paper towers at the Berkeley Recycling Center

105. Abandoned shopping cart, Salton Sea, California

L. Hunter Lovins: The Sustainable Cowgirl
106. L. Hunter Lovins on her ranch in Eldorado Springs, Colorado

108. Wind turbines and electric power lines, Palm Springs, California
California was the first state where large wind farms were developed, beginning in the early 1980s. Now Texas is the leader in wind power development in the U.S., followed by Iowa, and then California.

111. Sierra SunTower, Lancaster, California
Sierra SunTower is a 5 MW commercial concentrating solar power (CSP) plant built and operated by eSolar. It is the only CSP tower facility operating in North America. An array of 24,000 heliostats (mirrors with sun-tracking motion) concentrates sunlight on a central receiver mounted at the top of a tower.

Beth Waitkus: The Prison Gardener
112. Beth Waitkus at San Quentin State Prison, San Quentin, California

115. Participants of the Insight Garden Program at San Quentin State Prison

117. Inmate with flower

Alice Waters: The Food Revolutionary
118. Alice Waters at her home in Berkeley, California

120. Organic tomatoes at the Santa Barbara Farmers Market, California

123. Green onions at the Santa Barbara Farmers Market, California

Diane Wilson: An Unreasonable Woman
124. Diane Wilson on her sunken shrimp boat off the coast of Seadrift, Texas

127. Alcoa World Alumina, Point Comfort, Texas
The facility includes a 3,000-acre refinery and a C-30 hydrate facility. Each month several ships arrive carrying red bauxite. It takes several days for the cranes to unload an average ship, which contains about 50,000 metric tons of bauxite, that blows into the surrounding communities, parks, and waterways.

129. One of four toxic sludge ponds at the Alcoa plant in Point Comfort, Texas

Marci Zaroff: The Eco-Fashion Innovator
130. Marci Zaroff on El Matador Beach, Malibu, California

132. Clothing made from organic cotton, silk, and cashmere, and ECOlyptus® from the FASE collection

135. Cotton bud, San Joaquin Valley, California
The second-highest producing state, behind Texas, the San Joaquin Valley is the primary area of production for cotton in California.

Resources

Frances Beinecke
Natural Resources Defense Council
40 West 20th Street
New York, NY 10011
212-727-2700
www.nrdc.org

Janine Benyus
Biomimicry Guild
321 E. Broadway
Helena, MT 59601
406-495-1858
www.biomimicryguild.com

The Biomimicry Institute
P.O. Box 9216
Missoula, MT 59807
406-728-4134
www.biomimicryinstitute.org

Sally Bingham
Interfaith Power & Light
220 Montgomery St., Suite 450
San Francisco, CA 94104
415-561-4891
www.interfaithpowerandlight.org

Judy Bonds
Coal River Mountain Watch
www.crmw.net

Majora Carter
Majora Carter Group
901 Hunts Point Ave, 2nd floor
Bronx, NY 10474
718-874-7313
www.majoracartergroup.com

Sustainable South Bronx
890 Garrison Avenue, 4th Floor
Bronx, NY 10474
646-400-5430
www.ssbx.org

Vivian Chang
Asian Pacific Environmental Network
310 8th St. #309
Oakland, CA 94607
510-834-8920
www.apen4ej.org

Green For All
1611 Telegraph Avenue, Suite 600
Oakland, CA 94612
510-663-6500
www.greenforall.org

Theo Colborn
The Endocrine Disruption Exchange
P.O. Box 1407
Paonia, CO 81428
970-527-4082
www.endocrinedisruption.com

Agnes Denes
www.greenmuseum.org/content/artist_index/artist_id-63.html

Sylvia Earle
Mission Blue
2470 Mariner Square Loop
Alameda, CA 94501
510-522-5117
www.ocean.nationalgeographic.com/ocean/missionblue

Kathryn Gilje
Pesticide Action Network North America
49 Powell St., Suite 500
San Francisco, CA 94102
415-981-1771
www.panna.org

Centro Campesino
216 Oak Avenue
North Owatonna, MN 55060
507-446-9599
www.centrocampesino.net

Lois Gibbs
The Center for Health, Environment and Justice
P.O. Box 6806
Falls Church, VA 22040-6806
703-237-2249
www.chej.org

Sarah James
The Gwich'in Steering Committee
122 First Avenue, Box 2
Fairbanks, AK 99701
907-458-8264
www.gwichinsteeringcommittee.org

Hazel Johnson
People for Community Recovery
13116 S. Ellis Avenue
Chicago, IL 60827
773-840-4618
www.peopleforcommunityrecovery.org

Winona LaDuke
Honor the Earth
2104 Stevens Avenue South
Minneapolis, MN 55404
612-879-7529
www.honorearth.org

White Earth Land Recovery Project/ Native Harvest
607 Main Avenue. Callaway, MN 56521
www.nativeharvest.com

Annie Leonard
Story of Stuff Project
1442 A Walnut Street, #272
Berkeley, CA 94709
510-883-1055
www.storyofstuff.com

L. Hunter Lovins
Natural Capitalism Solutions
11823 N. 75th Street
Longmont, CO 80503
720-684-6580
www.natcapsolutions.org

Beth Waitkus
Insight Garden Program
415-730-6301
www.insightgardenprogram.org

Alice Waters
Chez Panisse Foundation
1517 Shattuck Avenue
Berkeley, CA 94709
510-843-3811
www.chezpanissefoundation.org

Diane Wilson
PVC Campaign
Center for Health, Environment and Justice
9 Murray Street, Floor 3
New York, NY 10007-22223
212-964-3680
www.chej.org/BESAFE/pvc

Marci Zaroff
FASE
www.fasethefuture.com

Global Organic Textile Standard
www.global-standard.org

Transfair USA
www.transfairusa.org

Acknowledgments

Birthing a book is no small undertaking and *Eco Amazons* would not have come into existence without the enthusiasm, participation, and support of so many people. I am indebted to everyone below for sharing in the vision.

To the twenty women who grace the pages of this book, I offer my deepest appreciation and admiration. These eco-warriors joyously took time from their critical work to share their lives and knowledge with me.

Colin Finlay is an honorary eco amazon. Unflinchingly, he scaled toxic mountains, almost faced arrest, and physically endangered himself to capture the remarkable images so integral to telling these stories. I could not have asked for a more intrepid, creative, or talented cohort.

When *Eco Amazons* was just in its embryonic stage, Julia Butterfly Hill responded with a resounding "Yes!" when asked to write the foreword. Her prose is a clarion call for us all.

As a first time author, I was blessed to have second eyes throughout the process of developing the book. My undying gratitude goes to Marta Salas Porras, who contributed her design expertise and significantly influenced the look and feel of *Eco Amazons*. And I am most appreciative of Leslie Jonath and Robert Forte's thoughtful editorial feedback.

Along the way, the following people generously helped me with everything from access to their programs, to providing invaluable advice: Adrienne Arieff, Lorrae Rominger, April Bucksbaum, Kirby Walker, Randy Rosenberg, Claire Greensfelder, Marianne Manilov, Adam Browning, David Shearer, Miss Jackie and Hunters Point Family, James Cochran and Sandy Brown and Swanton Berry Farm, Steven Scholl-Buckwald and Pesticide Action Network, Sandy Saeteurn and Asian Pacific Environmental Network, Charles Higgins and Slide Ranch, Patrick Lampi, Amy Deavoll and eSolar, Ben Carlson and Doug Lybeck and Friends of the Urban Forest, Father Lawrence, Marion Abney, Deborah Munk, and John Jurinek.

Colin and I were privileged to have the talented Unnikrishnan Raveendranathan as our photography assistant. He worked on the images as if they were his own.

Eco Amazons could not have been realized without the generous support of the Richard and Rhoda Goldman Fund and the Goldman Environmental Prize, and the Charles Evans Foundation, and with additional funding from the Baum Foundation, the Fred Gellert Family Foundation, and Marion Hunt. Thank you for understanding the power of storytelling as a means for inspiration and change.

At powerHouse, I was fortunate to have two open-minded publishers, Daniel Powers and Craig Cohen, and to collaborate with Rachelle Nidra Somma on the design of the book.

And special thanks to my agent Jessica Papin, who believed in this project from the moment it crossed her desk.

I am humbled to have traveled on this journey with all of you.

Dorka Keehn is a journalist and activist. A leader in the women's movement, she is a founder of Emerge America (emergeamerica.org), the premier training program for Democratic women planning to run for political office; a founding board member of Ignite (igniteca.org), an organization that provides political and civic education to high school and college women; and a Commissioner on the San Francisco Commission on the Status of Women. Dorka also hosts the arts and culture Internet and radio program, *Keehn on Art* (keehnonart.com), and has produced several programs for television including the two-time Emmy-award-winning documentary, *Of Civil Wrongs and Rights: The Fred Korematsu Story.*

Colin Finlay is one of the foremost documentary photographers in the world. He has been awarded the prestigious Picture of the Year International (POYi) six times, and his photographs have been featured in *Vanity Fair, TIME, U.S. News and World Report, American Photo, Photographic Magazine,* and *Discovery*. Colin has published four previous photography books including *Testify* (Zuma Press, 2006) and *Darfur: Twenty Years of War and Genocide in Sudan* (powerHouse, 2007). www.colinfinlay.com

Eco Amazons

Compilation & editing © 2011 powerHouse Cultural Entertainment, Inc.
Text © 2011 Dorka Keehn
Photographs © 2011 Colin Finlay

Published in the United States by powerHouse Books,
a division of powerHouse Cultural Entertainment, Inc.
37 Main Street, Brooklyn, NY 11201-1021
telephone: 212.604.9074, fax: 212.366.5247
email: ecoamazons@powerhousebooks.com
website: www.powerhousebooks.com

First edition, 2011

Library of Congress Control Number: 2011923383

Hardcover ISBN 978-1-57687-571-1

Printing in China by Everbest Printing Company through Four Color Imports, KY
Book design by Rachelle Nidra Somma
www.rachellesomma.com

A complete catalog of powerHouse Books and Limited Editions is available upon request;
please call, write, or visit our website.

10 9 8 7 6 5 4 3 2 1

Printed and bound in China